The Artist's Complete Guide to
DRAWING THE HEAD

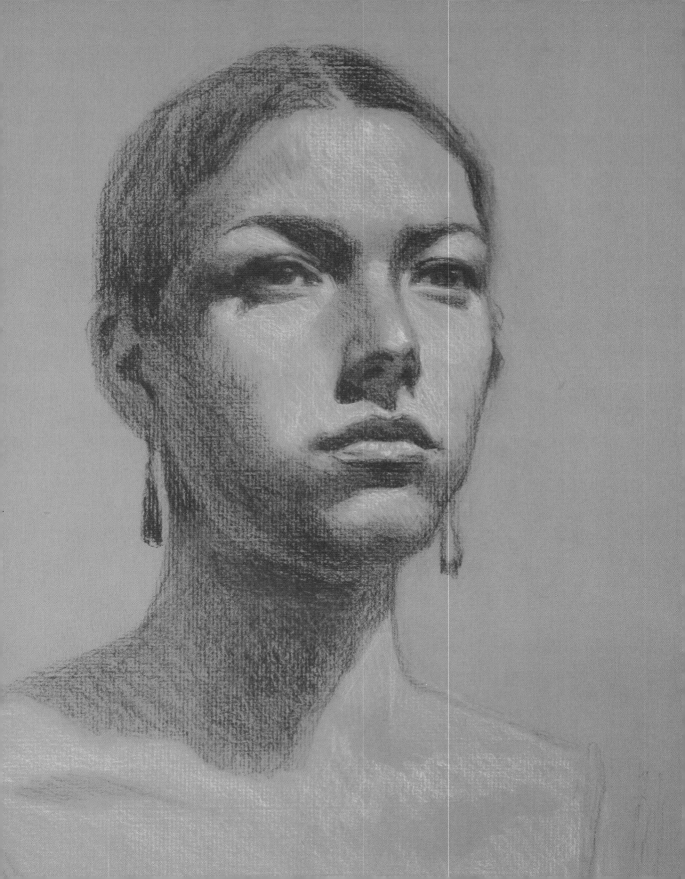

The Artist's Complete Guide to
DRAWING THE HEAD

WILLIAM L. MAUGHAN

WATSON-GUPTILL PUBLICATIONS/NEW YORK

ACKNOWLEDGMENTS

Without valuable help from my wife, Susan Maughan, and her sister, MaryAnn Webster, in the preparation of this book, it would not have come to pass. I am grateful to Lorser Feitelson, the father of hard-edge abstraction and post-surrealism, for teaching me to analyze and draw the representational form. I would also like to thank Richard and Elisa Stephens and the Academy of Art College for giving me the opportunity to develop this material into the curriculum. I owe a special word of thanks to my editor, Holly Jennings, for the countless hours of phone conversations, e-mails, and rewrites.

Front cover model: Tweed Conrad

A NOTE FROM THE AUTHOR:

All of the heads in this book were drawn life-size, between approximately six and eight inches.

Copyright © 2004 by William L. Maughan

First published in 2004 by Watson-Guptill Publications, Crown Publishing Group, a division of Random House Inc., New York
www.crownpublishing.com
www.watsonguptill.com

Library of Congress Cataloging-in-Publication Data

Maughan, William L., 1946–
 The artist's complete guide to drawing the head / William L. Maughan.
 p. cm.
Includes index.

 ISBN-13: 978-0-8230-0359-4
 ISBN 0-8230-0359-0 (pbk. : alk. paper)
 1. Head in art. 2. Drawing—Technique. I. Title.
 NC770.M38 2004
 743.4'2—dc22

 2003020387

Senior Editor: Joy Aquilino
Editor: Holly Jennings
Designer: Jay Anning
Production Manager: Hector Campbell

Printed in Malaysia

First printing 2004

8 9 / 11 10

Text set in Adobe Garamond

This book is dedicated to my children,
Brittany, Meagan, Weston, Tyson, Matthew, Bradford, and Bryant.

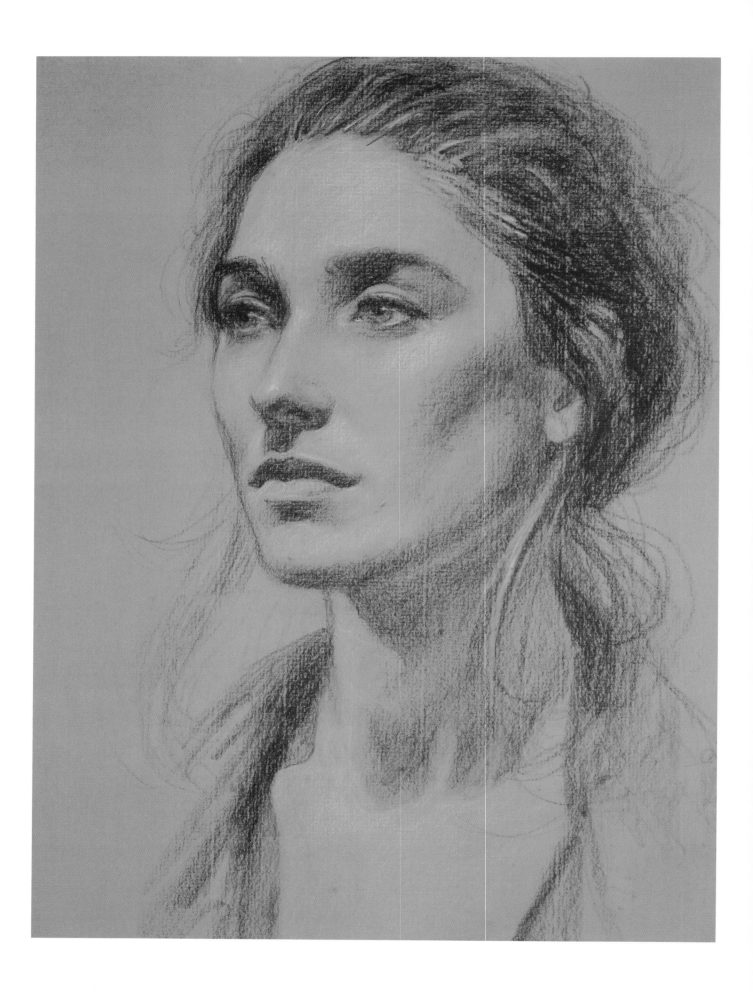

CONTENTS

PREFACE 10

INTRODUCTION
THE DRAWING METHOD AND MATERIALS 13

CHIAROSCURO 14
Sfumato 15

THE MATERIALS 16
Substitute Materials 16

WORKING WITH THE PENCIL 17
Drawing Shadow Shapes 18
Sharpening the Pencil 18

CHAPTER ONE
PRINCIPLES OF CHIAROSCURO 21

LINE VERSUS VALUE 22
"Lost-and-Found" Line 23

VALUE AND FORM 24
Paper + Two Pencils = A Full-Value Range 25

THE SHADOW SHAPES AND THEIR EDGES 26
Form-Shadows 26
Cast-Shadows 26
The Shadow Edges 28

THE FORM IN LIGHT 29

ANALYZING FORM 30
Negative Shapes 33

CHAPTER TWO
PRINCIPLES OF DRAWING THE HEAD 35

TWO MASSES OF LIGHT AND SHADOW 36

LIGHTING THE HEAD 37
Artificial and Natural Light 38
Light Advances; Dark Recedes 38

SINGLE FOCAL POINT 43

PERSPECTIVE AND THE THREE-QUARTER VIEW 45
Perspective 45
Planes of the Head 47
Foreshortening 48

VALUE PATTERN 52

ADDRESSING THE BACKGROUND 53

CHAPTER THREE
THE DRAWING PROCESS, STEP-BY-STEP 55

SCULPTING THE HEAD 56

GESTURE 57
The Tilt 59

PROPORTIONS 60
Placing the Features 62

THE ANATOMY OF THE EYES 65
The Orbicular Cavity 65
The Natural Slants of the Eye 67
The Eyelids, Pupil, and Iris 68
Positions of the Eyes 69

DRAWING THE EYES 70
Highlights on the Eyes 72
Using the Paper Value 75
Examples of Eyes 76

NOSE AND MOUTH 82
The Structure of the Nose and Mouth 84
Examples of the Nose and Mouth 86

EARS 94
Placement of the Ear 95

HAIR 100

TROUBLESHOOTING EXAMPLE 105

CHAPTER FOUR
PUTTING IT ALL TOGETHER 107
THE FIVE ESSENTIAL DRAWING STEPS 108
Review 108
The Demonstrations 109

GOING FORWARD 118
Practice Ideas 118
Self-Critique 121
Taking Your Skills to the Next Level 121

CHAPTER FIVE
DRAWING FROM MULTIPLE SOURCES 123
COMBINING REFERENCES 124
A Demonstration 126

EXAMPLES OF COMPOSITE DRAWINGS 128

CHAPTER SIX
WORKING WITH COLOR 133
FROM DRAWING TO PAINTING 134

THE COLOR "WHEEL" 136
Complementary Colors 136

COLOR INTENSITY 138
Mixing from the Tertiary Colors 138

COLOR TEMPERATURE 140
Color Relationships 142
Warm Advances; Cool Recedes 142

FAMILY OF COLORS 143
Expressive Color 145

PASTEL PAINTING 148
The Materials 149
Caring for Your Pastel 150
Applying the Charcoal Pencil 150
Applying the Tone 150
Applying the Pastel 151
Painting the Background 152
Pastel Demonstration One 153
Pastel Demonstration Two 156

INDEX 160

PREFACE

I have taught for thirty years, and during that time, I have been asked continually what books I can recommend to reinforce the instruction I give in the studio. Unfortunately, since most books teach the reader to construct the head linearly and to add a general tone to fill out the form, I couldn't recommend a single one. The drawing method I teach is based on value, rather than line, and the centuries-old principles of chiaroscuro. This book was borne in response to these repeated requests from countless and dedicated students. In your hands it will introduce and reinforce a distillation of the same lectures and demonstrations my students have received over the last three decades.

Without question chiaroscuro is the best basis for drawing the illusion of three dimensions on a two-dimensional surface. The method is based on the study of light as it falls across the structure of form, producing both form- and cast-shadows. When an exact rendering of both form- and cast-shadows is achieved, the result is a convincing likeness and the illusion of three-dimensionality.

The key to this book is, It's all in the shadows. If the shadows are correct in size, shape, and placement, the likeness, sex, age, nationality, and expression will be captured. The illusion will be lifelike and appear three-dimensional. In fact, if an exact likeness is not the goal, you must force your drawing away from the exact likeness that will automatically occur when you apply the principles I teach. Once you have gained confidence that both form- and cast-shadow shapes describe structure, you will be able to draw anything and draw it well. When artists say they are good at drawing objects but cannot draw people, they have not come to know this simple truth: Whether drawing a figure, landscape, still life, animal, or portrait, it is all the same, just light and shadow.

In this book I will walk you through the principles and five drawing steps—gesture, proportions, shadow shapes, edge control, and detail—that will enable you to achieve a likeness of a model. It's best to follow the contents of the book in the order given, since one principle builds upon another. However, the beauty of having a book as a teaching guide is that you can go back and review what you have learned at any time. Unlike the students in my class, you do not have to take notes. Just read and look; all the notes are written down.

THE CHAPTERS

In the "Introduction" you will become acquainted with the drawing method, including its historical roots, and the materials you will use to draw a head. In the first chapter, "Principles of Chiaroscuro," the basic principles of the drawing method are described in depth, including the relationship between value and form, form- and cast-shadows, and shadow edges. In the second chapter, "Principles of Drawing the Head," you will be taught how to successfully pose, light, and foreshorten the head, and how to create a lively composition using value pattern and negative space.

The third chapter, "The Drawing Process, Step-by-Step," focuses on gesture, proportions, and, to a great extent, the features of the head. Anatomy is knowledge, and the more knowledge you have of the structure you are drawing, the greater will be your ability to recognize the shadows created by that structure. However, knowledge alone is not enough. My family physician can name every bone and muscle in the body, but he can't draw well. Though the edges of shadows will be visible if you observe them closely, your observation will be enhanced by your knowledge of anatomy. But ultimately, if the shadow shapes, which are the result of light on form, are correct in size, shape, and placement, they will describe the anatomy for you accurately.

The fourth chapter, called "Putting It All Together," puts all that you've learned into practice. It's about *doing*. You will find four demonstration drawings, suggestions on how to criticize your own work constructively, practice ideas, and thoughts about how to take your drawing to the next level of subtlety. The fifth chapter, "Drawing from Multiple Sources," teaches you how to combine life, photo reference, and your imagination to create a realistic "likeness" of something that is both real and imagined. The resulting composite drawings are not likenesses in the sense of traditional portraiture, but rather are realistic renderings of nonreal subjects.

The final chapter, "Working with Color," introduces you to pastel painting. Since drawing in value is a crucial developmental step in learning to paint, the material in this chapter is a natural progression from learning about putting the principles of chiaroscuro into practice. Working with pastel, the same medium you will have used in the first five chapters, you will make the transition from drawing the head in a four-value scale to painting the head in color.

GENERATIONS OF LEARNING

My art school teacher Lorser Feitelson, the father of hard-edge abstraction and post-surrealism, exposed me to the principles of chiaroscuro. Although he chose to be a nonfigurative artist, he could draw in a realist style like Raphael and Caravaggio. He taught me to analyze form and describe structure in the same way that Leonardo da Vinci, Raphael, Caravaggio, Hals, Velázquez, and Rembrandt did—by drawing shadow shapes. He was in his eighties when he passed on this knowledge to me, and I have passed it on to others who have also become successful illustrators and fine artists. The more I drew, the more I saw; the more I taught, the better I became. Nothing gives me greater pleasure than to assist others in attaining their potential by developing the gift inside them.

In all the years of illustrating, I have never come across a book more valuable than *Creative Illustration* (Viking Press, 1947) by Andrew Loomis. It is the bible for illustration. As old as it is, the information is just as relevant today as when the book was written. In his book Loomis addresses value pattern, light on form, as well as a great deal more on composition and the process of illustration. For the fine artist I highly recommend *The Human Figure* (Dover, 1985) by J. H. Vanderpoel, first published in 1907. (Though both books are now out of print, they are available in libraries or as used copies.) Vanderpoel was a great teacher in Chicago at the turn of the last century, and young artists from all over the country flocked to study under him. Vanderpoel's writings reinforce the instruction given to me by my teacher Lorser Fietelson, with examples of his students' work as well as his own demonstrations. Beginning with Postimpressionism and later Modernism, a taste for flatness emerged, causing instruction in chiaroscuro to be neglected and its principles misunderstood or forgotten. Thanks to artist-instructors such as J. H. Vanderpoel in the early 1900s and Andrew Loomis in the mid-1900s, this knowledge has been preserved and passed on. The text of this book reinforces what they taught, the very same concepts handed down by the great masters of the Renaissance. Finally, I want to thank the numerous models who have posed for me over the years and whose likenesses can be found within the covers of this book.

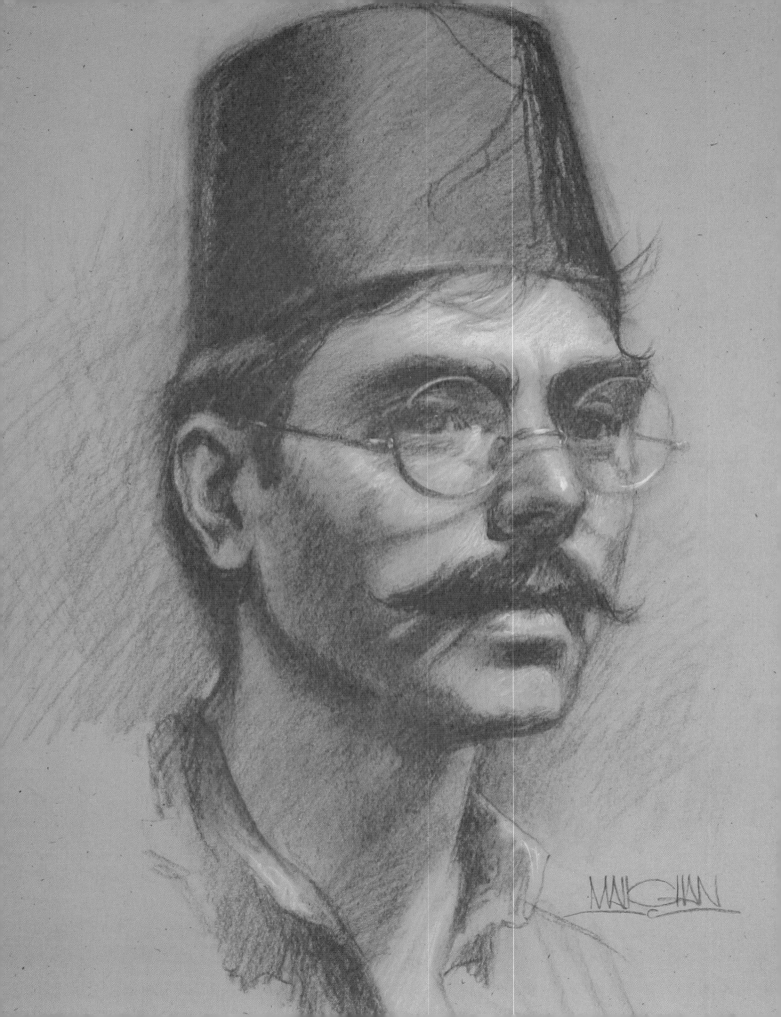

THE DRAWING METHOD AND MATERIALS

CHIAROSCURO

When drawing a portrait, you are creating an illusion. If you are successful, the head will appear three-dimensional, despite the fact that it is drawn on a two-dimensional surface. The technique to create this illusion is called chiaroscuro, an Italian term meaning "light *(chiaro)* and dark *(oscuro)*". Once you have mastered it you will be able to draw or paint anything realistically.

Chiaroscuro is not an invented formula, but rather the result of the observation of light and shadow on form. When illuminated properly, form divides into two major masses of value, that is, of light and dark, or shadow. Duplicating the exact shapes of both light and shadow, and paying particular attention to the edges between the two, is fundamental to capturing a likeness.

It was Leonardo da Vinci (1452–1519) who, in the late 1400s, first realized that duplicating the shape of shadows was fundamental to creating the illusion of three-dimensional form and a model's likeness. In the *Mona Lisa* (1503–5), Leonardo's mastery and refinement of the principles of chiaroscuro are fully evident. In this masterpiece Leonardo has clearly described the overall structure of his model's head, and the mass and specific likeness of each feature, by rendering the shadow shapes in value without detail or outlines. Leonardo's breakthrough use of value and shadow shapes ushered in a new epoch and approach to rendering that has been practiced by countless artists through the centuries: Michelangelo, Raphael, Titian, Rembrandt van Rijn, Vermeer, John Singer Sargent, and Thomas Eakins, among others.

In his studies Leonardo identified two distinctively different shadows. The first, a form-shadow, is caused by form turning away from the source of light. A soft, gradated edge is created between the lit portion of the form and the portion of the form that is in shadow—that is, the round part of the form that has turned away from the light. The second, a cast-shadow, is caused by form intercepting the light and casting its shadow on an adjacent surface. This produces a hard edge between light and the cast-shadow. Thus the division between the two contrasting values of light and dark will, depending on the shadow created, either be a soft transition or a hard, abrupt one.

Leonardo must have observed that all shadows begin as form-shadows and end as cast-shadows—that is, each shadow shape begins soft and ends hard in relationship to the source of light. From experience artists learned that the more they emphasized the difference in appearance between the two types of shadows, the more effective their illusion; the closer in similarity, the less effective. Once you as the artist have convinced the viewer that a soft-edged shadow describes form turning away from the source of light and that a hard-edged shadow describes the protrusion of form that has intercepted the light, you have established a visual dialogue with the viewer. The more consistent you are in emphasizing the difference between a form- and cast-shadow edge, the clearer the dialogue. If the difference appears vague or inconsistent, the viewer will be confused.

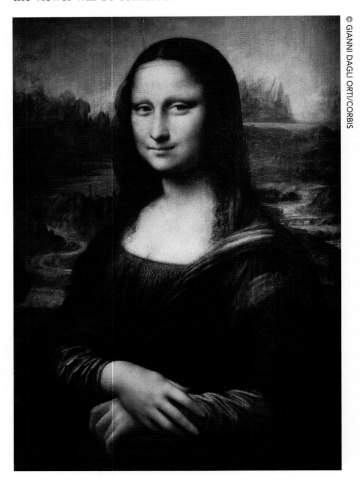

The *Mona Lisa* *is a masterful refinement of the principles of chiaroscuro. The painting is reproduced in a monochromatic tone to dramatize Leonardo's use of light and shadow masses to render form.*

SFUMATO

Leonardo used a technique called sfumato (meaning "smoke") to further soften edges of a contour. Paintings are sometimes described by writers and critics as having a smoky quality. The dark and hazy effect they observe is most likely the result of a dark, transparent glaze that often diminishes strong value contrast. A glaze, however, is not sfumato. The term describes a quality, or treatment, of a form's contour.

Based on the principle that our eyes cannot focus on more than one depth of field at the same time, everything beyond the focal point will be less defined and blurry. Therefore contours of all rounded forms will disappear like smoke (sfumato), since smoke has no discernable edge. Artists who struggle with contours that always seem too hard or tight, like an outline, have probably never been exposed to sfumato, an old-master technique that is still extremely useful today. As a student, I was taught to draw and paint hair like smoke with the assurance that my rendering would be more like hair than actual hair. And my professors were right.

Everything beyond the eyes, the focal point in a portrait, will be less defined and blurry.

THE MATERIALS

I use pastel pencils for chiaroscuro drawing because they have a soft consistency, produce rich, bright color, and give me a great deal of control. I recommend the **CarbOthello pencils** manufactured by Stabilo because they have a narrow shaft, and I prefer the CarbOthello color number 645 for my dark value. However, any pastel pencil will do. Just remember that the dark value must be as dark as the white is light, so the paper will be exactly halfway between them. Though the official CarbOthello color for number 645 is "Caput Martuum Red," it is essentially a sanguine color. For simplicity I refer to it as sanguine, or number 645, throughout this book.

The paper I use and recommend is **Strathmore's "Charcoal" paper** in "Velvet Gray." It comes in twenty-five-sheet packs and is available in one size only (nineteen by twenty-five inches). I often cut a sheet in half to use it for two drawings since, when drawn life-size, the average head is about six by eight inches. I use the smooth, back side of the paper since the textured side produces a checkerboard look that tends to overpower any subtlety in a drawing.

Strathmore's "Velvet Gray" paper is actually a tan color that blends well with the darker of the two pencils you will use, number 645. The paper color is a perfect middle value between white, your light-value pencil, and sanguine, your dark-value pencil. If you were to use a paper that is too light in value, your application of highlights would not be noticed. If the paper is too dark, the white appears too light.

The **X-Acto® knife** and **sand pad** are used to sharpen and sand the point of the pastel pencil. The **kneaded eraser** is used to blot away excess value in shadow shapes. I do not recommend spraying your finished pastel drawings with fixative since it tends to darken pastel pigment. For dislay, a pastel drawing should be framed behind glass, though be careful the paper does not touch the surface of the glass. For storage, pastel drawings can be stacked one on top of the other; if they do not slide back and forth they will not smear.

SUBSTITUTE MATERIALS

For the dark value, you can use an extrasoft charcoal pencil, such as a 6-B, in place of the pastel pencil. I do not recommend white charcoal pencils since they are much harder and therefore not as bright. Charcoal is much darker than CarbOthello's number 645, so the paper you use must also be of a darker value. The paper value that is halfway between black charcoal and white is a color called "Pottery Green," also manufactured by Strathmore. I do not recommend using markers or other liquid media since it is more difficult to produce soft edges with them.

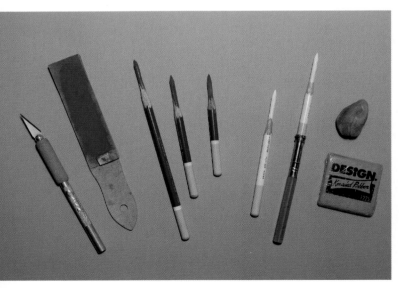

X-Acto® knife, pencils, sand pad, and kneaded eraser photographed on Strathmore's "Velvet Gray" paper

What You Will Need

- ☐ CarbOthello pastel pencil in "Caput Martuum Red" (Number 645)

- ☐ CarbOthello pastel pencil in "Titanium White" (Number 100)

- ☐ "Charcoal" paper in "Velvet Gray"

- ☐ X-Acto® knife

- ☐ Sand pad

- ☐ Kneaded eraser

WORKING WITH THE PENCIL

To hold the pencil correctly, position it between the thumb and the first three fingers below the palm of your hand. Keep your wrist locked and use your elbow and shoulder to move the pencil, rather than your wrist and fingers. Since you will be drawing with the side rather than the pointed tip of the pencil, you will produce a soft stroke, which is desirable. Accentuate the subtlety of your stroke by applying your pencil with a soft pressure, as if you are caressing the drawing surface. The key is to not go too dark too soon! This will facilitate edit-ing, allowing you to refine shadow shapes during a longer period of time without overrendering.

Blending sanguine or white pencil with your finger is acceptable when blending into paper value, though it is important that the paper appear as halftone value between the light and shadow. If you blend the white and sanguine together, not only will you destroy the middle value of the paper, but you will create a horrible pink color in its place.

Hold the pencil between the thumb and the first three fingers, and draw with the side of the pencil rather than the tip.

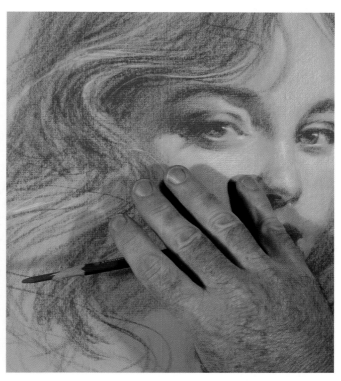

Use your finger to blend the sanguine or white pencil into the paper value.

On the Pencil

Hold the pencil as you would a paintbrush, as though you were painting with dry pigment. If you hold the pencil as if you were writing your name, this angle will produce a hard line, which is undesirable.

DRAWING SHADOW SHAPES

With the side of your pencil, not the point, apply value to the paper in a circular, up-and-down, as well as side-to-side, motion. Begin in the center of the shadow shape, and without lifting your pencil from the paper, add more and more value until the graphic shape of the shadow appears. If the placement of the shadow shape appears too low, simply add value to the top of the shadow shape to correct the location. Blot away any excess at the bottom of the shape with a kneaded eraser. Since the resulting shape will have soft edges, all form-shadow edges occur automatically. If the shadow shape is a cast-shadow, its edge should be hardened, or crisped, with the point of the pencil.

APPLYING SFUMATO. By drawing with the side of your pencil, rather than the tip, you will automically create a soft edge. However, you may wish to soften the edges, especially contours, even further to create a smokelike effect, known as sfumato. To create a smokelike contour, apply multiple strokes, rather than a single line. As you work, your hand may inadvertently smear the drawing and soften the edges even further. If more softening is necessary, smear the edge with your finger; just be careful not to smear sanguine into white pigment. Drawing with a much softer pressure will also make the edges less defined.

SHARPENING THE PENCIL

If right-handed, hold the pencil in your left hand and the X-Acto knife in your right. Place the thumb of your left hand on top of the thumbnail of your right hand. While holding the X-Acto knife stationary in your right hand, press against your right thumb with your left thumb for resistance as you bring the pencil toward your body with the fingers of your left hand. As you bring the pencil back, lift the pencil up to the blade. This will control the depth of each cut. Roll the pencil with your fingers as you bring the pencil forward for each new cut. Avoid nicking the pastel pencil, since this will cause the tip to break off. Gradually cut deeper and deeper until you have exposed three-quarters of an inch of pastel. Then, using the sand pad, sand to a point by rolling the pencil while sanding from side to side.

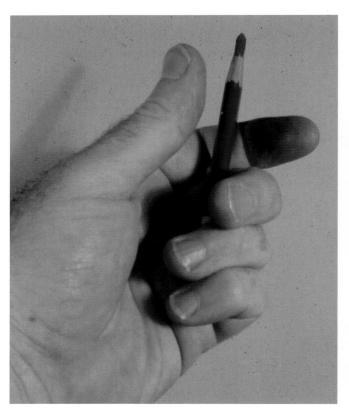

If you are right-handed, hold the pencil in your left hand.

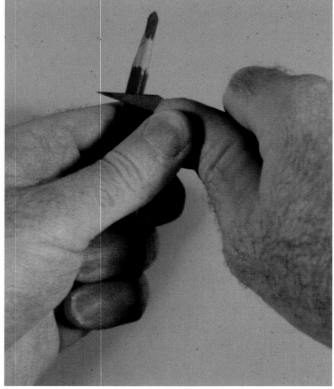

With the X-Acto knife in your right hand, place the thumb of your left hand on top of the thumbnail of your right hand.

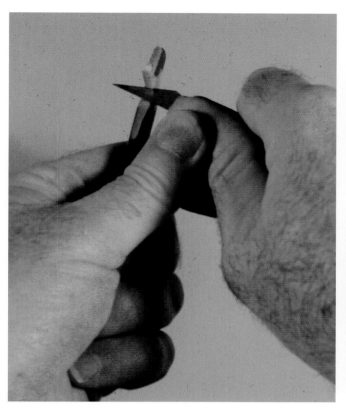

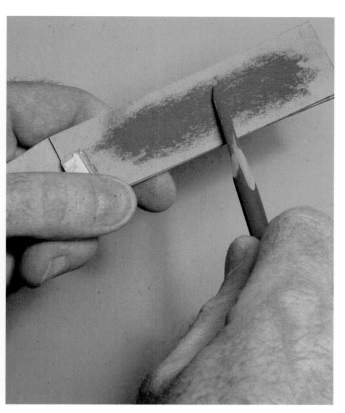

Holding the X-Acto knife stationary in your right hand, bring the pencil toward your body with the fingers of your left hand. Roll the pencil with your fingers, slowly cutting deeper and deeper until you have exposed three-quarters of an inch of pastel.

Sand to a point by rolling the pencil while sanding from side to side.

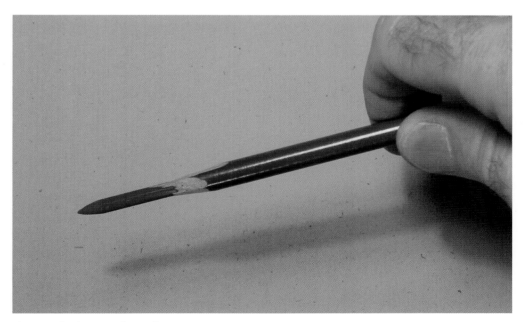

A properly sharpened pencil

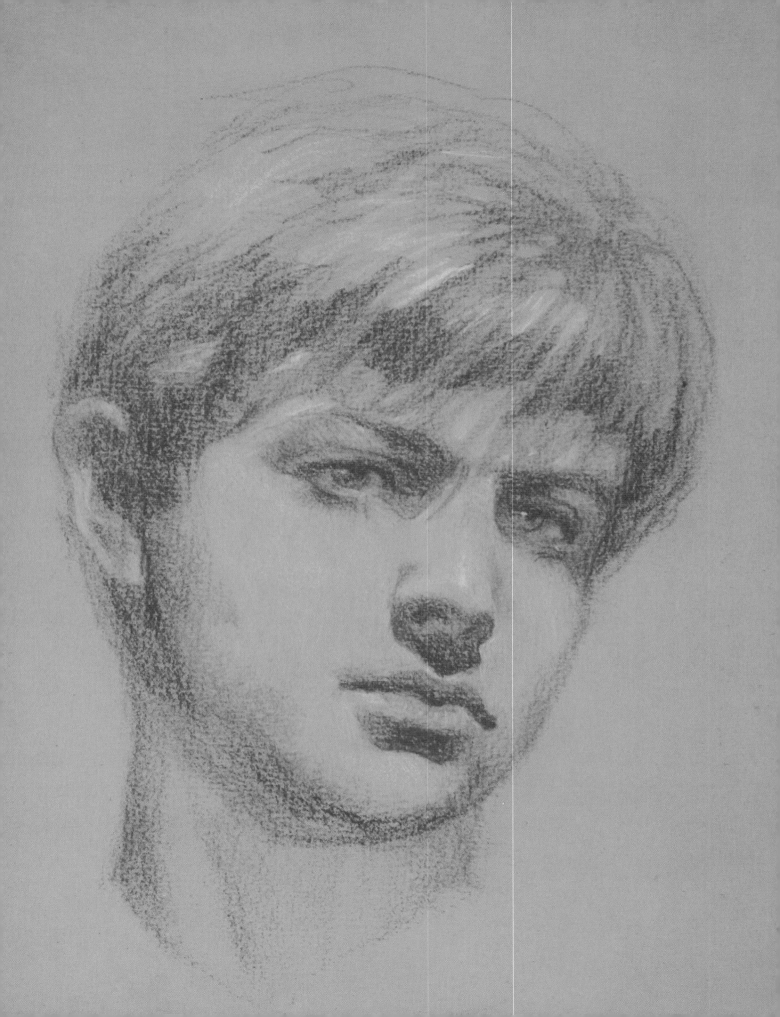

PRINCIPLES OF CHIAROSCURO

LINE VERSUS VALUE

Line is an artistic invention. It does not exist in nature. Yet as children, we begin to draw by using lines and outlines to create stick figures and basic shapes. Most likely you were praised at an early age for your ability to neatly fill in between the lines in coloring books. Even later, in high school or college, many of you may have been encouraged to develop your skills through contour and cross-contour drawings. And shading becomes a superficial attempt to lose the unwanted line. Chiaroscuro, the drawing method I will teach you to use in this book, provides an alternative, and more convincing, way to give the illusion of three dimensions on a two-dimensional surface. Once you've become proficient with the technique and grasped its principles, you will clearly see the foolishness of teaching students to describe nature through line and then have them struggle unsuccessfully to lose the line that should never have been there in the first place.

In reality the illusion of a line is a common edge shared by the two contrasting values of light and dark. Contour is the outside edge of form. It is not and should never be treated as a line. An outline is a solid line that follows the contour of a form. And though outline is useful to define a form's contour, it can never describe its three-dimensional structure. That is why certain cartoon drawings, those that make heavy use of outline, appear flat on the page. To duplicate reality the artist must describe form through value relationships.

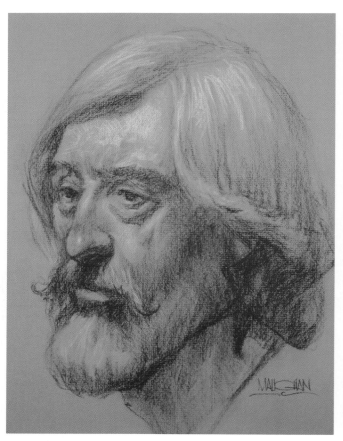

Structure was defined with shadow shapes, not line.

Structure was defined incorrectly, with line.

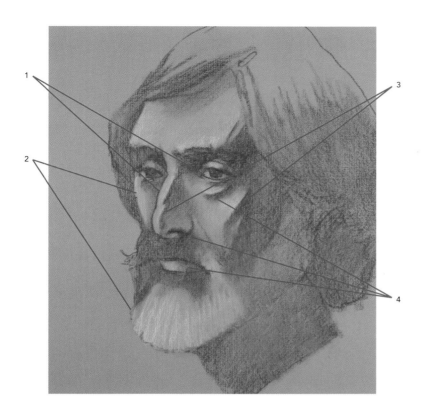

This drawing is an example of what not to do. 1. An outline was used to separate two forms that should have been separated by value. 2. White was applied to the far edge of the form, which flattened it. 3. The form-shadow edges were rendered hard, which makes rounded forms appear square. The transition between light and form-shadows should have been indicated as a soft, blended edge. 4. Finally, cast-shadows are either absent, vague, or soft-edged. They should have been consistently defined with a hard edge.

"LOST-AND-FOUND" LINE

Though line is essentially nonexistent in chiaroscuro drawings, there is one exception. A graceful and sensitive "lost-and-found" line can be used sparingly as a decorative element. It should not be used as an outline to separate two forms, but as a way to create variety in the contour. The amount of pressure you apply to the stroke controls the range and grace of your lines. Try applying a very sensitive and light pressure where the contour of form is illuminated and bold pressure along the contour where it is in shadow. I refer to this as lost-and-found line. It disappears, or becomes "lost," in the light areas and then bold, or "found," in the shadows. The speed at which the eye travels around the contour of a form is regulated and varied by the weight of a line; the eye travels slowly when is it lost, fast when it is found. Note that even lost-and-found lines, if used at all, should be added last, after you're confident that your model's features are correctly placed and are rendered in perspective.

LOST THIN

FOUND THICK

LOST THIN

FOUND THICK

Variation in line creates interest whereas a continuous, equally weighted line deadens the effect of subtle rendering.

VALUE AND FORM

Drawing, and painting for that matter, is the process of establishing value, or tonal, relationships—everything is either lighter or darker than something else. Value, which is sometimes also referred to as tone, exists on a scale of nine tonal ranges from the lightest to darkest, with gradations of value between them. Value number five is referred to as the middle value, or halftone. If an artist attempts to render all nine values for each of the objects within a composition, the value pattern and composition will fail. The range of values that an artist uses to describe form depends on the *local* value of the objects within a composition—meaning that each object will have its own value range relative to others.

Commonly five values are used to render local value in light and shadow: two in highlight, two in shadow, and a halftone in the middle. The middle value for a light object is value number three on the value scale, for a middle-value object it is value number five, and for a dark object it is value number seven. Note that the darkest shadow value of the light object, number five, is the same value as the highlight of the dark object.

The "Velvet Gray" paper I recommend is not the halftone (value number five) on the value scale. It is actually lighter in value. It is, however, the halftone between your white and sanguine pencils. We will be using four values, not five, to describe local value: two in the light (highlight and halftone, or the paper value) and two in the shadow (reflected light and the darker value of both the cast-shadow and the form-shadow core).

Four-value scale

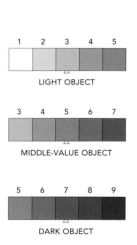

LIGHT OBJECT

MIDDLE-VALUE OBJECT

DARK OBJECT

Typically five values are used to render local value in the two masses of light and shadow: two in highlight, two in shadow, and a halftone in the middle. We will use four values—two in the light mass and two in the shadow mass.

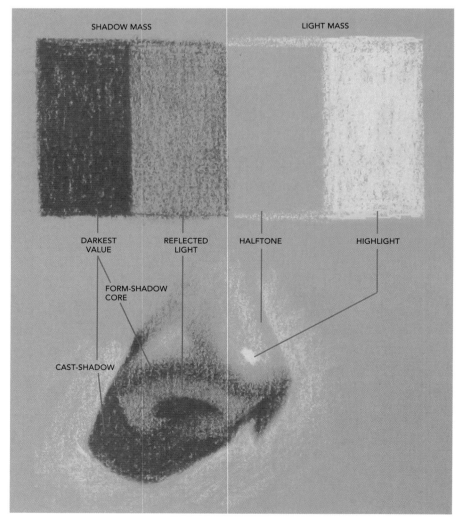

PAPER + TWO PENCILS = A FULL-VALUE RANGE

Using the "Velvet Gray" paper and the white and sanguine pencils is the most efficient way to achieve a full range of values. Since the paper serves as the middle value, the paper automatically does a great deal of the work for you. Using only the paper surface with the white and sanguine pencils, which represent opposite ends of the value scale, you will be able to render a full and rich range of values.

If the middle value of the paper is trapped, or enclosed, by a hard white edge, the paper will appear darker than the middle value. This will allow you to darken a form on the light side of the head without using the sanguine pencil, which describes shadow value. If the paper value is trapped by a hard dark edge, the paper appears lighter than the middle value. This will allow you to advance a halftone on the light side of the form without using your white pencil, which should be reserved for describing highlights.

DARKER THAN HALFTONE

HALFTONE

LIGHTER THAN HALFTONE

In the rectangular piece of paper, the top square of white shading gradually blends into the paper value toward the center. The sanguine square at the bottom gradually blends into the paper toward the center. The value of the paper in between the two is the halftone, or middle, value of the drawing. The paper value in the center of the top square is trapped, or enclosed, by the white value, making it appear darker than the middle value between the top and bottom squares. The opposite is true of the paper value in the center of the bottom square, which is trapped by sanguine.

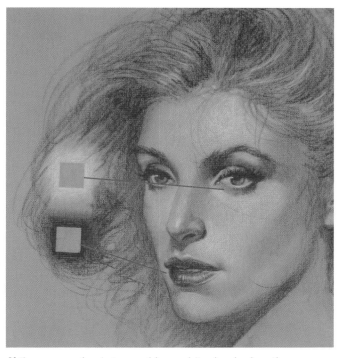

On Value

Your white pencil should always be reserved for highlights; the tone of the paper should be used for the middle values in your drawing.

If the paper value is trapped by a white, hard edge, the paper will appear darker than the middle value. This effect allows you to darken a form on the light side of a model—such as the lower lid of the model's eye—without using the sanguine pencil that is used to describe shadow value. If the paper value is trapped by the sanguine pencil—such as the model's lips— it appears lighter than the middle value.

THE SHADOW SHAPES AND THEIR EDGES

It is not the contour of forms that the artist must observe and draw with accurate precision, rather it is the shape of the shadows that fall across a form, since it is they that describe the structure of form. Starting with value only, your goal is to attain a likeness of your model. Detail is added only after a likeness is achieved. The structure of form- creates a shadow based on its position to the source of light. Therefore if you recreate the exact shadow shape using value, you have described the structure, or feature in the case of the human head, that created the form- or cast-shadow. Also, if you have correctly rendered the shadow, it will describe the location and direction of the source of light, which is most often outside the picture plane. Shadow shapes are not shading or tone applied in a general way!

Since the key to duplicating reality is to draw the exact shape of the shadows, both form and cast, with careful attention to their edges, it is central to your success that you learn to identify the shadow shapes and understand the principles that affect them. The good news is that there are certain constants that, if followed, will make your work easier. The first truth to keep in mind is that your rendering of a shadow's shape, size, and edge must be precise. A vague or general shadow shape will not convey likeness. Second, cast-shadows are always hard and form-shadows are always soft. Third, all shadows begin as form-shadows and end as cast-shadows, falling away from the light source. You will begin to recognize these constants as you study light and shadow on form.

FORM-SHADOWS

When the form curves away from the source of light, the light gradually gives way to shadow. A soft gradation occurs as the light on the form gives way to shadow. It is therefore called a form-shadow. This type of shadow begins at an oblique angle to the light and has a soft edge. A form-shadow is almost always comprised of two parts: reflected light and the shadow core.

The portion of the form-shadow that contains reflected light is illuminated either by ambient light or light that has bounced off another form. Reflected light is never as strong as the original source of light. The area between the weaker light of the shadow and the stronger original source of light compresses the form-shadow into a core, which is without light of any kind. It is the darkest part of the form-shadow. The core blends toward both the original light source and the reflected light.

The amount of reflected light a form-shadow contains is guided by two factors: the strength of the primary light source and the distance of the reflecting form, or surface, from the form-shadow. The greater the distance between the form-shadow and the reflecting form, the weaker the reflected light. If the distance between them is too far, the form-shadow may not receive any reflected light at all. Also, the brighter the primary light source, the greater will be the amount of reflected light that is generated; the weaker the light source, the weaker the reflected light. However, remember that no matter how bright the reflected light is, it will never be as light in value as the halftone value, which is always reserved for the light side of the form.

CAST-SHADOWS

When a form is illuminated, it intercepts the light and prevents it from striking adjacent forms. However, the contour of the form that has intercepted the light will cast its shadow on an adjacent form, or forms. Thus a cast-shadow simultaneously describes the contour of the illuminated form, the distance the first form is to the second, and the contour of the second form. Like the core of the form-shadow, a cast-shadow is without light of any kind. The form-shadow core and cast-shadow are thus both rendered with the darkest value in the four-value scale.

When a cast-shadow merges with the core of a form-shadow, the two shadows become one. Though this may seem confusing at first, you will learn over time to trust the shadow shape to communicate convincingly. You will not lose the structure by drawing a cast-shadow over adjacent forms. A shadow is the result of the struc-

ture of form in relationship to the light source. Therefore the drawing of the precise shadow shape will reveal the structure, not cloak it in obscurity.

The following scenario describes how a cast-shadow and the core of a form-shadow might merge. If the front plane of the head were illuminated and the side plane of the head were in shadow, the front plane of the cheek would be illuminated and the side plane would give way to a form-shadow, creating a soft edge between the two planes. If the hard-edged cast-shadow from the nose did not end before it came into contact with the cheek, it would merge into the form-shadow. As the core of the form-shadow and the cast-shadow are the same value, they would become one shadow. The cast-shadow from the tip of the nose would not be visible beyond the core of the form-shadow, since it disappears into it.

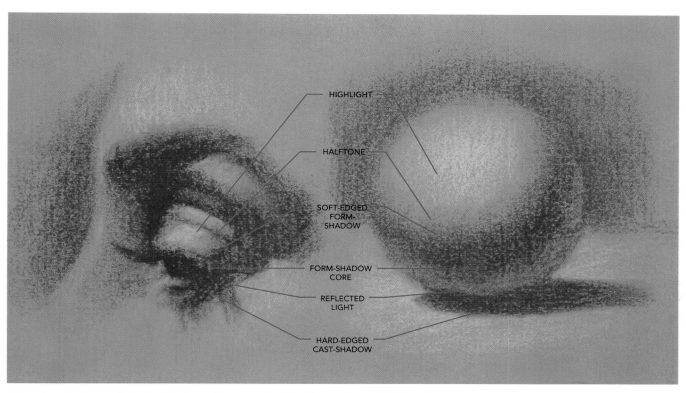

The sphere is the perfect, simple shape for demonstrating the anatomy of light and shadows. On the sphere the shadow began as a soft form-shadow toward the source of light and ended on an adjacent surface as a hard cast-shadow away from the light source. This pairing of two round shapes—a ball and an eye—demonstrates how the same principles regarding form- and cast-shadows apply to both, regardless of subject matter.

THE SHADOW EDGES

The key to drawing shadow shapes is edge control, that is, knowing when a shadow's edge is hard or soft. Remember that all shadows begin as form-shadows, which have soft edges, and end as cast-shadows, which have hard edges. Before placing highlights on the light side of your model, you should always be satisfied that your shadow edges are accurately defined. Once you feel satisfied you have achieved a likeness, crisp or harden the edges of all cast-shadows. This will define the structure.

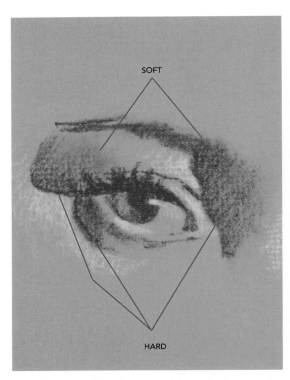

Lines indicate the soft edges of form-shadows and the hard edges of cast-shadows.

On Shadow Edges

Some cast-shadows may appear soft because of atmospheric light, and some form-shadows may appear hard if the curve of a form is abrupt. However, cast-shadows are always hard and form-shadows are always soft.

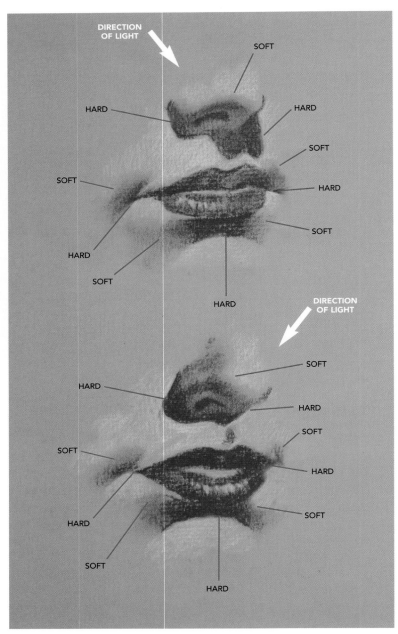

The top drawing of a nose and mouth is lit from above and the left. The bottom drawing is lit from above and the right. Note where the edges of each shadow are soft (form) or hard (cast).

THE FORM IN LIGHT

A combination of both halftone and highlight creates variation on the illuminated side of the form. Halftone on the portion of the head that is not in shadow (the light side) is created automatically by the value of the toned paper. Highlights are created with your white pencil and appear only in the lightest areas on the model. When lit from above, the lightest area is the model's forehead, becoming somewhat less intense toward the chin.

Just as there are two treatments of shadow edges, that is to say, both hard and soft, there are two treatments of highlights. If, for example, a highlight meets a cast-shadow edge, it will begin as a hard edge. It will become progressively softer as it fades and disappears into the halftone of the paper surface, which will give way to the soft edge of a form-shadow. When highlights share the common edge of a cast-shadow, they should always be clearly distinguished from halftone. Doing so will help emphasize the difference between form- and cast-shadows, and give your drawing visual clarity.

On Reflected Light

Since reflected light is part of the shadow mass, it can never be as light as the original light source. It is therefore indicated by a light application of the sanguine pencil. The paper value, on the other hand, is reserved for the halftone on the light side of your model—the side that is facing the light source. Just remember that no area on the shadow side can be as light as the paper value.

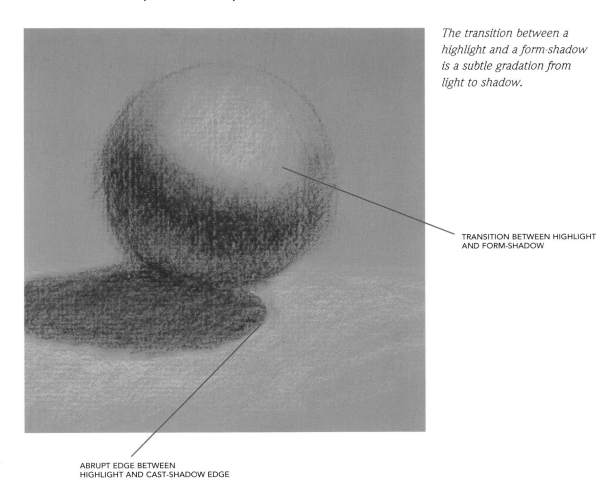

The transition between a highlight and a form-shadow is a subtle gradation from light to shadow.

TRANSITION BETWEEN HIGHLIGHT
AND FORM-SHADOW

ABRUPT EDGE BETWEEN
HIGHLIGHT AND CAST-SHADOW EDGE

ANALYZING FORM

It is important to cultivate the habit of analyzing form—that is, not only to *see* form but also to study the individual elements of a shadow as it falls across a form. These individual elements make up what we will call the "anatomy of a shadow." Once artists have understood the principles of chiaroscuro, the major difference in the quality and accuracy in their work reflects how closely they look and how much care they have taken to accurately record what they see. Many artists attempt to capture their subject in line and then, without truly studying form, add value in a general way. Yet if you take the time to look closely at your subject, to analyze the shapes of shadows and their edges, and to record them in terms of value, you will achieve a convincing likeness. You will

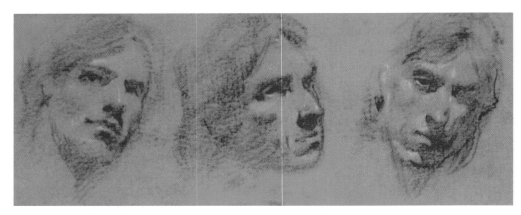

The top three drawings on this sheet are quick head studies. I made them deliberately small—two inches in height—to diminish detail and concentrate on shadow shapes. These quick studies helped to warm up my hand and eye coordination. For the fourth and larger drawing the model is posed in a three-quarter view, and I drew him at a distance of five feet. The model is positioned above my eye level and is lit from above, causing the front and side planes to be equal in size.

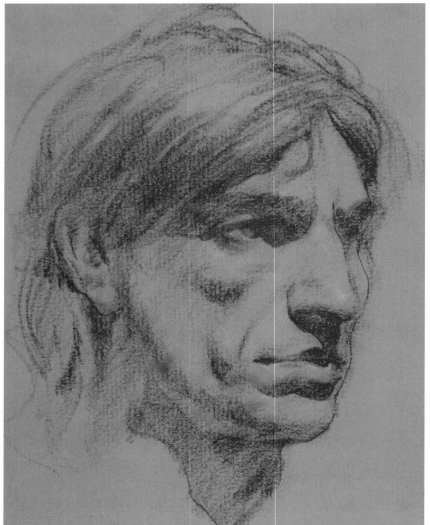

come to intuitively understand this most basic point: It's all there—the sitter's sex, age, facial structure, and expression—in the shape of the shadows and their edges.

Shadow is the result of the absence of light, which is caused by the roundness of form or the interception of light. As form turns away from the source of light, a gradual transition from light to shadow occurs. At the point where the light has been intercepted, and becomes a cast-shadow, the transition is complete. The shadow eventually ends on an adjacent form as a hard-edged silhouette of the first form. Thus all shadows begin as form and end as cast, and each shadow progresses from soft to hard.

Should a cast-shadow continue into a form-shadow on an adjacent form, the cast-shadow merges into the core of the form-shadow and the two become one. In other words, a shadow cannot fall across another shadow, for without light there can be no shadow.

The next several drawings were made with the same model and light source. However, in each drawing the model's pose and my position in relation to the model change. Sometimes I've drawn the model from above, sometimes from below, and sometimes closer or farther away. Note how the shadows differ in each drawing as the model's pose and my viewpoint changed yet in each case describe the structure of the same forms.

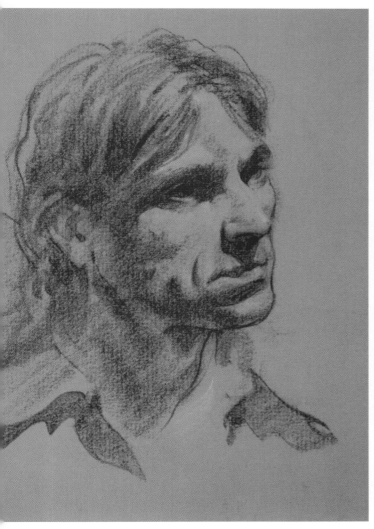

In this drawing the model is posed in a near-profile, three-quarter view to my right. The head is positioned at an inward tilt and is backlit, making it difficult to center the light. I drew the model at a distance of ten feet.

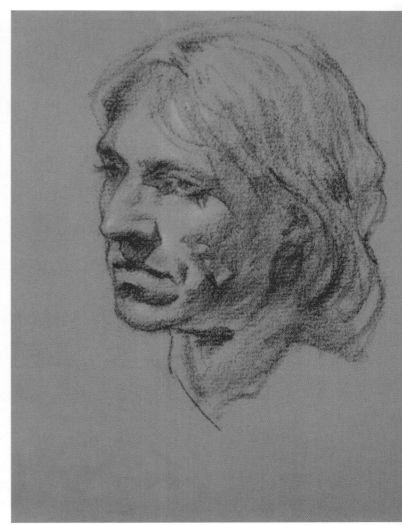

In this drawing the model is posed in a near-profile, three-quarter view to my left, and is positioned below my eye level. The model seems remote, and does not relate to the viewer.

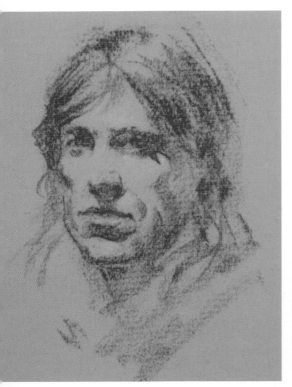

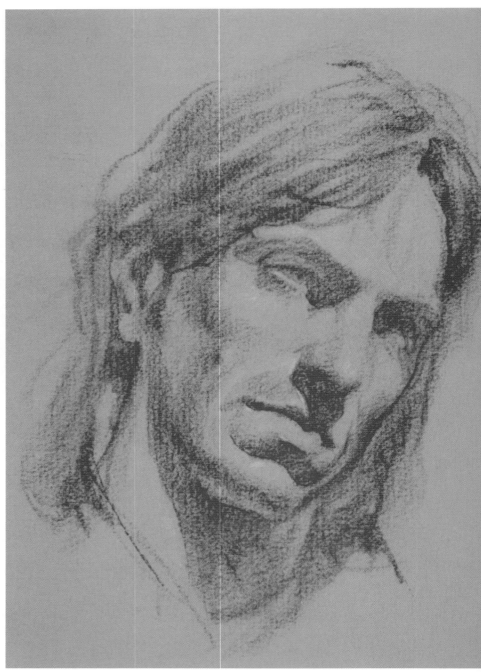

The model is now posed in a slight three-quarter view to my left, with his head subtly tilted to my right. This time I drew him from a farther distance of fifteen feet, which caused the drawing to be too small (about three inches high).

In the final drawing all the variables—pose and attitude of the model, lighting, and my distance from him—are ideal. The model is posed in a slight three-quarter view and has an animated tilt to my right. The light source is positioned above, to my left, and toward the front of the head, allowing for the fullest illusion of three-dimensionality. I positioned myself five feet from the model, who is looking in the general direction of the viewer.

NEGATIVE SHAPES

By now you've learned that shadow shapes—the "positive" shapes—must be correct in size and shape for a likeness to occur. The portion of the head that is illuminated creates *negative shapes* between the shadow shapes. Along with the shadow shapes, they too must be correct in size and shape. For example, if the negative shape between the shadow of the eye and the shadow of the nose is too far apart, the nose will appear too long. Thus negative shapes are useful guides to judging if your shadow shapes are correct in size and shape, and if they are correctly placed. In this regard they are as important as shadow shapes. Think of negative shapes as puzzle pieces that must fit between the shadow shapes if the configuration (and hence the likeness of your model) is to be correct.

Negative shapes can be used as puzzle pieces to determine correct placement of shadow shapes. This diagram identifies some negative and positive shapes on the model's head. Negative shapes are the areas of the head that are not in shadow. The edges of negative shapes are less defined than positive ones (shadow shapes).

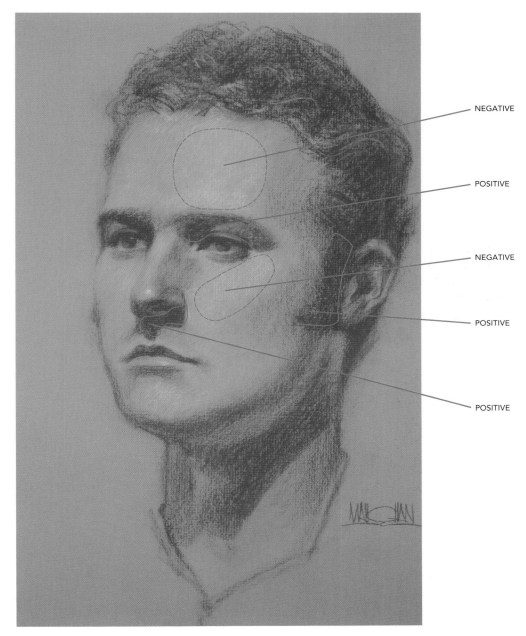

NEGATIVE

POSITIVE

NEGATIVE

POSITIVE

POSITIVE

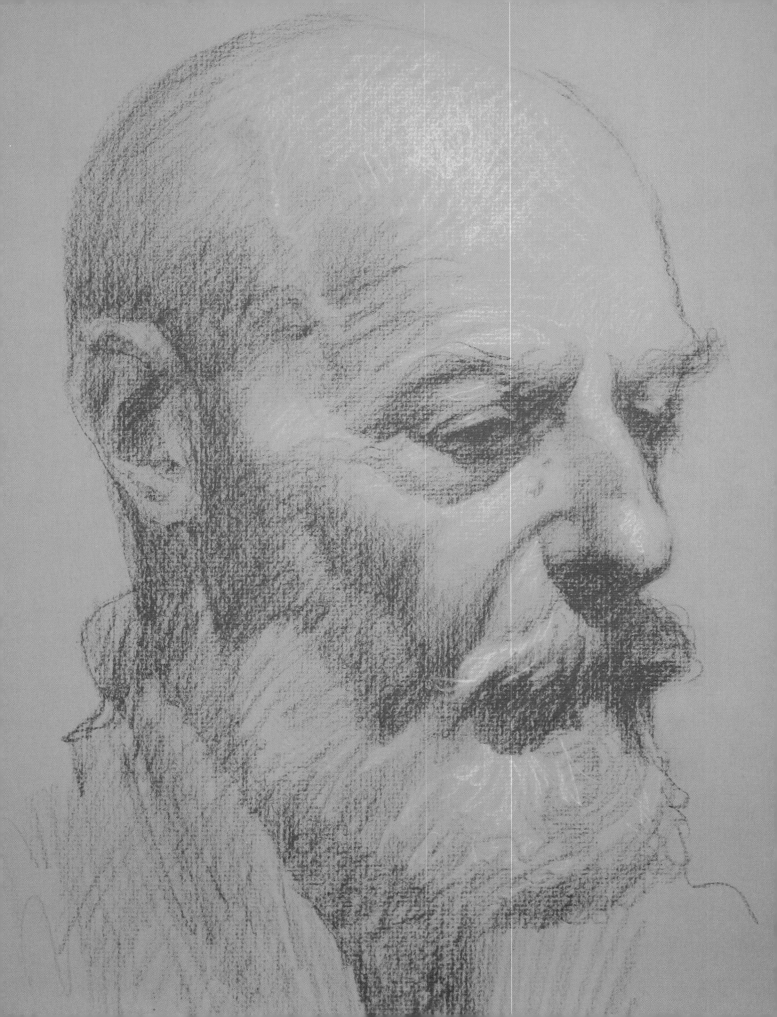

PRINCIPLES OF DRAWING THE HEAD

TWO MASSES OF LIGHT AND SHADOW

When using one light source, the head and its features are divided into two major masses of light and shadow. The easiest way to see the head as simple but separate masses of light and dark value is to look at your model through half-closed eyes. This eliminates all detail and allows you to see the simple dark graphic shapes of the features. The more precisely you duplicate the dark masses and shadow shapes, the more accurate will be your rendering of the underlying structure. This is your key to achieving a true structural likeness. Conversely, the less accurately the shadow shapes are recorded, the less likely a likeness will be achieved.

Within the light masses there are two values: the highlight and the middle value, also called halftone.

The shadow masses also have two values. The darkest value in the shadow mass is shared by the cast-shadow and the core of the form-shadow. Both are devoid of any light. The other value is reflected light in the form-shadow, which is created by light bouncing off an adjacent object. It is the lightest area in the shadow mass.

The two major masses of light and shadow, and the values assigned to them, must remain distinct. Never allow the darkest areas of the light mass, the halftone, to be as dark as the lightest area of the dark mass, the reflected light in a form-shadow. Reflected light can never be as light as any value on the light side of the form. If that occurs you will lose the two-value relationship, and the structure will break down.

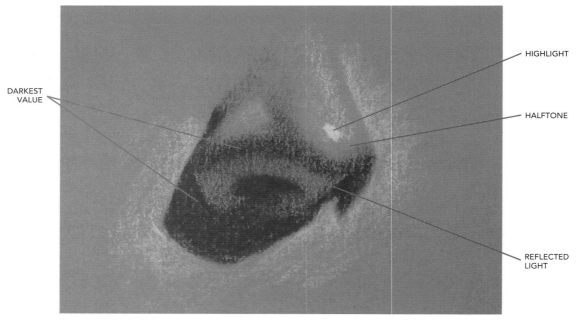

DARKEST VALUE

HIGHLIGHT

HALFTONE

REFLECTED LIGHT

The light ends and the form-shadow begins on the roundness of the nose tip. The shadow becomes a hard-edged cast-shadow beneath the protruding nose form. You can see two values on the light side: highlight in white pencil and halftone as the paper value. Within the shadow you see the compressed core of the form-shadow and the cast-shadow, the darkest values. Within the form-shadow there exists a lighter value called reflected light. Although this area is illuminated, it is less intense than the area illuminated by direct light. Therefore reflected light falls within the shadow area and is part of the dark mass.

LIGHTING THE HEAD

When lighting the head, it's best to use only one light source. Though restricting yourself to one light source simplifies your work, this is not the main reason for doing so. Unless you are extremely skillful with lights and lighting design, when using a second light source, you risk introducing another set of form- and cast-shadows coming from a different direction. The clear light-and-shadow relationship that you are seeking to convey to the viewer will suddenly become confused, and your ability to create an illusion of three dimensions on a two-dimensional surface will be thwarted.

The position of the single light source should be above, slightly to the front, and to the left or right of center of your model, depending on his or her pose. This lighting arrangement will produce light and shadow not only from the top to bottom of your model's head, but also from side to side. With this posi-

tion you are using light to help separate not only the front plane of the head from the side planes, but also the top from the bottom plane, a crucial factor in creating the illusion of three-dimensionality. If the front and side planes are lit equally, and therefore of the same value, there will be no structure and the head will appear flat.

A light source that is positioned above the model will add a stronger contrast around the eyes; this will draw the viewer's attention to the eyes, the focal point in a portrait. The light will become somewhat less intense as it moves toward the chin and neck. This will give a sense of roundness to the front plane of the head. Close your eyes halfway to determine how rapidly the light diminishes as it moves down and across the planes of your model's head.

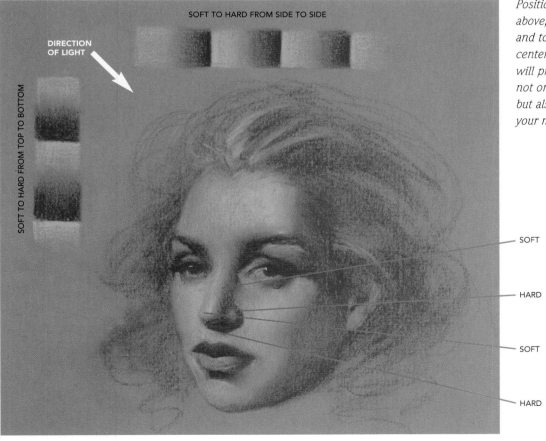

SOFT TO HARD FROM SIDE TO SIDE

DIRECTION OF LIGHT

SOFT TO HARD FROM TOP TO BOTTOM

SOFT

HARD

SOFT

HARD

Position a single light source above, slightly to the front, and to the left or right of center of your model. This will produce light and shadow not only from top to bottom, but also from side to side, on your model's head.

Artificial and Natural Light

When using artificial light, use a seventy-five-watt flood lamp with a reflector shield placed approximately four to five feet above and to the front and side of your model. If you are using natural light, position the model so the light comes in high from a north-facing window (north light is the most consistent in temperature and intensity). Whether the source is artificial or natural, the position of the model to the light remains the same. When using artificial light, move the light in relation to the stationary model; when using natural light, position the model in relation to the light source.

Light Advances; Dark Recedes

When a model is backlit (also called rim lit, or rim lighting), the light source is positioned to the side and slightly behind the model, appearing brightest on the edge of the outside contour. Since light advances and dark recedes, this presents a problem. When rim lit, the outside contour is lighter than the center of the form, causing the center to recede visually and the contour to advance. The result is flattened form. Rim lighting will also cause more than half of the front plane and all of the side planes to fall into shadow. This also emphasizes a flattened appearance, since the front and side planes will share the same value.

To avoid the effects of rim lighting when using just one light source, as we are, it is necessary to bring the light off the edge toward the center of the form. This will make the edge darker and cause it to recede from the viewer's eyes. Since you are using only one light source, you must center as much as possible—that is, by moving it to the front and side of the model.

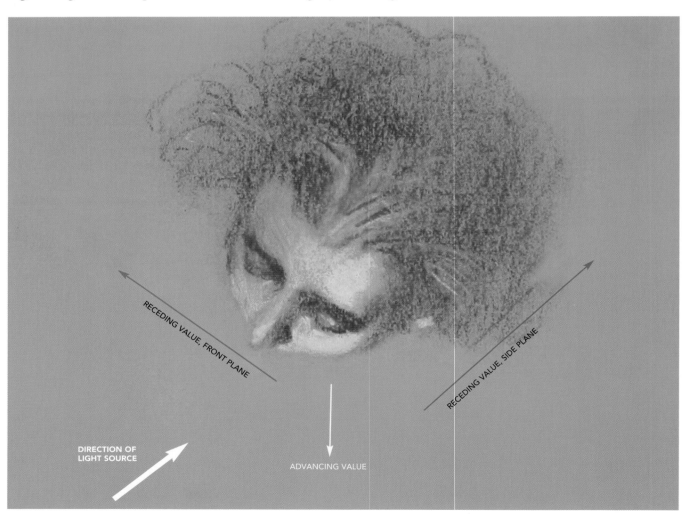

The light source is centered on the form to advance the corner of the intersecting planes, which is the lightest area on the form. The front and side planes gradually darken and recede from the viewer.

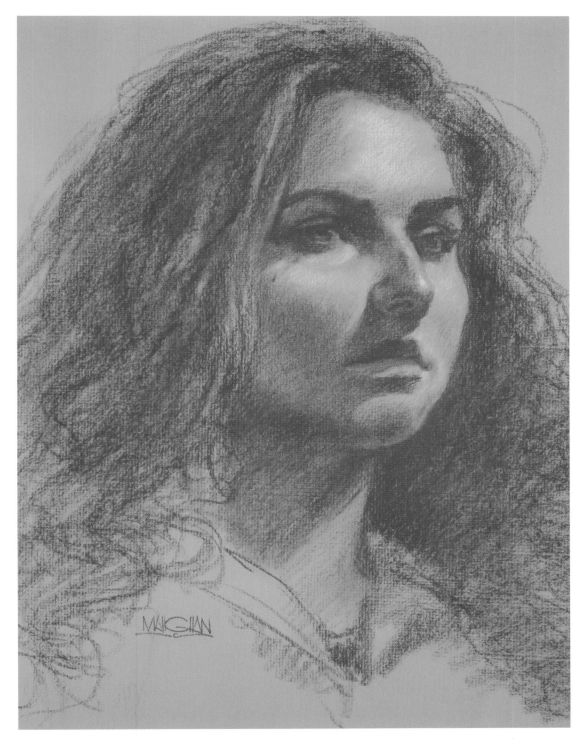

Since the light was first striking the form on the distant contour, the light was centered to darken the contour and therefore cause the distant edge of the front plane to recede.

On the Contour

Highlight placed on the contour flattens form. The contour can be made to appear darker and softer if you fade the white pencil into the halftone of the paper before reaching it.

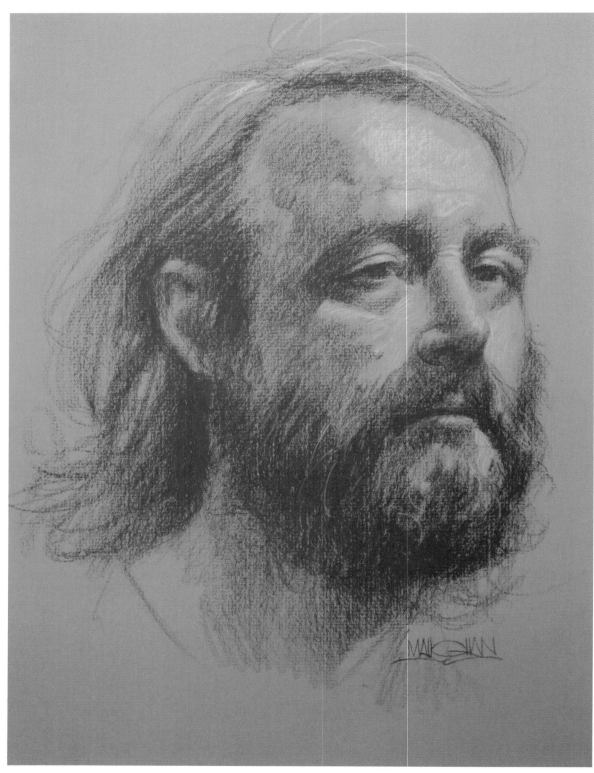

This model was rim lit, which directed the light to the distant contour of the form. The lighting also placed much of the head in form-shadow. Since there is not a combination of form- and cast-shadows, the effect is less dimensional. I spent a considerable amount of time simply trying to correct the problems created by the poor lighting. Nonetheless, the overall results are not as good as they would be if the model were properly lit. For example, since there were few cast-shadows to help describe depth and structure, the beard appears flat.

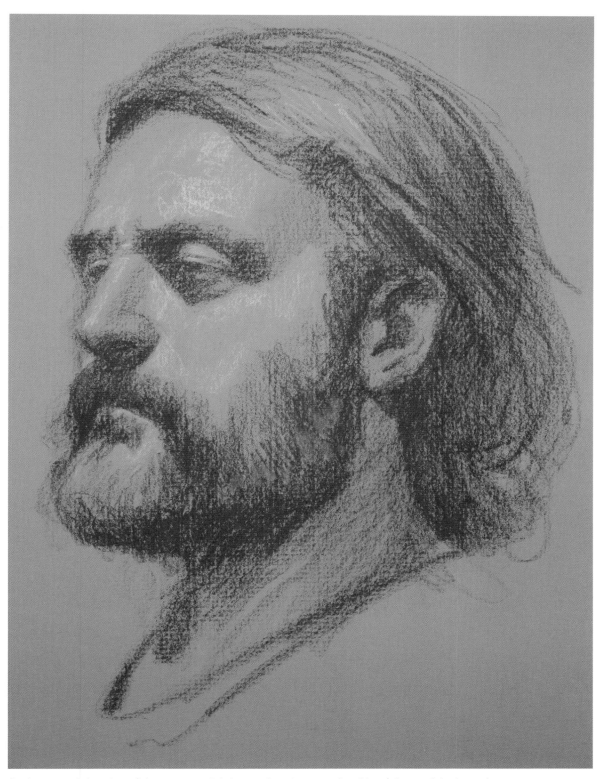

In the second drawing of the same model, I moved to the opposite side of the model where the lights was placed slightly off center. Now the light created desirable cast-shadows and caused the center or near edge of the front and side planes to advance. This drawing was completed in a quarter of the time it took me to draw the model who was rim lit, with much better results.

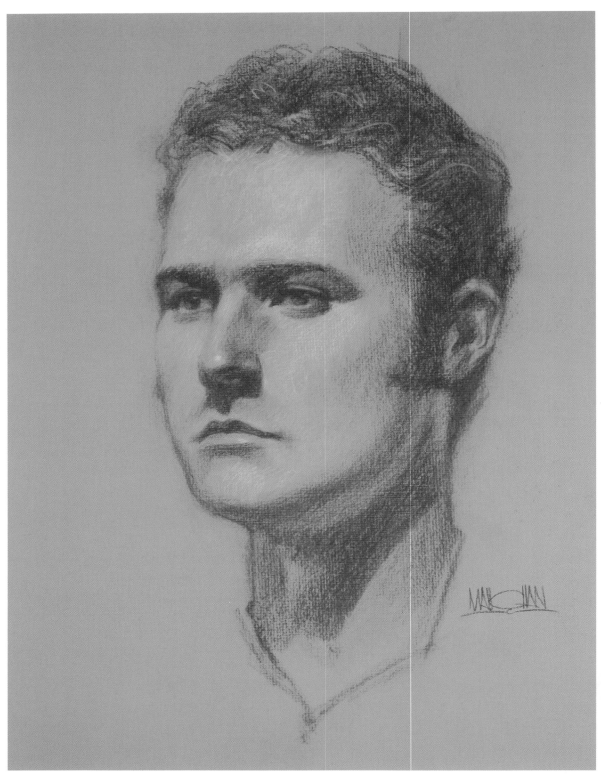

In this example, the light is positioned above the model and therefore is strongest on the forehead, becoming less intense as the light falls across the cheek, chin, and neck. This is the most desirable position for the light source. If the light is centered on the edge of the front and side planes, both planes will recede since light always advances and dark always recedes.

SINGLE FOCAL POINT

The human eye cannot focus on two depths of field at the same time, or on two objects in the same depth of field. Stereoscopic viewing proves that we see double images slightly out of registration except for the focal point that is in focus. This means everything in your vision that is peripheral to the focal point will be blurry or out of focus. Try focusing on an object with one eye closed and note the position of surrounding objects. Now close that eye and open the other, focusing on the same object. The object focused on remains stationary. The surrounding objects, however, including those in front as well as those behind, move or shift.

Taking these natural phenomena as a guide, everything in your drawing, except for the focal point, should be rendered out of focus and have a diffused edge. The softer your edges are the more realistic the result. In fact, if you treat edges, and especially hair, so softly as if they were about to disappear like smoke (see discussion of sfumato, page 15), you will direct the viewer's attention to the center of interest, which will be in sharp contrast to the rest of the drawing. The importance of the eyes as the focal point in a portrait is also based on human psychology. To engage another person, either in flesh and blood or in a drawing, we look him or her in the eyes. Even without words much can be communicated through the eyes. It is the most common focal point, not the nose, forehead, mouth, or any other part of the head. Have you noticed how uncomfortable it can be when someone you are speaking with avoids your gaze? When this happens, we feel as if we are not making a connection with that person. When the center of interest in a portrait is the eyes, a sense of communication is created between the model and the viewer.

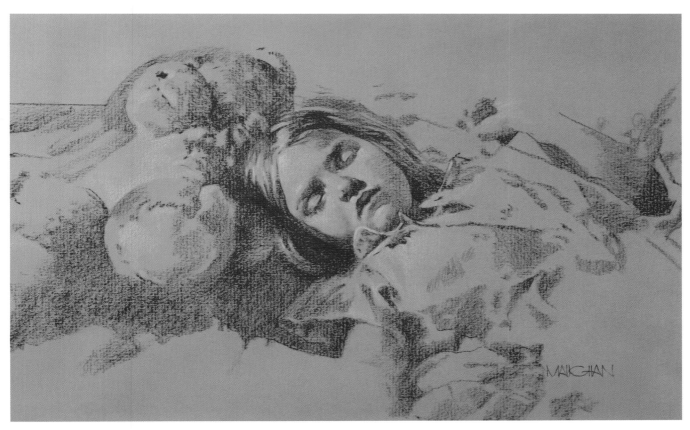

Everything except the focal point, in this case the little girl's head and, in particular, her closed eyes, is out of focus and soft-edged.

The viewer's eye will gravitate to the area you have most sharply delineated. In this drawing the model's eyes have dark cast-shadows with crisp edges against the light forehead, providing contrast of both shape and value. The nose and mouth have less value contrast and the contour of the head and the hair is out of focus.

Perspective and the Three-Quarter View

I prefer a slight three-quarter view to the static profile or a symmetrical frontal view. It allows me to center the light on the corner of both the front and side planes of the head and create foreshortened perspective, which allows for diminished detail and diffusion (sfumato) of contour. Yet perhaps most importantly, the three-quarter view places an emphasis on the eye on the nearside as the focal point.

Perspective

Later in the same century that it was "discovered," Leonardo da Vinci asserted that "perspective is the rein and rudder of painting." He was referring to a scientific system of perspective known as linear perspective that was developed by the architect and artist Filippo Brunelleschi (1377–1446) in the early part of the fifteenth century. In his treatise *Della Pittura* (On Painting) of 1435, the theoretician and architect Leon Battista Alberti (1404–1472) codified the new system for other artists' use. Though artificial, and predicated on the viewer's stationary vantage point, the system of linear perspective is still regarded by most today as being a "truthful" way to render what the eye sees.

Linear perspective is a mathematical system for creating the illusion of space and depth on a two-dimensional surface—that is, to metaphorically turn the picture plane into a picture window. Variations on linear perspective include one-point, two-point, and three-point perspective. One-point perspective should be used only when the front plane of a form is perpendicular to the viewer's gaze. If the form is positioned so that no one plane is parallel to the drawing surface, as in three-quarter views, then two vanishing points are necessary—thus called two-point perspective. Three-point perspective is the most complex of the three and is used for aerial viewpoints. Since the three-quarter view is used consistently in this book, we use only two-point perspective.

When using linear perspective, the artist employs a *horizon line, vanishing point,* and *orthogonal lines.* The horizon line runs across the picture plane at the eye level of the viewer. In a landscape the horizon line is where the sky appears to meet the ground. In one-point perspective the vanishing point should be located near the center of the horizon line. The vanishing point is where all parallel lines (orthogonals) appear to come together. Orthogonal lines are "visual rays" that help the viewer's eye to connect points around the edges of a form to the vanishing point.

In two-point perspective the vanishing points are often not within the picture plane, but in the imaginary distance off to the left and right of the drawing surface. This is the case when drawing the head in three-quarter view, since the head fills the drawing surface. Consequently, when you draw a head in two-point perspective, there will not be a distant point at your eye level toward which parallel lines converge. Instead, simply apply the principles of perspective, knowing that parallel lines, like railroad tracks, appear to converge in the distance. Therefore the eye and corner of the mouth will appear farther apart vertically on the nearside than on the distant side.

How rapidly the eyes and mouth diminish can be observed through *sight measuring.* If right-handed, lean your head into your right shoulder and close your left eye. Then, while holding a pencil between the second and third fingers, sight down your arm, which should be locked at the elbow. Place the top of the pencil at the corner of the model's eye and run your thumb up the

On Perspective

Do not chase shadow shapes or perspective. After taking a break your model may not return to the exact same pose. Once the gesture and proportions have been established and are in perspective, do not move them to align with a change in pose. Adjust your model instead.

pencil to the corner of the model's mouth. Now compare that measurement to the same points of reference on the distant side. You will not have actual perspective lines to correctly place features. However, as long as the features appear to converge at a distant vanishing point, they will appear to be in proper perspective. If they do not, the features will not appear to be in proper perspective.

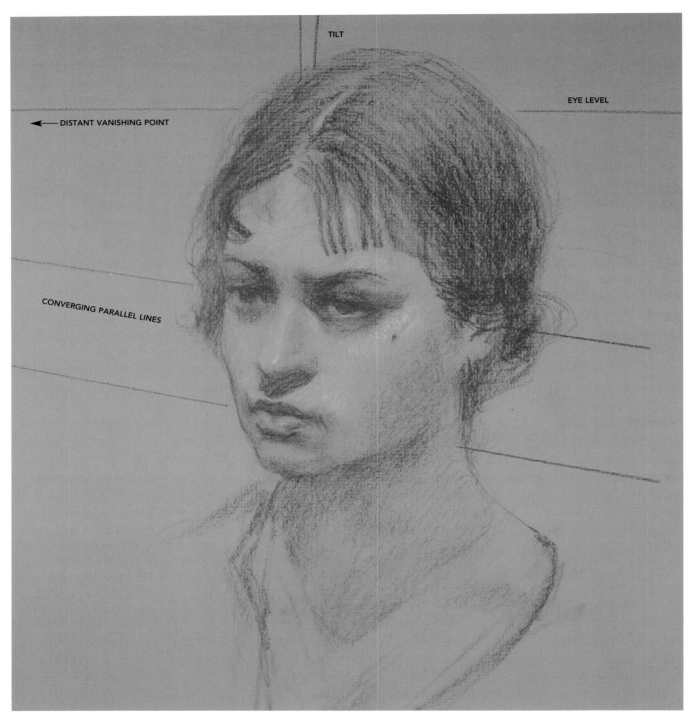

This model is positioned below eye level with her head tilted slightly to our right.
Her eyes and mouth converge toward the eye level.

Planes of the Head

It's important to remember that a sitter's likeness is predicated on the artist having first depicted the three-dimensional *structure* of the head, which is often described as the *planes* of the head. The rendering of structure and resulting likeness can be achieved by duplicating the shadow shapes created by the structure, or form. The edge of a form-shadow (which is soft) and the edge of a cast-shadow (which is hard) can be identified by analyzing the structure of the form creating the shadows. From experience the artist knows that all shadows begin as form-shadows nearest to the source of light and end as cast-shadows farthest from the source of light.

The shape of the head consists of six planes: top, bottom, front, back, and two sides. Both the front and side planes of the head recede from the viewer's eyes when in a three-quarter position. According to the rules of perspective, the features on the front and side planes will diminish in size as they recede from the viewer.

The vertical line represents the common edge of both front and side planes. It is the area of the head that is closest to the viewer. The combination of the model's position and the strength and position of the light source will cause this edge to visually advance toward the viewer, accentuating the three-dimensional structure of the head. The horizontal lines represent orthogonals that are converging toward a distant vanishing point.

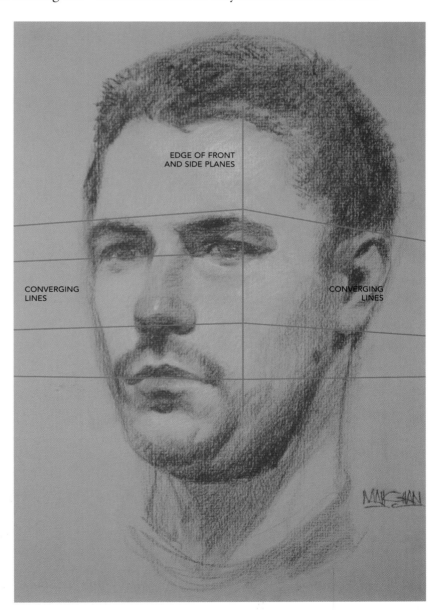

EDGE OF FRONT AND SIDE PLANES

CONVERGING LINES

CONVERGING LINES

On Structure

Structure is made visible through light and shadow. All light and no shadows = No structure; all shadow and no light = No structure.

FORESHORTENING

Foreshortening is a technique used in drawing and painting to render figures or objects convincingly within a spatial, pictorial field. It is essentially the process of applying linear perspective to the figure or objects. As you foreshorten your model's head in a three-quarter view, keep two constants in mind. The first is that, regardless of the tilt of the model's head or your eye level, parallel lines, when in perspective, will converge at only one of the two distant vanishing points. Second, if two or more objects of the same size are viewed at different depths, they will appear progressively smaller as they recede in the distance.

These principles can be seen in the two drawings of the same female model below and opposite. The heads are shown in a three-quarter view and are in two-point perspective. The eyes and mouth, which are parallel, will converge at a distant vanishing point in perspective regardless of the viewer's eye level. Therefore the distance between the eye and corner of the mouth on the nearside will be farther

This model was viewed from below. From this viewpoint— looking up at the model— her near eye is higher than her far eye, and her eyes and mouth converge at a distant vanishing point. The distance from eye to chin appears longer than from eye to crown.

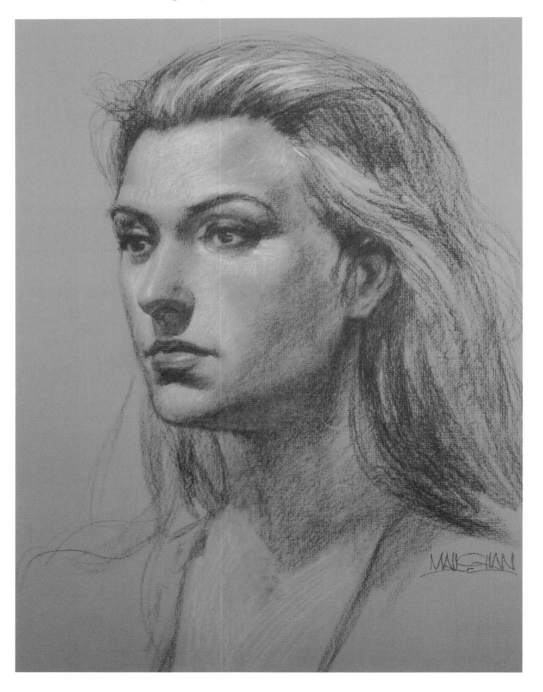

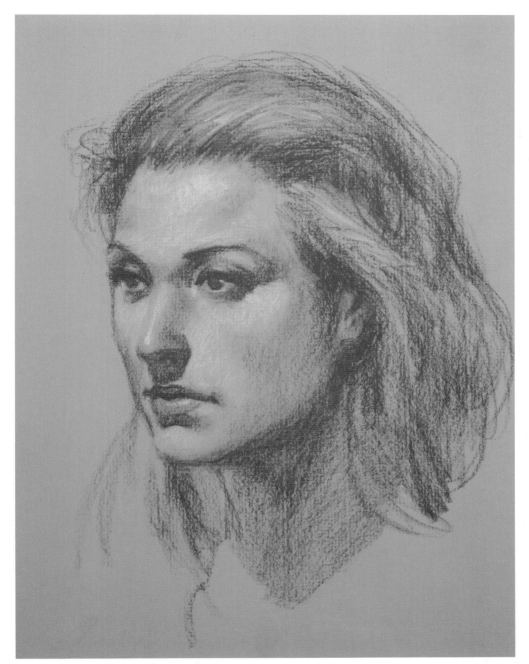

This model was viewed from above. From this vantage point, her near eye appears lower than her far eye, and her eyes and mouth still converge at a distant vanishing point. The distance from eye to crown appears longer than from eye to chin.

apart than the same measurement on the farside. If your eye level is below, and you are therefore looking up at your model, the eye on the nearside of the model's head will be placed slightly higher than the eye on the farside. Conversely, if your eye level is above, and you are looking down at your model, the eye on the nearside of your model will be placed slightly lower than the eye on the farside.

In addition to the front and side planes of the head, the distance between the top and bottom planes is also affected by perspective. If your eye level is above, and you are looking down at your model, the distance between eye and crown will appear greater than from eye to chin. If your eye level is below, the distance between eye and chin appears greater than from eye to crown. Although equal in measurement, each is viewed at a different distance and angle. The next two drawings of a male head illustrate, by comparison, incorrect and-correct foreshortening.

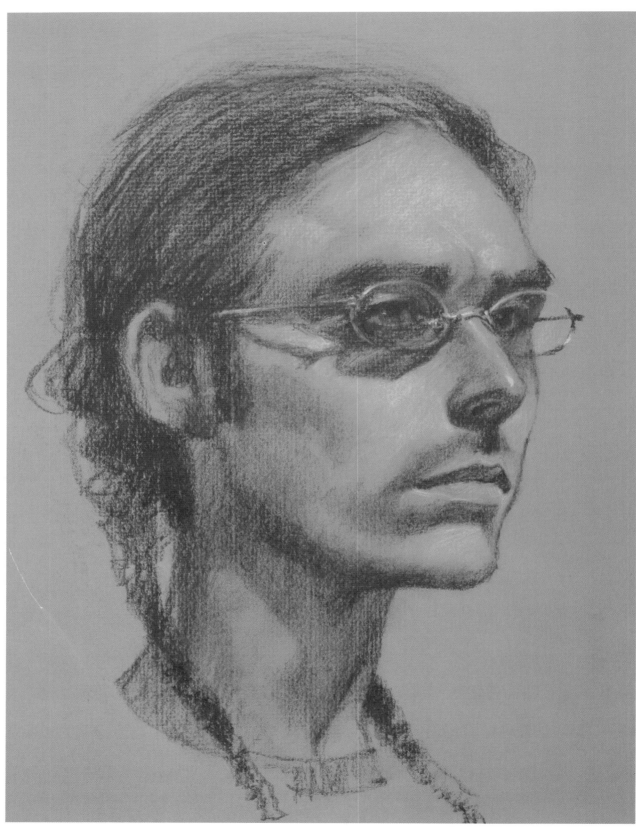

This head has not been correctly foreshortened. The outside corner of the mouth is too low for the angle of the eyes.

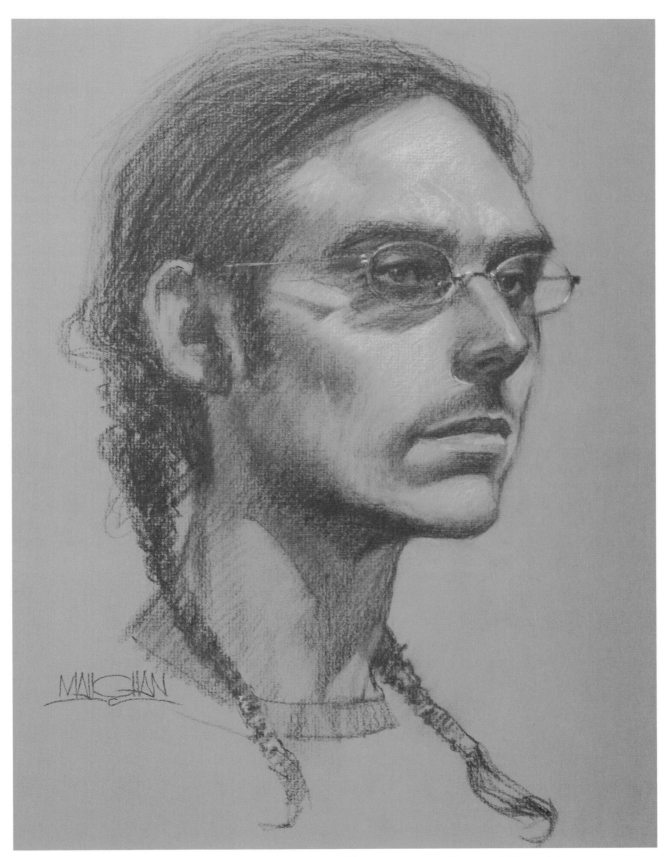

In this drawing the model's eye and mouth are correctly drawn. They converge at a distant vanishing point.

VALUE PATTERN

Since every object has a local value, or color, all shadows on all objects will not be of the same value, nor will all highlights on all objects be the same value. The lighter an object's local value, the lighter its highlight and shadow. The darker the local value, the darker the shadow and highlight. The local color of the sitter's hair might, for example, be a specific color of brown; it will also be a specific value—that is, a light, middle, or dark shade of brown. More importantly, an object's value must be compared to the value of adjacent objects. An object may be dark, but how much darker or lighter is it than other objects near it?

Value pattern is the arrangement of local values so shapes separate visually without the addition of line. Your arrangement of values will not be guided by light and shadow, but by the local value of the objects in your composition. Without variation in value between objects or shapes, you will not have composition. For example, the color of hair might be blond or brunet. More importantly the local value is light or dark. Light hair is not visible against a light background, just as dark hair is not visible against a dark background. However, simply by using value pattern, as illustrated in the pair of drawings below, dark hair will separate from a light background and light hair will separate from a dark background.

Even though objects within your composition will be divided into masses of light and shadow, they must never lose their local value relationship to one another. Imagine this scenario. A sitter wears a light-value collar under a dark, middle value coat. Her skin is a light middle-value and her hair a dark value against a middle-value background. Her light middle-value face surrounded by her dark hair would be the strongest contrast of value, and the focal point of the composition. Since the other values are closer in value, they produce less contrast and thus do not compete for interest. To downplay the chance that other values might distract from the focal point, the common edge between values can be further diffused by applying the technique of sfumato.

On Local Value

The eyes include additional elements—the eyebrows, lashes, pupils, and irises—that are of a dark local value. These dark elements will visually connect with the shadows formed in the area of the eye and become one graphic shape, or dark mass. Yet they will remain visible since they are darker in value than the shadow value.

This pair of drawings shows the use of value pattern to separate middle-value hair from a dark background and dark hair from a middle-value background.

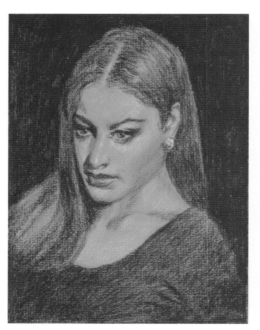
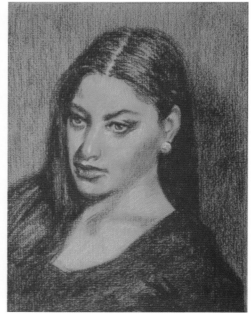

ADDRESSING THE BACKGROUND

Value pattern is but one aspect of a successful composition. The artist must not only be sensitive to the arrangement of shapes based on their local value, but also to the size and configuration of shapes. Variety is said to be the spice of life. So it is with composition. If the shapes are repetitive, a composition will be boring.

Variety applies both to positive and negative shapes, or space. Positive space is that which you can identify. Negative space is the area between the positive shapes, or space, even if the space constitutes a portion of an object that can be identified. For example, the negative space between two trees on a hill might be sky. If there are a number of trees on the hill, variation in grouping, size, and shape of the trees will be a concern. However, the negative space between the trees must also be addressed since it is an integral part of the composition. In a portrait the placement of the head on the picture plane will fragment the background and dictate the distance between the contour of the head and the perimeter of the picture plane on the top and both sides. For this reason I do not place a head in the dead center of my drawing surface. To vary the negative space around the head, and therefore make it more interesting, I place the head slightly above center and to the left or right of center with the head facing the larger, negative, background space.

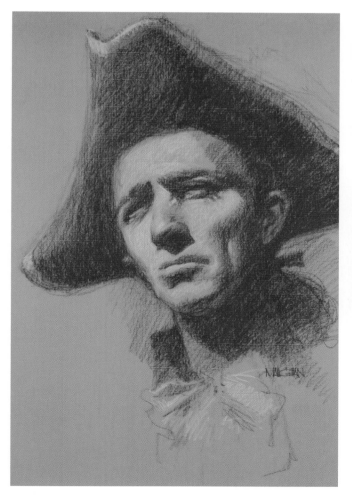

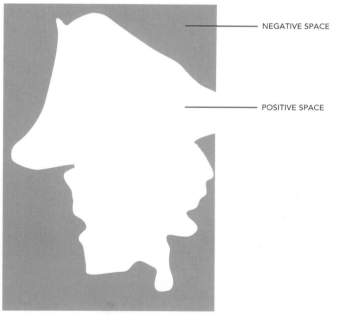

NEGATIVE SPACE

POSITIVE SPACE

To vary the negative space around the head, place the head slightly above center and to the left or right of center with the head facing the larger, negative, background shape.

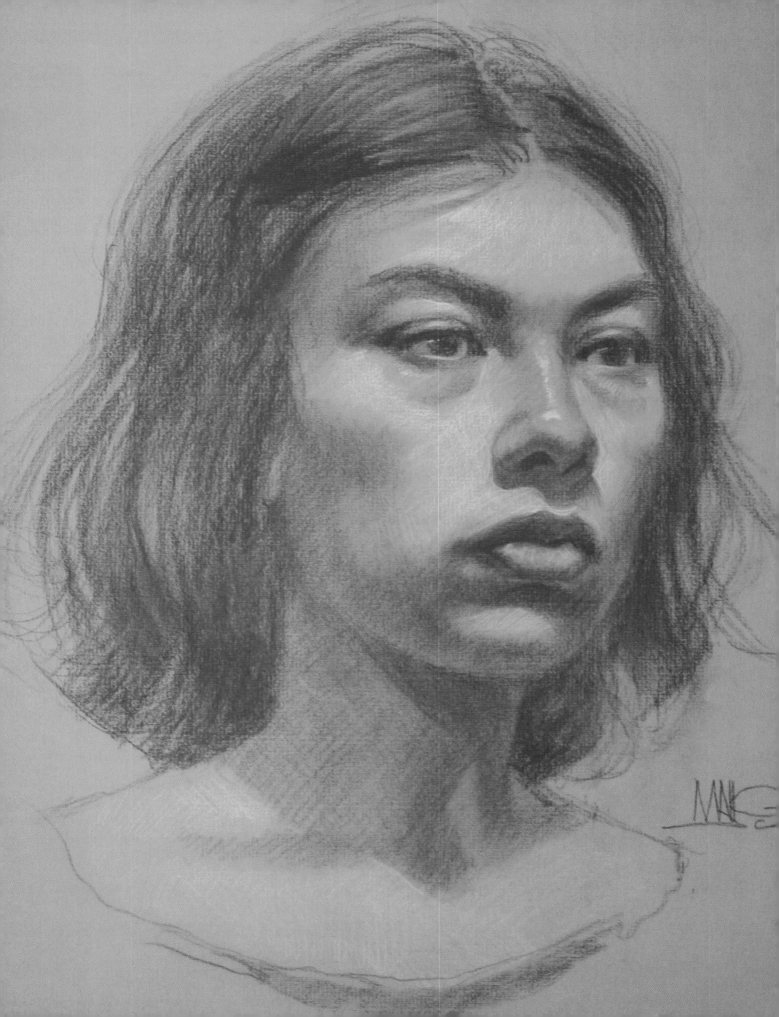

THE DRAWING PROCESS, STEP-BY-STEP

SCULPTING THE HEAD

The stages of development in a drawing parallel the same sequence as sculpting in clay. You would never begin by sculpting the features first and then attempt to build a clay head around them. Likewise, do not begin a drawing with the features. When sculpting, you begin by applying clay to form the general shape, or gesture, including hair, neck, and shoulders. Once the shape is achieved, exact proportions are measured. By carving out and applying clay, the forms take shape. The details, if any, come last. A drawing is approached in the exact same sequence.

This portrait, like all the drawings in this book, is drawn in value. Lit from above, it appears three-dimensional as though sculpted in clay. The structure is made visible through light and shadow, which makes both sculpture and drawing come alive.

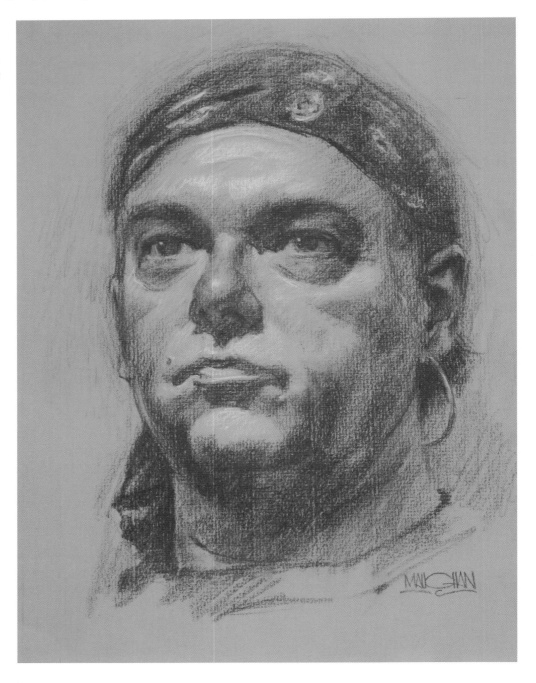

GESTURE

Gesture is what makes the sitter's pose interesting and captures the sitter's attitude, or air. It is the tilt of the head—forward and backward, as well as side to side—and the placement of the hair, neck, and shoulders. The slight forward and side tilt of a head, the angle at which the hair falls, is body language and communicates expression. The gesture drawing is your first attempt at placing the model's most general characteristics on paper. Since, when drawing, the best practice is to move from the general to the specific, the gesture should

The model's position is captured in the gesture drawing.

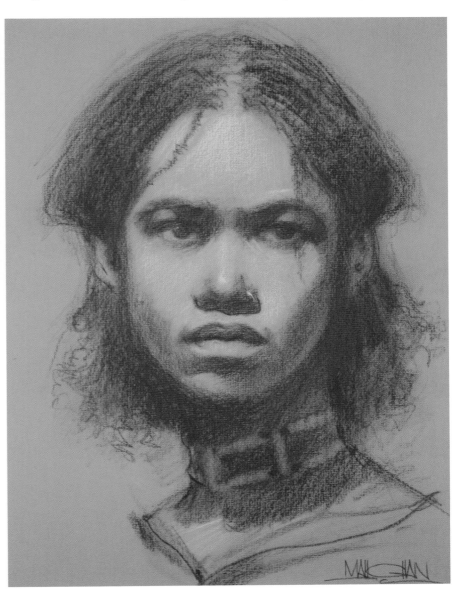

In the finished drawing, the gesture drawing will always be visible if it has been maintained.

always be captured first. This cannot be achieved later as you develop the drawing. You must begin with the sitter's gesture and never lose sight of it, always striving to maintain it.

A gesture is not an outline but consists of multiple soft strokes that indicate the contour. The strokes should hold the contour of a form so softly that it nearly disappears. A hard, pressured outline will not disappear, and cannot be easily corrected. Since a gesture drawing has no detail, it is not precious and can easily be corrected. Once you've got the gesture down, you can then judge if the size and placement of the head are correct. Before moving on to the next step, ask yourself, "Do the surrounding negative shapes vary in size and shape? Could the placement be improved? Did I unintentionally crop off desirable elements because I drew too large?"

The model's gesture has been captured with a loose contour drawing.

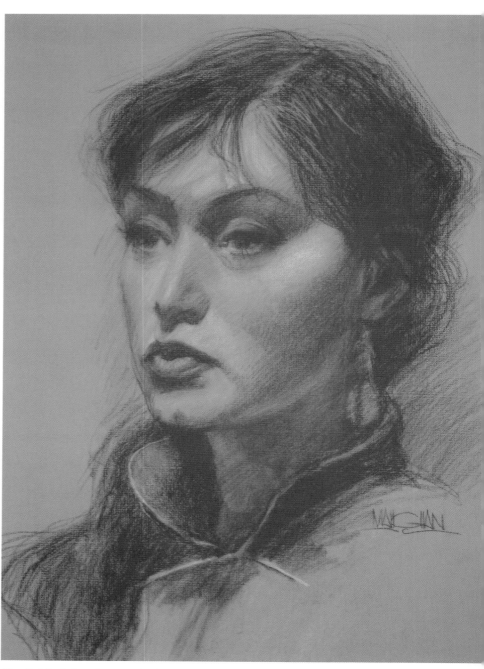

The finished drawing reveals the model's gesture, which is the foundation for all subsequent drawing steps.

THE TILT

The gesture in a portrait drawing must capture the tilt of the head not only from side to side, but also from front to back. The tilt dictates the placement of the features, which in turn often need to be foreshortened according to the tilt. If you begin your drawing by placing the features before capturing the tilt of the head, the features will arbitrarily determine the attitude of the head.

The gesture drawing also captures the tilt. This model's head is tilted backward slightly.

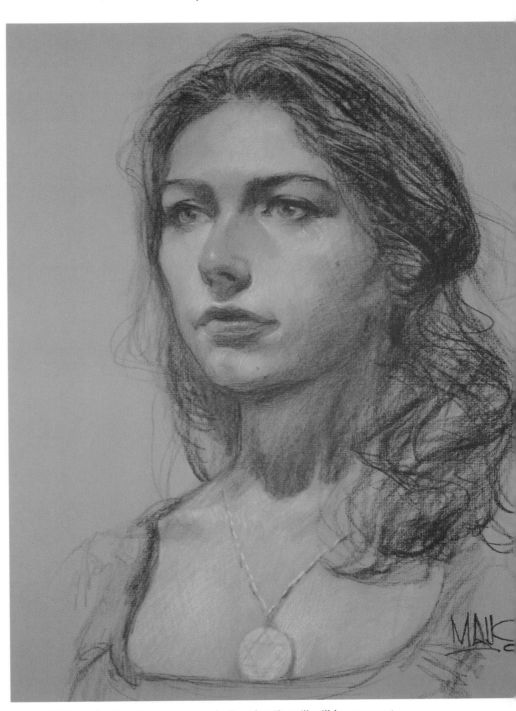

In the finished drawing the gesture, including the tilt, will still be apparent.

PROPORTIONS

The proportions of the head that we use today were applied as early as the 1500s. Proportions are not an arbitrary system but rather helpful rules that were born from observation. For example, at one time someone noticed that the length of an ear is equal to the distance between the eyebrow and the bottom plane of the nose. Most importantly it was observed that the proportion of the features was nearly identical on everyone, regardless of sex or nationality.

When anyone, artist or not, says there is something

The head is divided into proportional increments of one-half, one-third, and two-thirds.

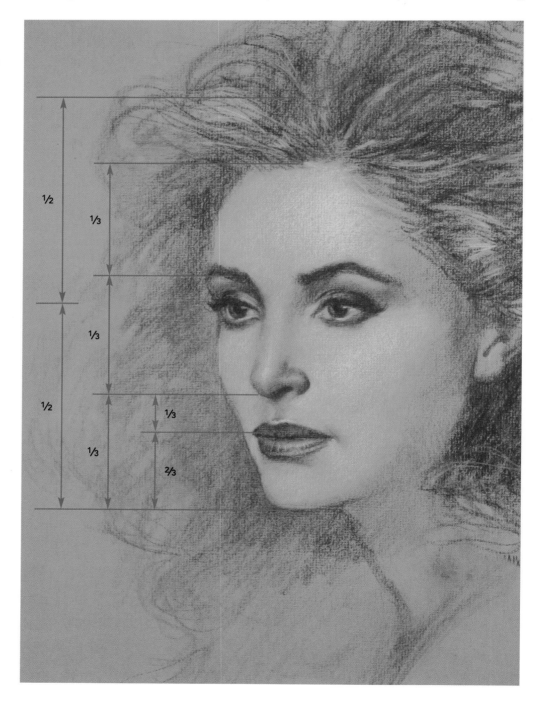

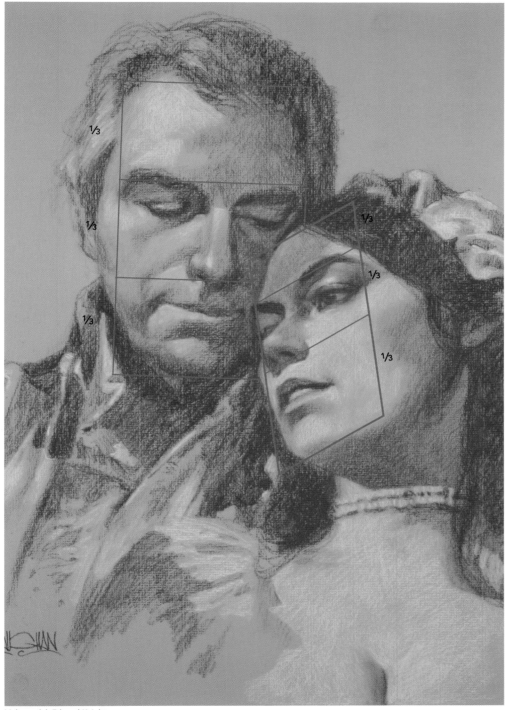

¹⁄₃ ¹⁄₃ ¹⁄₃ ¹⁄₃ ¹⁄₃ ¹⁄₃ ¹⁄₃

This drawing illustrates how the proportional increments of one-third appear progressively smaller in foreshortened perspective. The one-third divisional increments on the male are equal since his head, which tilts forward but only slightly, is nearly perpendicular to the viewer's eye level. The one-third increments on the female's head gradually reduce in size as they recede from the viewer's eye level since her head is severely tilted, and thus requires foreshortening.

Male model: Edward Knight

wrong with a drawing of the human head, he or she is most likely referring to the proportions. Perhaps one eye is placed too high or the nose is too long. If the features are not correctly placed, the face appears deformed and the likeness distorted. To avoid characterizations, it is more appropriate to begin with standard proportions and modify them as you refine the features. When artists observe an exaggerated feature on a model that appears to be an exception to the standard rules of proportion, they commonly and instinctively react by over-emphasizing that feature. The result will be a caricature, not a subtle rendering.

PLACING THE FEATURES

The most common mistake is the placement of the eyes. Eyes are located halfway between the top of the head and the bottom of the chin. The placement of the eyebrows is located visually. Once the eyes and brows are placed, divide the distance from the brow to the bottom of the chin in half. This determines the location of the bottom plane of the nose and the placement of the hairline. The mouth, or more precisely the division between the lips, is located one-third below the bottom plane of the nose, with a two-third increment to the bottom of the chin. The ear is equal in distance to the brow and bottom plane of the nose. The distance from the top edge of the wing of the nose to the inside corner of the eye is equal to the width of an eye.

The distance between the inside corners of the eyes is also equal to the width of an eye.

Always begin with the standard proportions and then adjust as required for your particular model's facial structure. In the three-quarter view foreshortening will always occur. Also note that if you are looking down at your model, the half-distance will appear greater from the top of the head to the eye than from the eye to the chin. Conversely, if you are looking up at your model, the half-distance will appear greater from the chin to the eyes than from the eyes to the top of the head. After you have divided the head proportionally, you will begin drawing the shape of each shadow that describes the individual features.

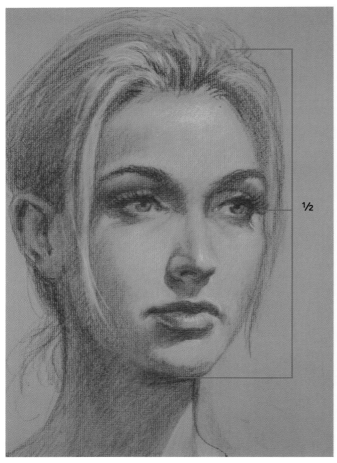

This drawing illustrates the proper placement of the eyes. The top of the head is neither the hairline of the forehead nor the strands of hair. If you use either as visual points of reference, the eyes on your model will be placed too high. Only the crown of the skull should be used for placement of the eyes. As a result of the thickness of hair, or a hairstyle, a model's eyes may appear to be well below the halfway point, which is true in this drawing.

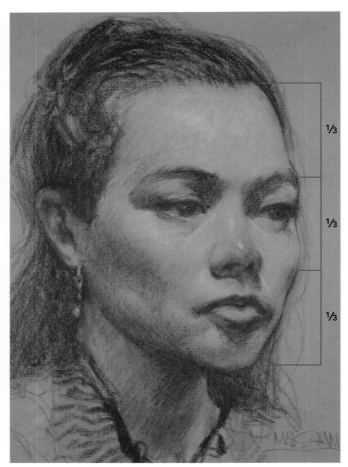

Once you've placed the eyes halfway between the top of the head and chin, begin the one-third increments with the placement of the brow, which is visually determined. Note that the eyebrow is slightly higher on the female than on the male.

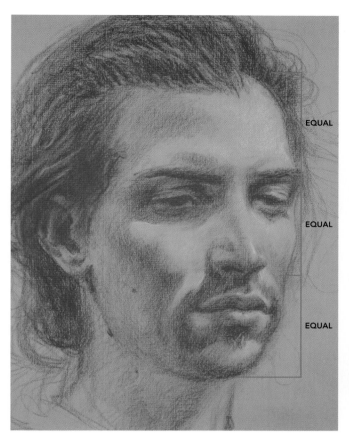

EQUAL

EQUAL

EQUAL

Divide the distance between the brow and the bottom of the chin in half to locate the bottom of the nose. The distance from brow to nose, nose to chin, and brow to hairline will be equal. The eyebrow is slightly lower on the male than on the female.

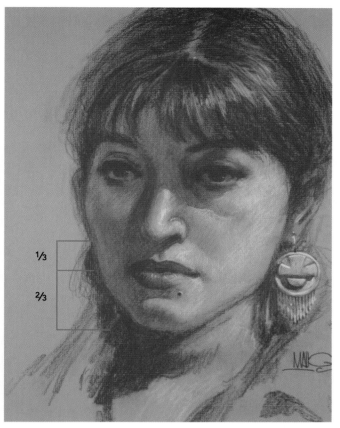

⅓

⅔

Two measurements of one-third and two-thirds divide the space between the bottom of the nose and the bottom of the chin. The division between the upper and lower lips is located one-third below the bottom of the nose. That distance is repeated twice from the division between the upper and lower lips to the bottom of the chin.

Seeing Is the Best Knowledge

In this chapter I am giving you a minimal amount of detailed information regarding the anatomy of the human head and its features. This information is meant to help you understand the anatomical structure that creates the shadow shapes of each feature. You may use the anatomical descriptions and drawing details to help you analyze your own drawings *after* they are complete. Most importantly, the anatomy lessons I give you should not hamper your ability to *see* during the drawing process. If you focus on what you *know* about anatomy when drawing a model rather than focus on seeing the model before you, the result will not be a likeness but rather a generalized drawing. Further, it can become quite easy to draw preconceived ideas out of habit, making the same mistakes over and over again. The best approach to drawing a head and its individual features is one of discovery—to gaze upon the forms as though you have never seen anything like them before. And since each human head is unique, truly you haven't. So do not let experience or your intellect destroy the journey. Let your mind go blank, and let your eyes tell you when the shadow begins and ends. Let the resulting shadow shapes reveal the structure to you.

Another common mistake that artists make is to place the lips halfway between the bottom of the nose and the bottom of the chin, and the eyes one-third from the top of the skull. The result is a long upper lip, and is consequently more apelike than human. In the first drawing below, the mouth has been improperly positioned halfway between the bottom plane of the nose and the bottom of the chin. In the second drawing the mouth has been properly positioned one-third below the bottom plane of the nose and two-thirds above the bottom of the chin.

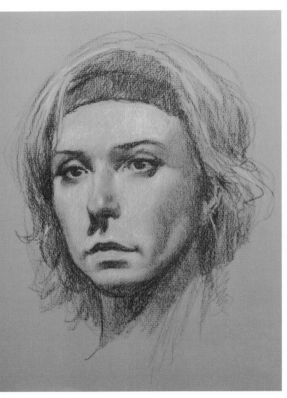

The mouth is incorrectly positioned halfway between the bottom plane of the nose and the bottom of the chin.

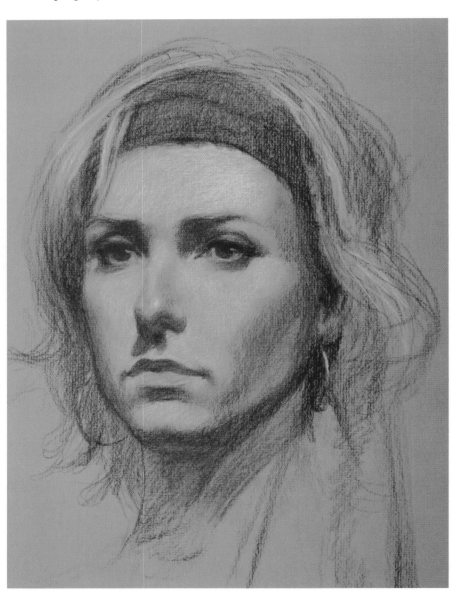

The mouth is correctly placed.

THE ANATOMY OF THE EYES

Of all the features, I have devoted the greatest amount of instruction to the eyes. This emphasis reflects both their importance as the focal point in a portrait and their visual complexity, especially in comparison to the nose, mouth, ears, and hair. Since all measurements should be taken from and adjusted to the eyes, they are the first feature I draw. (It is much easier to line up the nose to two accurately placed eyes than to line up the eyes to an accurately placed nose.) Also, when eyes are completed first, it is much easier to determine the degree of detail to be applied to the other features, which should always be subordinate to the eyes, the natural focal point in a portrait. After the shadow shapes of each feature are duplicated and refined

and the dark accents or highlights are applied, follow the same drawing sequence for each feature, moving from eyes and brows to nose, mouth, and hair.

THE ORBICULAR CAVITY

The orbit (eyeball) is housed inside the orbicular cavity (eye socket), which is somewhat rectangular in shape, though with curved corners. The orbit makes close contact with the top, bottom, and outside edge of the cavity. The inside upper corner creates a deep triangular depression that is horizontal below the brow, vertical toward the bridge of the nose, and diagonal back again following the curvature of the orbit.

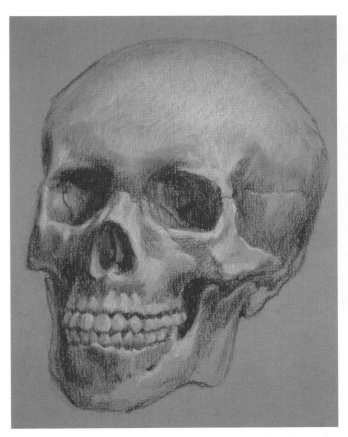

This drawing of a skull clearly shows the rectangular shape of the orbicular cavity.

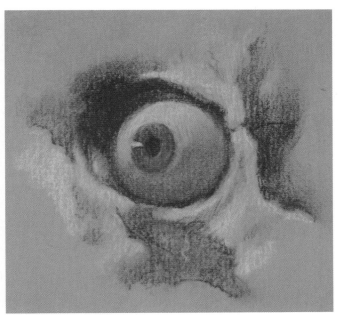

The orbit makes contact with the top, bottom, and outside edges of the orbicular cavity, creating a dark, triangular depression at the inside upper portion of the cavity.

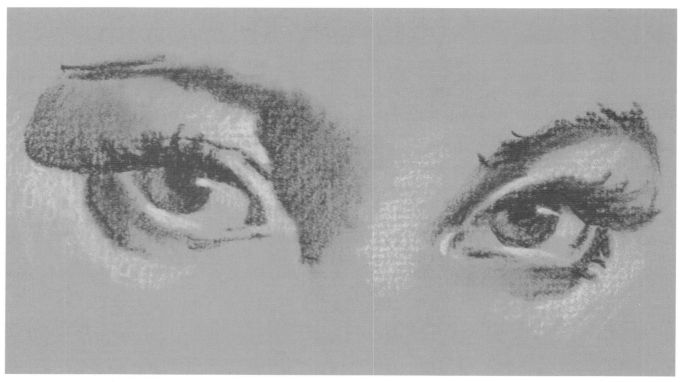

The concave, triangular depression creates a significant shadow shape.

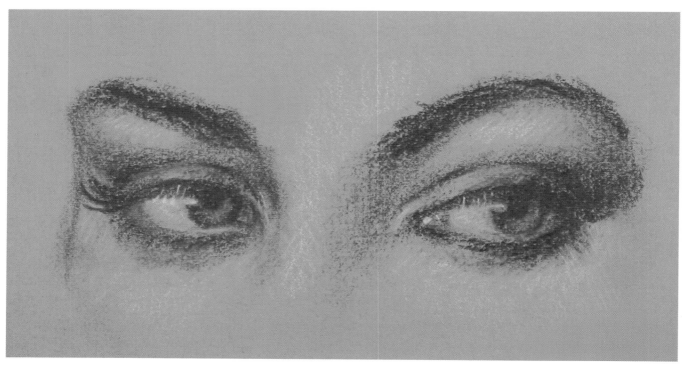

A common error when drawing the eyes in three-quarter view is to neglect to indicate the bony cavity between the cheek and brow. If this is not included, the eyeball will appear to protrude from the head.

THE NATURAL SLANTS OF THE EYE

The position of the orbicular cavity is at a downward, outward, and inward slant. The **downward slant** provides protection and runoff of perspiration. This creates a downward droop that would visually convey a depressing appearance. However, both the brow and outside corner of the eyelids are raised, which compensates for the droop. The brow begins inside and under the bony cavity, arching up to the outside before it angles down toward the temple. The outside corner of the eyelids is higher than the inside corner.

The **outward slant** of the eye allows us to see peripherally. The orbicular opening is angled slightly to the side, since the orbicular cavities are positioned on a curved frontal plane. This is especially important to note on a three-quarter view. The eye nearest to you will be nearly at a right angle to your position. The distant eye will be severely foreshortened.

The **inward slant** positions the eye somewhat downward, allowing simultaneous observation of objects slightly above the head and obstacles directly beneath the feet. Note also that when portraits are lit from above, the amount of light reaching the orbit is limited both by the brow, which casts a shadow over the area, and by the inward slant of the eye itself. Therefore you should reduce the intensity of light striking this area in your drawing. If you allow the cavity to be over-illuminated it will advance, flatten, and lose the inward slant.

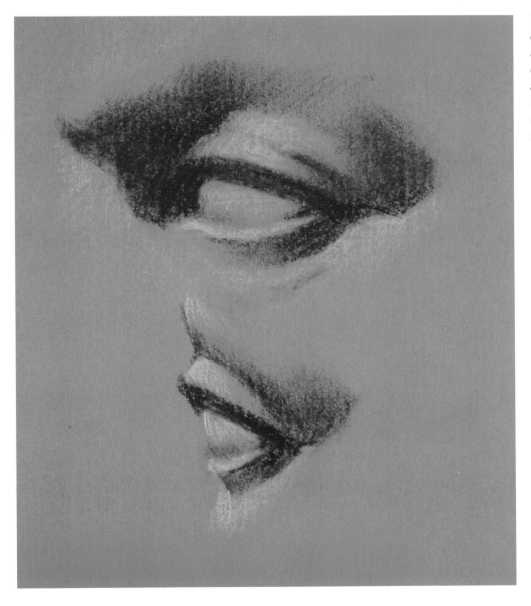

The top drawing illustrates the outward slant of the eye in a three-quarter view. The bottom drawing illustrates the inward slant in a profile view. Since both are drawn in value, the three-dimensional structure of the eye is emphasized.

THE EYELIDS, PUPIL, AND IRIS

The eyelids are equal in thickness at the inside corner. However, because the upper lid is functional, it is twice the thickness of the lower lid, which is stationary. The upper lid overlaps the lower lid at the outside corner, which is slightly higher than the inside corner. They are not horizontal.

The thickness of the upper lid is at an oblique angle to the artist's view. It is indicated by the length of the shadow cast by the lid upon the orbit. This produces a cast-shadow under the upper lid across the orbit. The thickness of the lower lid, which is at a right angle to the source of light when it is positioned above the model, is described as a light value trapped between the darkened portion of the orbit that curves away from the light and the darkened underside of the lower lid. The lower lid also cups the underside of the orbit.

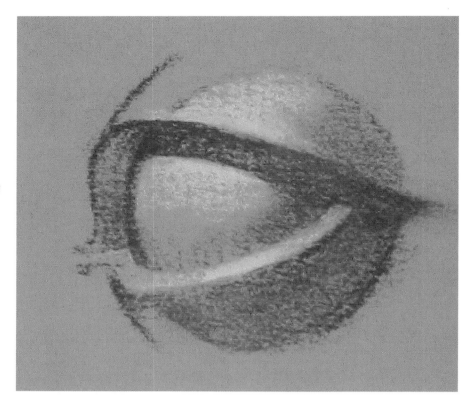

The eyelids must be described in value and not in line or they will appear as lines drawn on a ball.

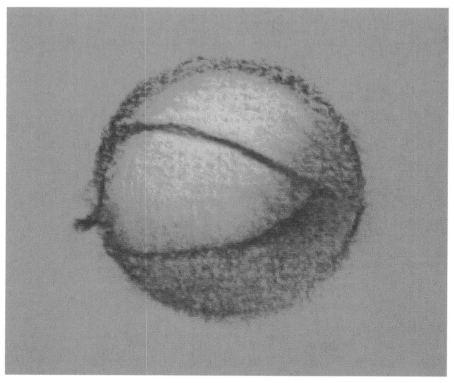

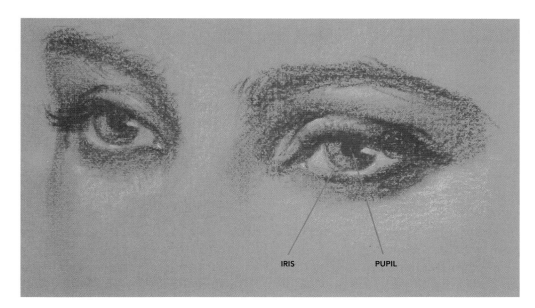

The pupil and iris are covered by the cornea, which protrudes from the orbit and is curved like a contact lens. The cornea gently rises and lowers the upper lid as the eye moves from side to side.

IRIS PUPIL

POSITIONS OF THE EYES

Alternative positions of the eye are approached no differently than the previous examples. The structure is defined by the shadows, as well as the negative distance between them. As the eye glances downward, the upper lid extends, creating a greater negative space between the shadow from the orbicular muscle and the shadow-mass edge of the upper lid and lashes.

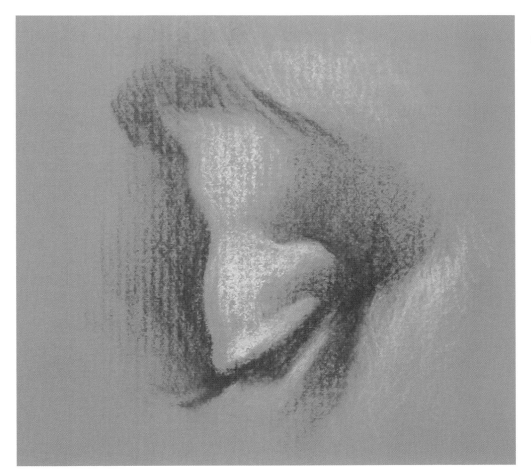

This eye is shown in a downcast position.

DRAWING THE EYES

After you have identified the placement of the graphic dark shape of the eye by dividing the gesture of the head into its proper proportions, indicate in value with the side of your pencil, not the point, the exact shape and size of the dark mass. Remember to begin in the center of the shape, adding value until you have duplicated the shape: Do not draw a line around the shape and fill it in. Start by drawing the triangular depression located at the inside upper corner of the orbicular cavity along the bridge of the nose. The brow is attached inside the orbicular cavity and within the triangular depression—the dark shape continues as a brow that rises above and arches out from the orbicular cavity.

The orbicular muscle is located between the brow and the upper lid. Since its shape is convex, it creates a form-shadow along the bottom outside curve. This dark value cups around the outside end of the orbicular muscle and back to the inside, thereby separating the orbicular muscle from the upper lid. Once you have indicated this value cupping of the lower lid, describe the thickness of the upper lid by indicating in value the cast-shadow across the ball.

The lid slides partially over the cornea, which covers the iris and pupil. The cast-shadow is generally equal to the thickness of the iris; therefore the iris and cast-shadow merge as one. Indicate iris, pupil, and cast-shadow as one graphic mass or shape. Do not make this graphic shape too dark too soon. Work very lightly at first, continually correcting the shape, size, and placement until a likeness appears.

Cup the underside of the orbit by indicating the shadow value under the thickness of the lower lid. Now compare the completed soft-edged graphic dark shape to that of the model. Adjust placement and correct shape. This is best done after the eyes, nose, and mouth have been indicated. The more information you have for comparison, the better your judgment. If you have indicated all dark shapes with the side of your pencil, producing soft edges, corrections can easily be made. If you have indicated the shape with a line and filled in with value, changes will be impossible. The likeness of the model should appear at this stage. If you do not have a likeness, continue to correct the dark shapes until you do.

Once you have achieved a likeness, crisp the edges of all cast-shadows. Remember that all shadows begin soft as form-shadows and end hard as cast-shadows from either top left or right of the model, depending on the location of the source of light. At this point you now add detail in the shadows; include, for example, a darkened core at the soft edge of a form-shadow to indicate the reflected light within them. The lighter portion of a form-shadow (the area containing reflected light) will automatically appear, merely by contrast, as you darken the core. It is necessary to darken the core since it contains neither direct nor reflected light. The core of a form-shadow and the cast-shadow are the same value, as both are devoid of light.

On Comparing the Eyes

If you are right-handed, begin to develop the model's right eye, which will be to your left. Then develop the model's left eye. This will enable you to use the first eye for comparison as you develop the second. If left-handed, do the opposite.

The shape of the triangular depression and brow are rendered in value.

The cast-shadow from the upper eyelid is separated from the outer curve of the orbicular muscle.

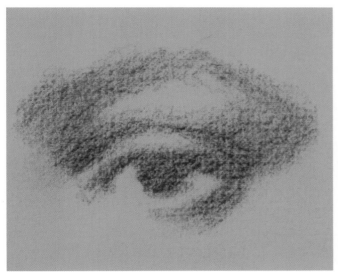

The pupil and iris are combined as a single shape of value; the shadow from the curved lower lid is indicated.

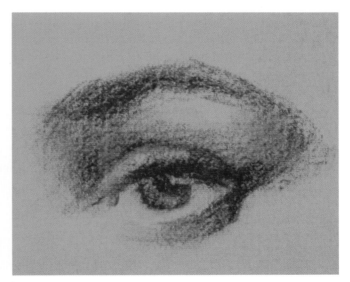

The pupil, lashes, and brow are defined.

HIGHLIGHTS ON THE EYES

Highlights on the eyes give vitality to a portrait. If you neglect to add them, your model will seem dull and lifeless. Just as there are two treatments of shadow edges—that is to say, both hard and soft—there are two treatments of highlights. If, for example, a highlight meets a cast-shadow edge, it will begin as a hard edge. It will become progressively softer as it fades into the halftone of the paper surface or before it meets the soft edge of a form-shadow.

The highlight above the form-shadow, which begins at a right angle to the source of light, must disappear into the halftone before the soft-edged form-shadow begins. This is a gradual transition from light to shadow—a delicate merging. The highlight blends into halftone, which in turn disappears into shadow as the form turns away from the source of light. The opposite is true when the highlight is placed next to and touches the hard edge of a cast-shadow. Without light there is no shadow. The surface under the cast-shadow would have been illuminated by the source of light if the object casting the shadow had not intercepted it. The highlight begins where the shadow abruptly ends.

Keep the highlight centered on the orbicular muscle to force the receding edges (by appearing darker) to wrap around the orbicular cavity. The upper lid slides a portion over the cornea. The cast-shadow from the upper lid is generally tangential to the top of the pupil. The highlight is located at the base of the cast-shadow, which begins in the iris, not the pupil. The highlight then fades to the corner of the orbit as it recedes from the artist's view.

The highlight, though very small, appears light since it is surrounded by a dark cast-shadow from the lid above, a dark pupil turning away from the source of light, and a darkened iris just below the highlight. The iris appears lighter as it approaches the cast-shadow from the upper lid on the opposite side of the pupil.

Gravity draws fluid to the center below the iris and above the inside edge of the lower lid. A highlight reflects off the fluid. The orbit becomes darker as it rolls under and approaches the lower lid, which is illuminated at a right angle to the source of light. Remember, this separation is visible only because two contrasting values share a common edge. There are no lines in nature! Describe the separation as contrasting values. Avoid drawing a dark line between the orbit and the inside edge of the lower lid.

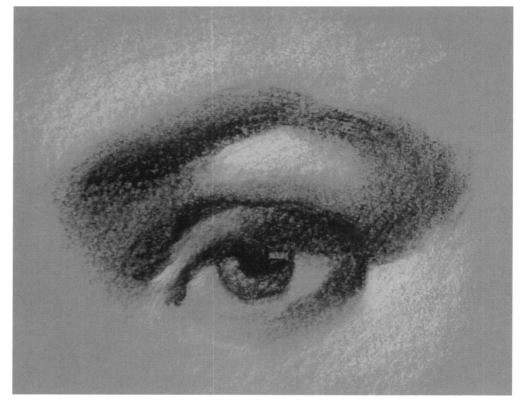

Highlights are centered on the orbicular muscle and placed at the inside corner of the intersecting lids and at the edge of the cast-shadow below the lower lid and orbicular muscle. A highlight is also placed above the brow, but does not touch it.

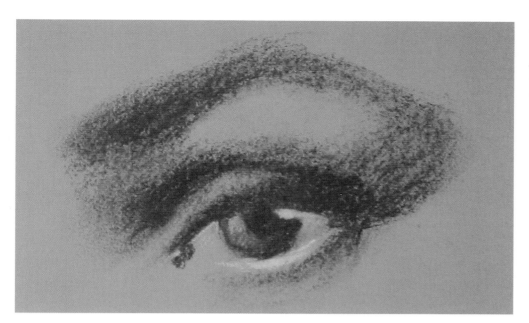

Highlights are placed on the orbit below the cast-shadow from the upper lid, as well as the iris and thickness delineating the lower lid.

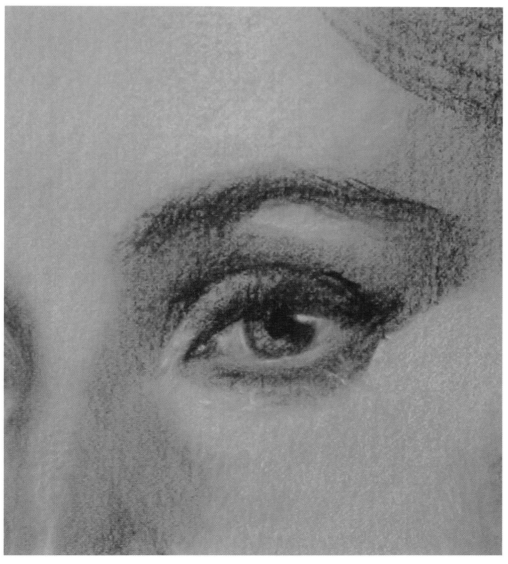

A detail of a head with the eye completed

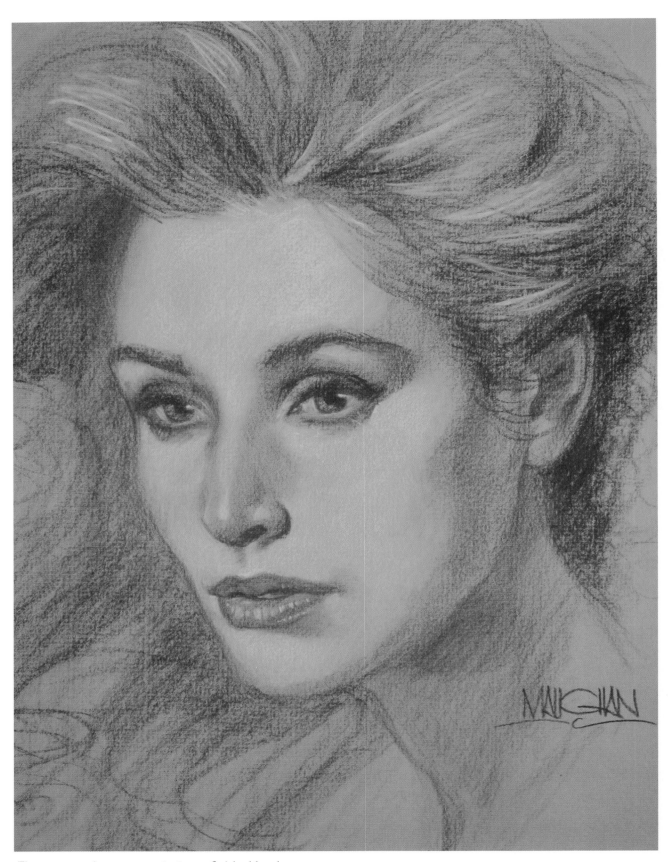

The eyes seen in proper context on a finished head

USING THE PAPER VALUE

By giving the white above the cheekbone a crisp edge, the middle value of the paper appears darker below the lower lid at the inside corner. This optical effect, caused by trapping (see page 25), enables you to turn the lid away from the viewer without using the dark pencil, which should be used only for the shadow value. By crisping the lower edge with a dark pencil, the paper value will appear lighter in the thickness of the lower lid near the outside corner where the lids meet. The value of the paper is darker than the highlight above the iris, yet light in comparison to the shadow, and thus will appear light and recede simultaneously.

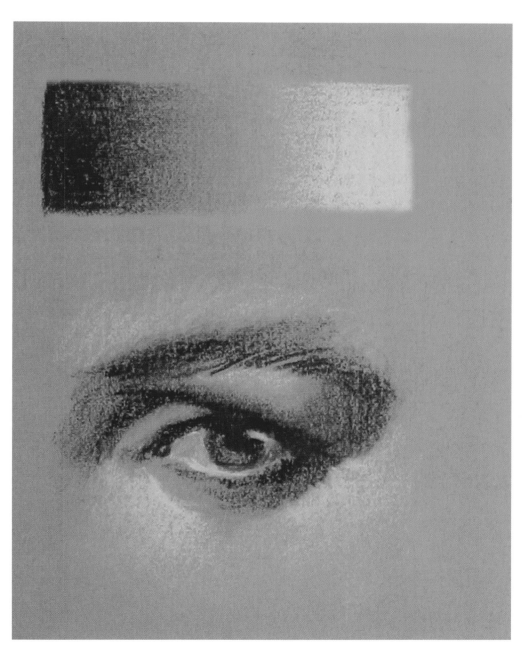

As can be seen by the shape of the dark mass, the female brow is typically arched higher than the male brow, rising above the cavity to expose more of the orbicular muscle.

Examples of Eyes

There is no formula for drawing features. There are differences between the sexes as well as the races. The key to structure and likeness is to begin with the graphic shape of the dark areas first. For the eye this consists of the shadows, brow, lashes, pupil, and iris. Although each of the following models was drawn in the identical sequence using the same principles, the graphic, soft-edged dark masses or shadow shapes differ in each drawing, mirroring, as they do, the unique structural characteristics of each individual. If your shadow shapes are correct in size, shape, and placement, an exact likeness—including nationality, sex, age, and facial expression—will be captured.

Value describes the triangular depression and brow.

Separation of the orbicular muscle and the upper lid, with a slight indication of the lashes

The cast-shadow from upper eyelid and the pupil and iris are indicated as a single value shape. The shadow below the lower lid has also been added in value.

The shapes were adjusted and dark accents were added.

A close-up view of the completed eye including the highlights

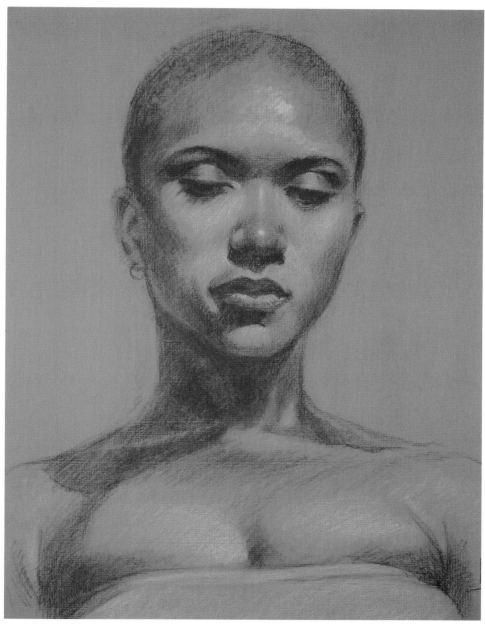

The eye, as seen in context of a completed head drawing, with the rest of the features

The triangular depression and lower brow of the male

The separation and outside curve of the orbicular muscle, and the cast-shadow from the upper eyelid, are indicated in value.

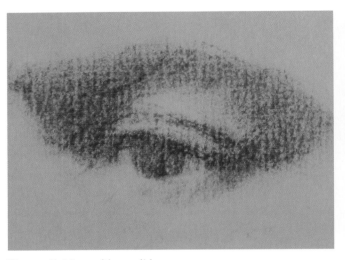

The pupil, iris, and lower lid

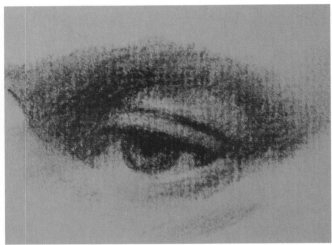

The shapes have been corrected, dark accents have been added to the pupil, and the brow and outside corner of the lids defined.

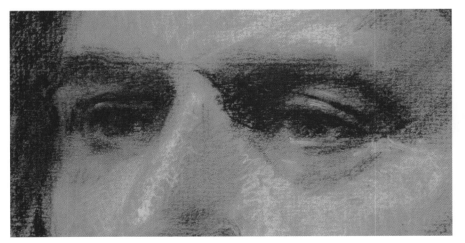

The eyes are completed, including the addition of highlights.

▶ The finished eyes seen in context of a completed head drawing. The male brow follows the bony edge of the cavity, exposing less of the orbicular muscle, as is the case with this model.

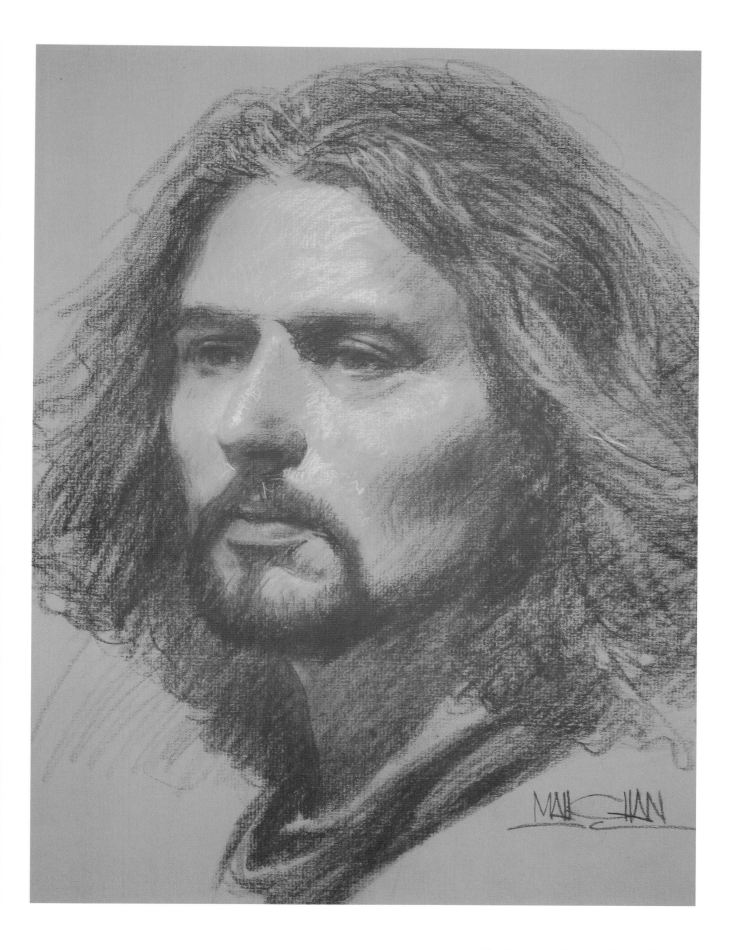

The arched brow is described in value.

The separation of the upper lid from the orbicular muscle and the cast-shadow from the upper lid, including the lashes, have been indicated in value.

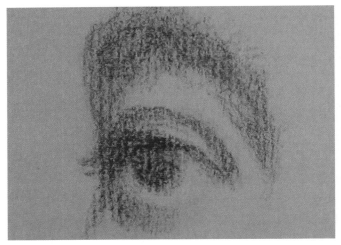

The pupil and iris are treated as a single shape and are attached to the cast-shadow from the upper lid. The shadow under the lower lid has been added in value. Remember that the dark mass of the eye consists not only of shadow, but includes all dark local value: for example, the brow, lashes, pupil, iris, mascara, eyeliner, etc.

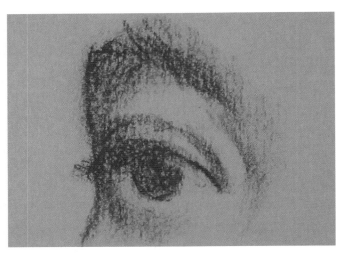

The longer shadow beneath the thickness of the lower lids, and along the orbicular muscle and upper lid, receive more light, giving the orbit the appearance of protruding forward from a flat plane.

A detail of the completed eye including highlights. The triangular depression on this particular female model is quite shallow and her brow is full. Therefore there is less shadow along the bridge, exposing more of the orbicular muscle to the light, especially toward the inside corners of the eyes.

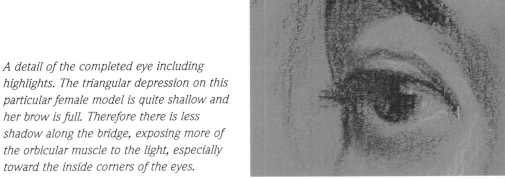

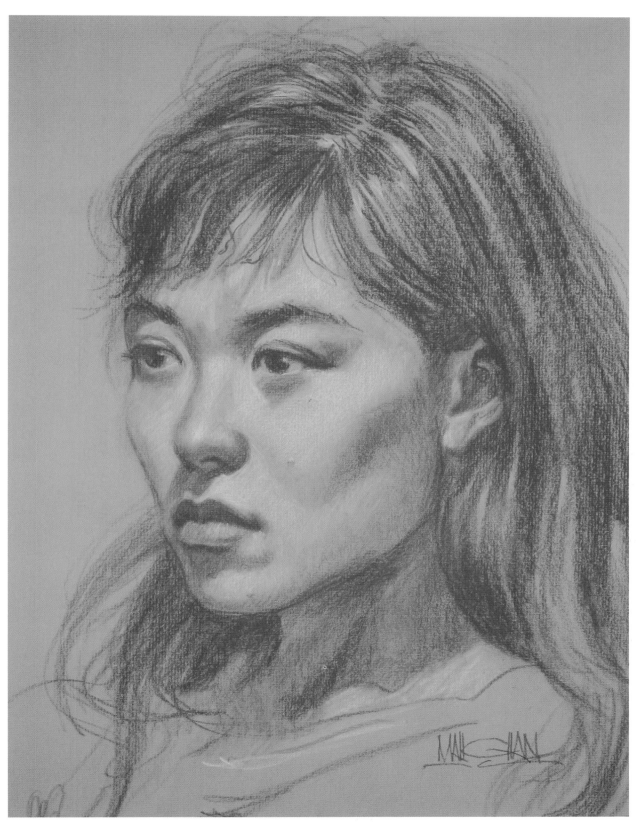

The eyes seen in context of a completed head drawing. High cheekbones, as can be seen on this model, give the face a broad appearance. This appearance is created by the large negative shape of light between the outside corner of the eye and the form-shadow of the cheek on the nearside.

NOSE AND MOUTH

Just as in the case of the eyes, the nose and mouth are described through light and shadow. The nostril opening is located on the bottom plane of the nose and therefore is in shadow when the nose is illuminated from above. The area above the upper lip is in light. The underside of the upper lip is in shadow, but the lower lip is in light. The next shadow begins soft at the curve of the bottom edge of the lower lip and ends hard above the chin, which is in light. The last shadow begins soft as the chin curves away from the light source and ends hard on the neck outside the picture plane. Light, shadow, light, shadow, light, shadow, from top to bottom.

From a distance a form-shadow edge on a small round object, such as the tip of a nose, will sometimes appear to have a hard edge. Nonetheless, it is a form-

A sequence of light and shadow repeats from the top to the bottom of the nose. The leading edge of each shadow is soft and the trailing edge is hard.

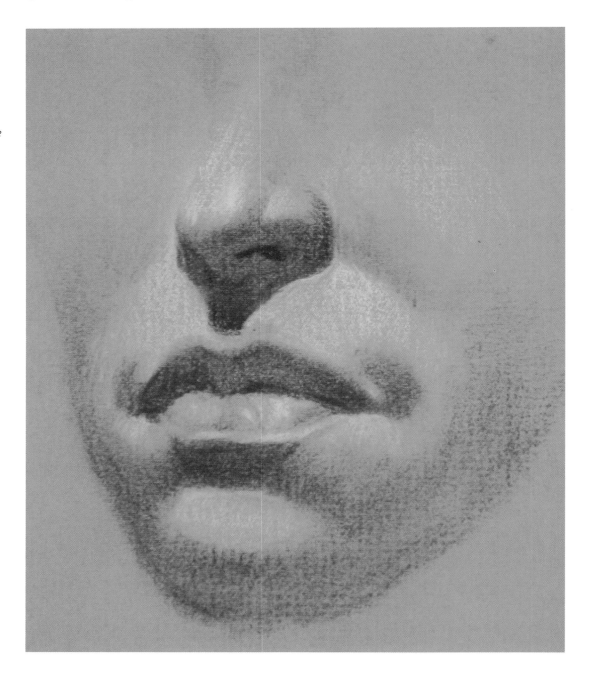

shadow and must be rendered softly, regardless of how hard it may look. Remember, *all shadows begin as form-shadows and end as cast-shadows*. Because the nose tip is so small, the turning of the form (that is, where the shape of the nose tip turns away from the light) takes place in less than one-sixteenth of an inch.

The wing on either side of the nose has a back plane. Many artists indicate the edge separating the wing from the cheek with line. In reality the edge is a cast-shadow. The edges of all cast-shadows should always be defined with value, not line. Lines around the nose or mouth

will destroy the sensitive nature of your drawing and turn it into a cartoon.

Three different planes, requiring three different values, merge at the nose wing. The first is the wing, a side plane that gradually turns away from the source of light into shadow, resulting in a hard-cast edge. The second is the cheek, which is at an oblique angle to the light and therefore often a halftone. The third is the area above the upper lip and beneath the wing. This area is at a right angle to the source of light and is the lightest of the three.

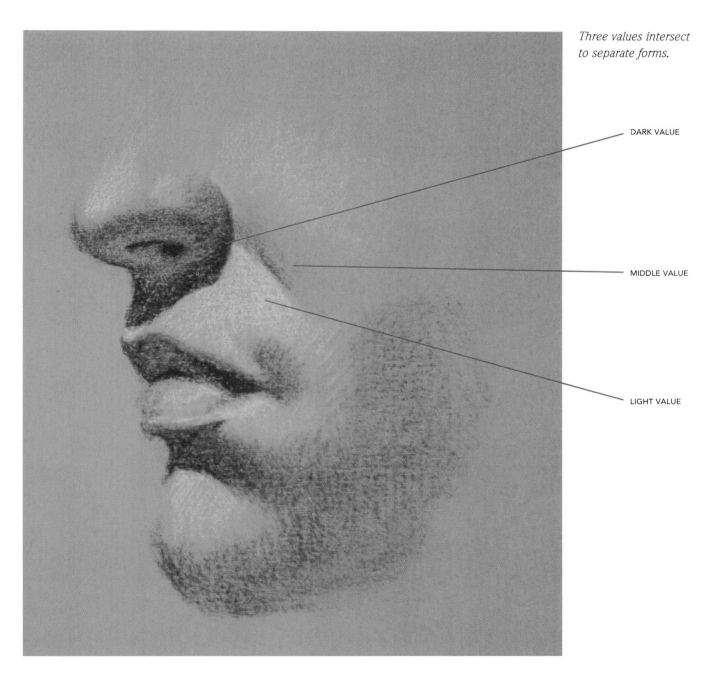

Three values intersect to separate forms.

DARK VALUE

MIDDLE VALUE

LIGHT VALUE

THE STRUCTURE OF THE NOSE AND MOUTH

A nose consists of top, front, bottom, and side planes. Each plane is at a different angle to the light source and therefore differs in value. The septum cartilage is thicker where it attaches to bone, then tapers, ending between two bulbs called the lower laterals. The separation between the bulbous tip can be quite pronounced on some heads and hardly visible on others. Because the bulbs are round in shape, the shadow beneath them is a form-shadow and is therefore soft.

The outside corners of the mouth are shaped like doughnuts on edge. The heavier the model, the more pronounced the doughnuts. The thinner, the less pronounced. The light describing the top of the doughnut gradually disappears as it approaches the doughnut hole, which is described as a soft form-shadow. The form-shadow ends as a hard cast-shadow. The light begins once again at the edge of the cast-shadow and gradually disappears as the doughnut rolls back into a form-shadow. The form-shadow ends again as a cast-shadow. Drawing in value around the mouth creates the underlying structure of the barrel shape of the teeth and gums.

Incorrectly drawn lips appear to be sitting on a flat surface disconnected from the corners of the mouth. This is typified by a dark upper lip that seems suspended above a flat white field on the nearside. Correctly drawn lips are attached to surrounding tissue and appear to grow out of the form. It is the soft transition from light to form-shadow that connects the lips to the surrounding tissue.

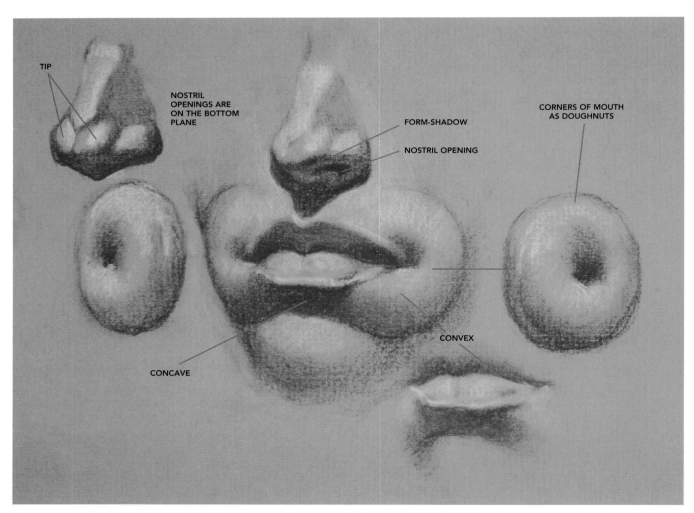

Think of the outside corners of the mouth as doughnuts. This will help you draw them correctly.

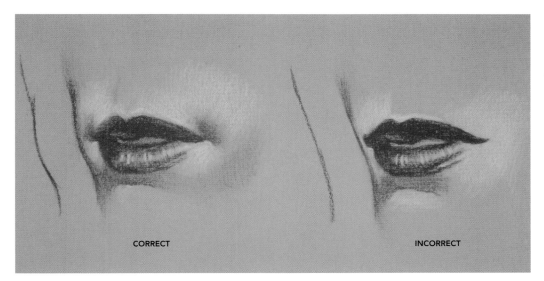

A common mistake in drawing the three-quarter view is failing to account for the doughnut shape on the farside of the mouth.

CORRECT INCORRECT

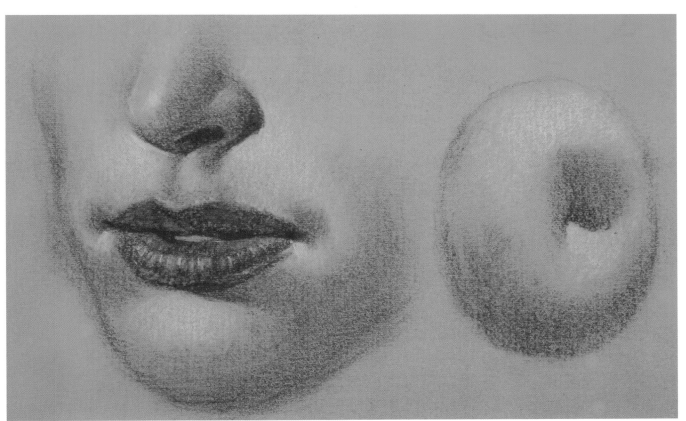

This mouth is drawn correctly. I used the doughnut concept to visualize the structure on both the near and far corners of the mouth.

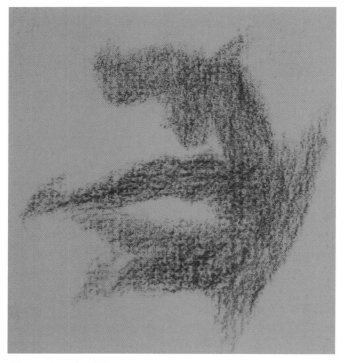

The underside of the nose, the upper lip, and the cast-shadow of both the nose and mouth combine as one graphic shape.

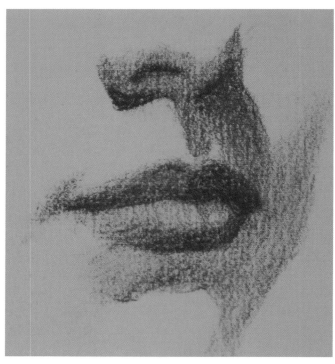

The cast-shadows were defined.

Highlights and dark accents were applied to both the nose and mouth.

On Placement

A common mistake is to place the mouth halfway between the bottom of the nose and chin, and to place the eyes one-third from the top of the head. It is the eyes, not the nose as you might automatically think, that are located halfway between the top of the head and the bottom of the chin. Correcting the placement of the eyes and mouth alone will vastly improve your drawing.

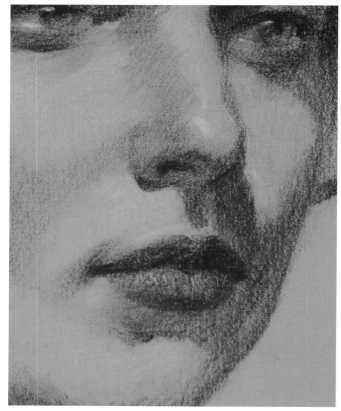

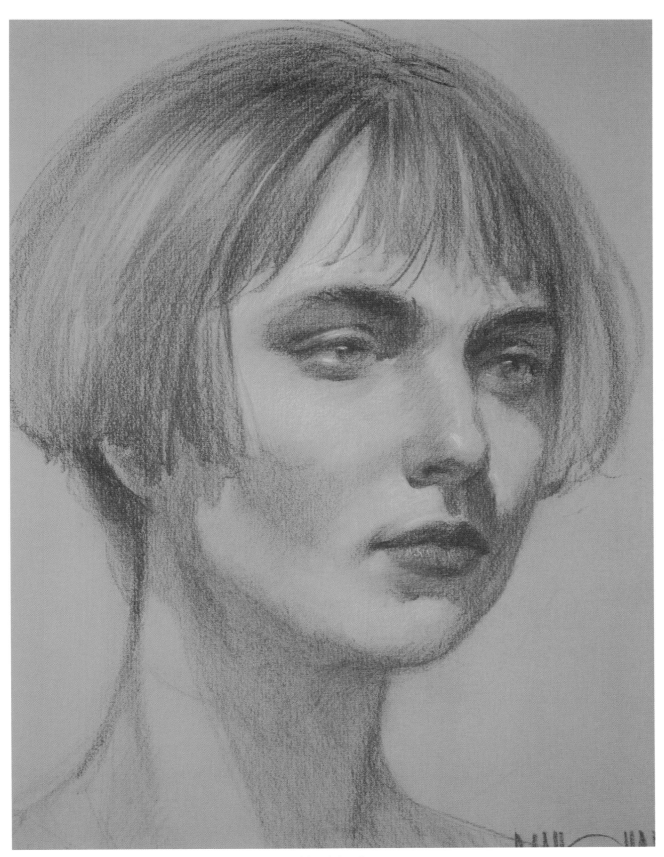

The nose and mouth seen in the context of a completed head drawing.

The shadow under the nose, the mustache, the upper lip, and the cast-shadow below the lower lip merge as one graphic shape.

Shadow shapes were corrected and the cast-shadows defined.

Additional refinements were made, including the highlights and dark accents.

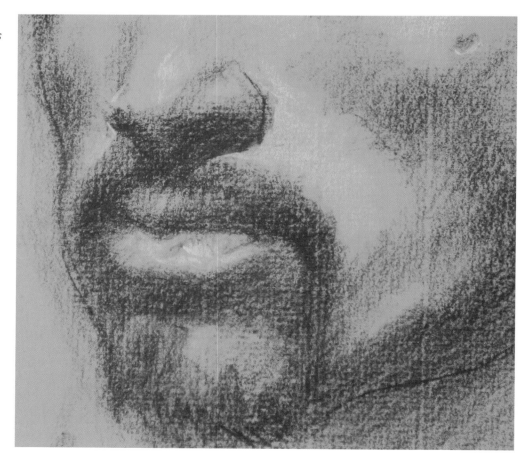

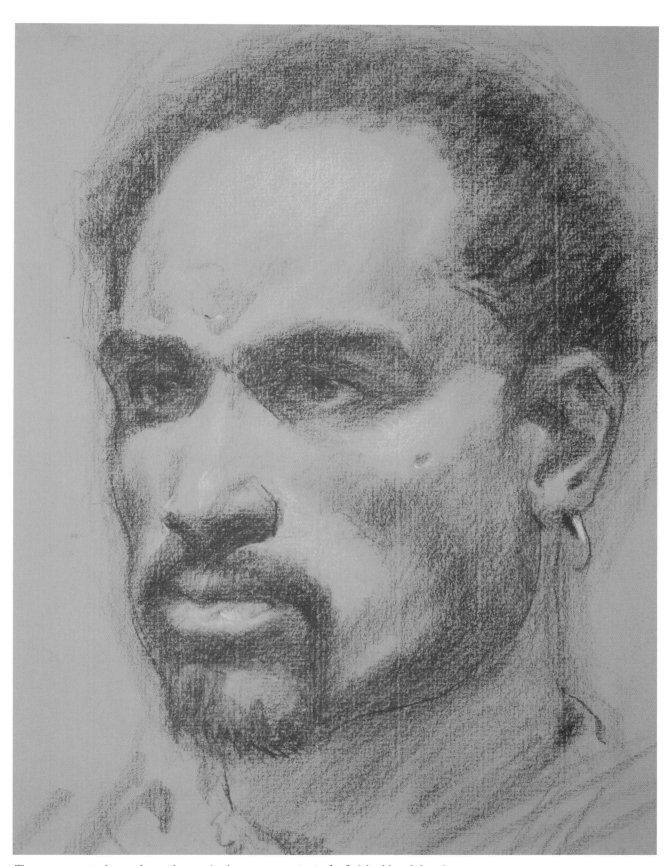

The nose, mustache, and mouth seen in the proper context of a finished head drawing

The bottom plane and cast-shadow of the nose, the upper lip, and the shadow below the lower lip have been indicated in value.

The wings of the nose were defined in value. Shapes were corrected and the cast-shadows defined.

Highlights and dark accents were added.

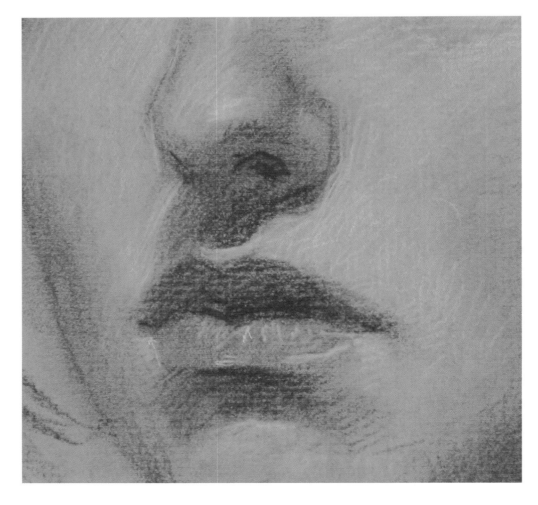

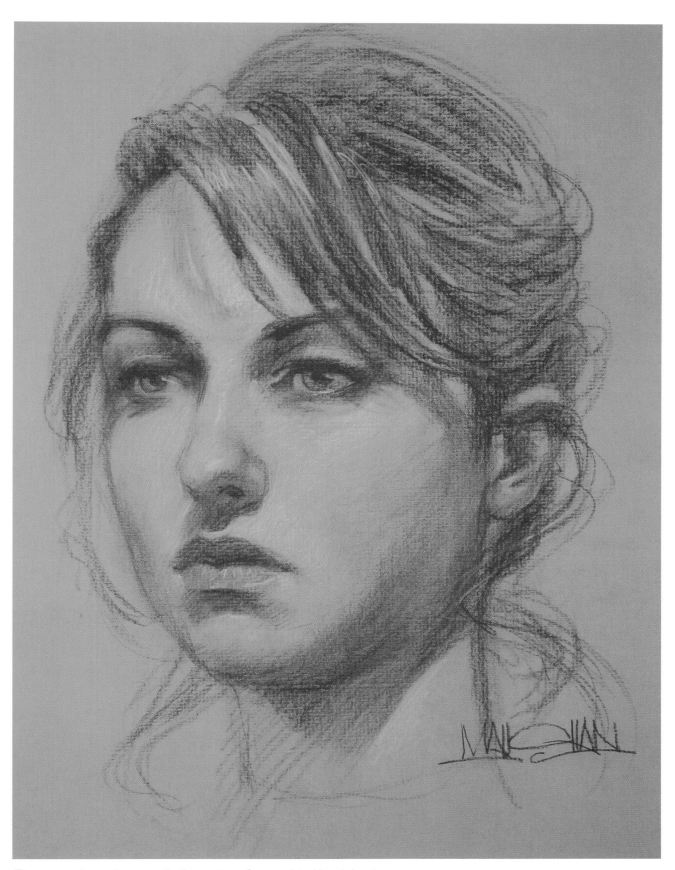

The nose and mouth as seen in the context of a completed head drawing

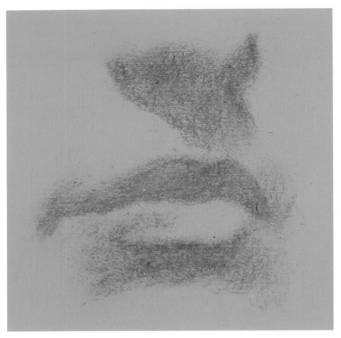

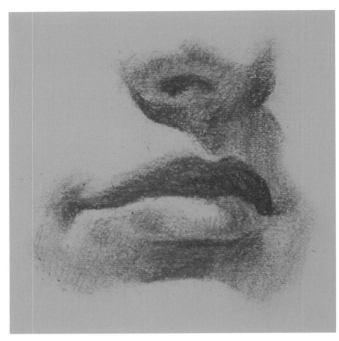

The underside and cast shadow of the nose, the upper lip, and the shadow beneath the lower lip have been indicated in a single value.

The shadow shapes have been finessed and the cast-shadows defined.

The completed nose and mouth including dark accents and highlights.

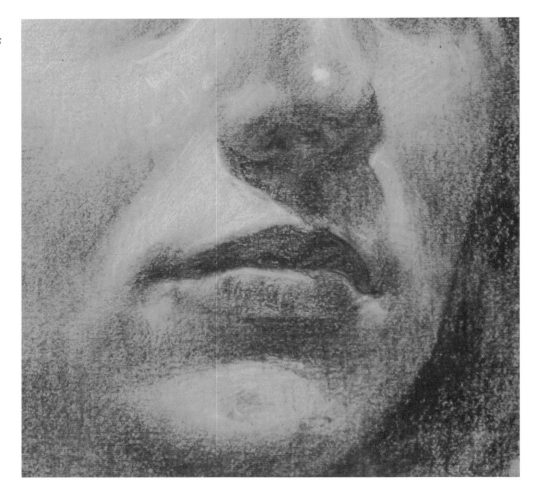

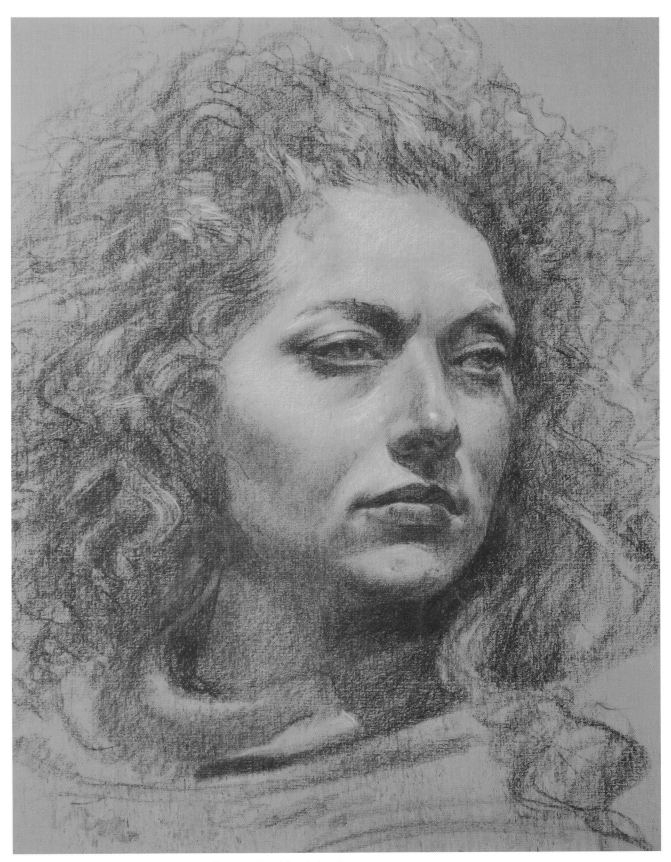

The nose and mouth seen in context of a completed head drawing

Ears

Variety is what creates interest in a drawing and reflects the uniqueness of your model. Though perhaps less readily apparent, ears are no exception to this "rule" of variety. No two individuals' ears are alike—there are always variations in shape, size, and angle. Even ears on the same individual are not shaped alike. After seeing numerous students neglect the ears, to the detriment of their drawings, my advice to you is to take the time necessary to draw them well.

It is especially important to pay particular attention to the outer rim, called the helix cartilage. Varying greatly in width, it begins above the canal opening, follows the outer contour, and ends at the lobe. If you learn only one thing from this book about drawing the ear, it should be this: Do not draw the ear's shape the same width all the way around.

If there is a strong contrast of both light and shadow on the ear, diminish the contrast by making the shadow lighter. Since the ears are at a different depth than the eyes, they will be soft-edged and out of focus, as well as diminished in contrast. (Remember that the human eye cannot focus on two different depths at the same time.) Since the eyes contain hard-edged, dark cast-shadows set beneath a brightly lit forehead, they will be the natural focal point and center of interest.

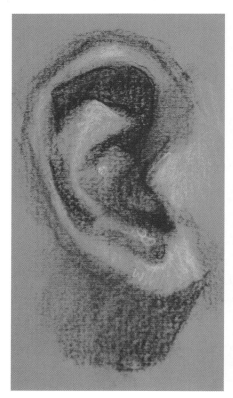

▲ Like the other features, ears are described through light and shadow.

▶ The outer rim of the ear varies greatly in width and should never be drawn the same width all the way around.

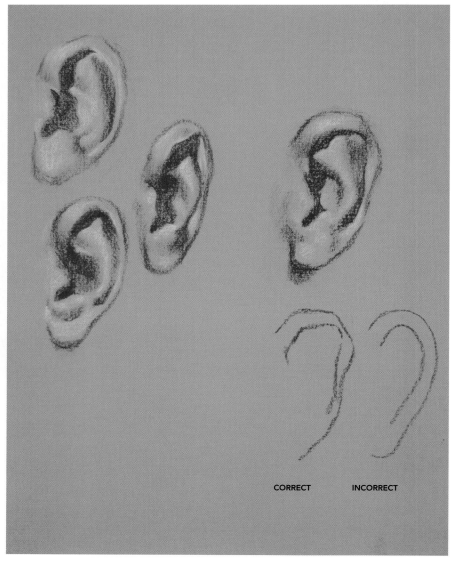

CORRECT INCORRECT

PLACEMENT OF THE EAR

The physical location of the ear canal is equal in distance from the corner of the eye to the bottom of the jaw directly beneath it. You can check this yourself by placing your index finger on the corner of your eye and your thumb at the edge of your jaw beneath it. If you pivot your thumb up, it should slide into the canal.

The visual placement of the ear is exactly halfway between the top of the brow and the bottom of the nose. As people age, both their nose and ears lengthen. Therefore the proportional relationship remains the same regardless of the age of your model. Although this measurement is equal, the ear will appear slightly smaller as it is seen in perspective in the three-quarter view.

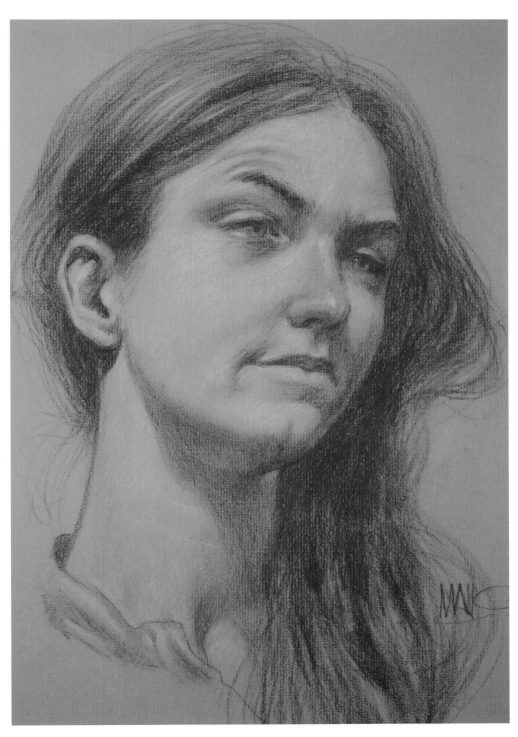

In a three-quarter view the ear will appear smaller than the proportional measurement from brow to nose since the ear is foreshortened in perspective.

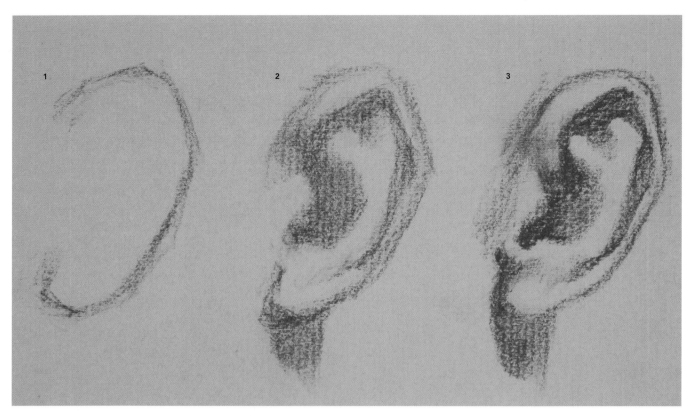

This group of three drawings illustrates the initial steps along the way to a completed drawing of the ear. Highlights and dark accents are added later. 1. The gesture is captured. 2. The shadow shapes are indicated in value. 3. The cast-shadow edges are defined.

A detail of the completed ear including highlights and dark accents.

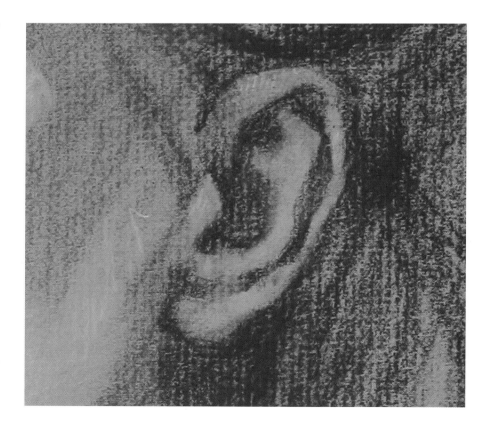

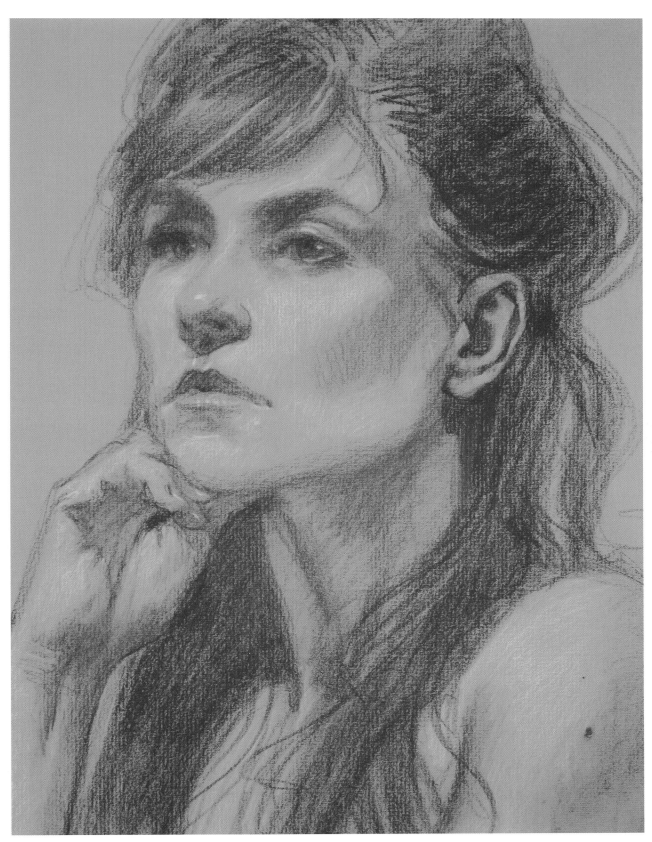

The ear seen in the context of a completed head drawing. Note that the back edge of the jaw is directly beneath the front edge of the ear canal.

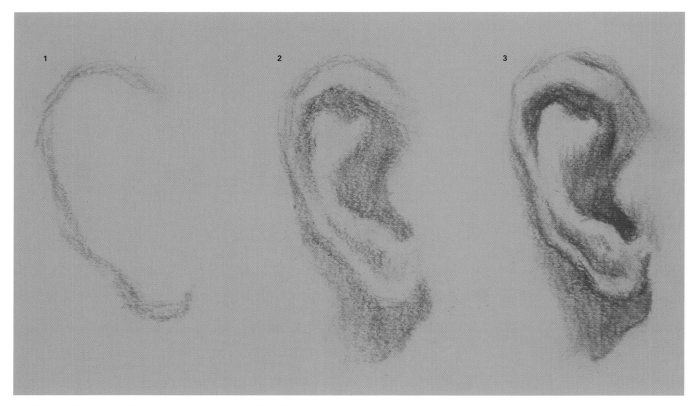

▲ Though the ear is different, the very same initial steps to complete a drawing are followed. 1. The gesture is captured. 2. The shadow shapes are indicated in value. 3. The cast-shadow edges are defined.

▶ Closeup of a completed ear with detail—highlights and dark accents—added. "Detail" is essentially stronger contrast. Some areas may need more contrast; others may not. Strong contrast will give more clarity and emphasis to a particular area.

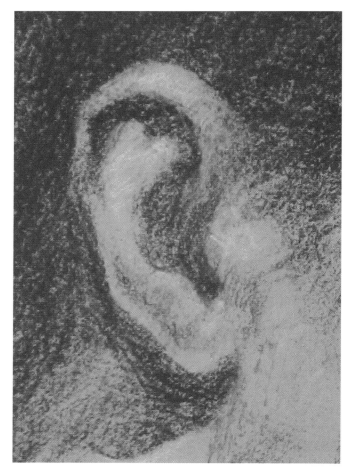

On Seeing

Do not fall into the habit of drawing all models in the same pose, for example, always facing to the right. You will stop looking and draw simply out of habit. In the same way, approach each ear as though you have never drawn one before. The same ear can be a new challenge every time you draw it because the angle and shadows will change with each new pose.

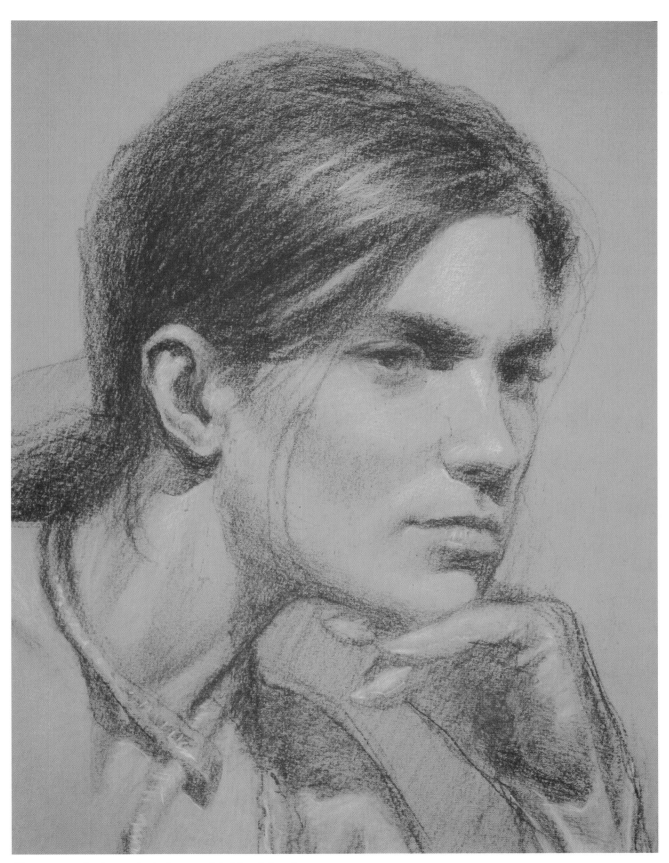

The ear seen in the context of a completed head drawing

HAIR

Treat both the inside and outside contours of the hair as if they have no definable edge, like smoke. Though, in this example, the contour of the dark hair appears distinct against the light background, it has in fact been rendered in sfumato (smokelike) so that it remains soft and out of focus. The hair should serve as an indistinct frame for the face and should never distract from the center of interest, the sitter's eyes.

Drawing the hair is best described by telling you what to do and, even more importantly, what *not* to do. Accumulated from years of teaching, these tips for drawing the hair should increase your learning curve and help you avoid the most common mistakes students make when learning to draw hair. Following the form of the head, the hair mass has six planes—a front, top, back, bottom, and two sides. To convincingly render the three-dimensionality of hair on a two-dimensional surface, hair should be treated as a mass of light and shadow. Use the direction of the light source on the forehead as a guide for placing highlights on the hair mass. Remember, though white can be used to describe highlight and sanguine to describe shadow, neither should be used to describe a local color.

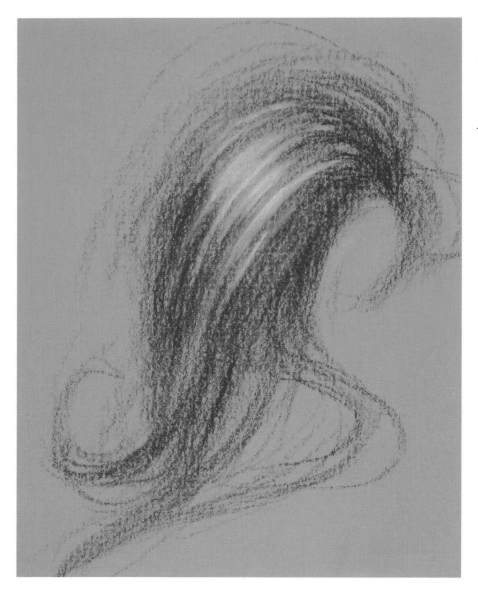

◄ *Though it may be tempting to treat hair as individual strands, don't do it! Instead, treat it as clumps of light and shadow.*

▶ *Do not delineate hairline from forehead with a contour line. Distinct lines separating hair from forehead gives the effect of a wig, or hairpiece. Natural hair grows in a visible blend of both hair and scalp, as can be seen in the part and above the temple. As the hair becomes thicker, the scalp disappears.*

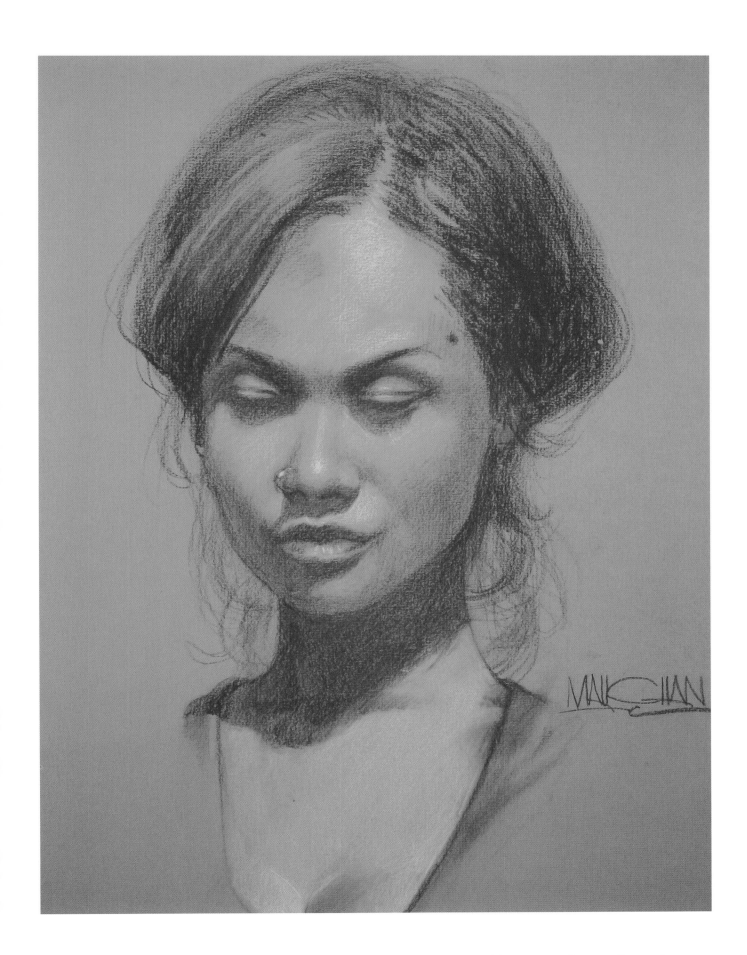

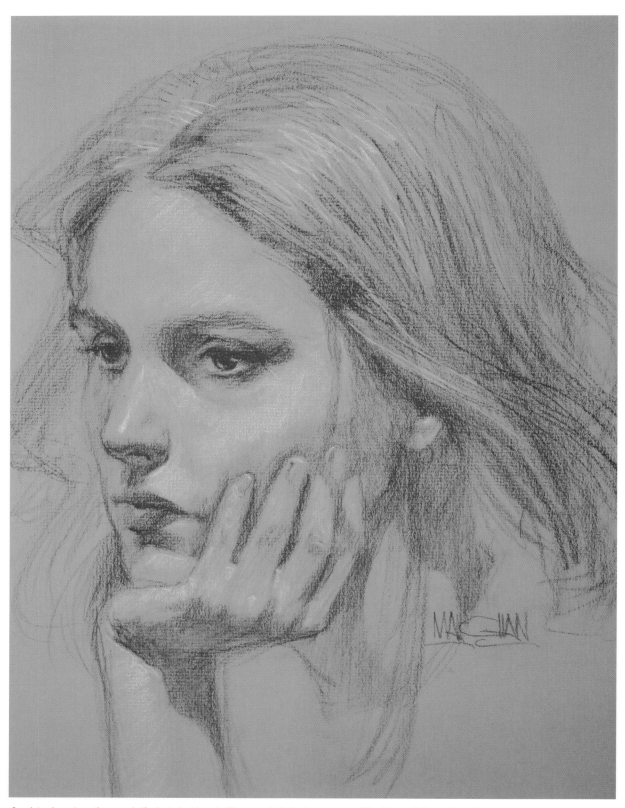

In this drawing the model's hair is blond. The model's hair was not filled in solidly with white, as tempting as it may have been. The hair was treated as light and shadow. There are dark shadows, but the overall value is much lighter than the drawing of a brunet opposite.

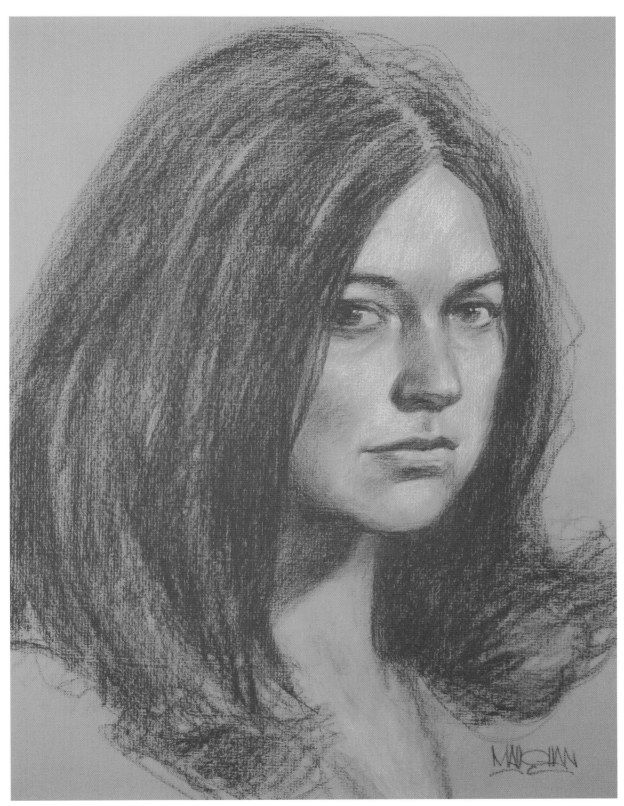

The model in this drawing is a brunet. Note that the hair was not filled in solidly with the dark pencil. The hair was rendered as light and shadow. Since the local value of the brunet's hair is much darker than the model with blond hair, the highlights are a darker value. In fact, the highlights on the brunet's hair are the approximate value of the shadows on the blond's hair.

Do not draw the mustache on the face or that is how it will appear, drawn on. *The mustache is a mass of front, bottom, top, and side planes of differing values. Think of it as a larger upper lip that wraps around the doughnut shape, producing larger shadow shapes.*

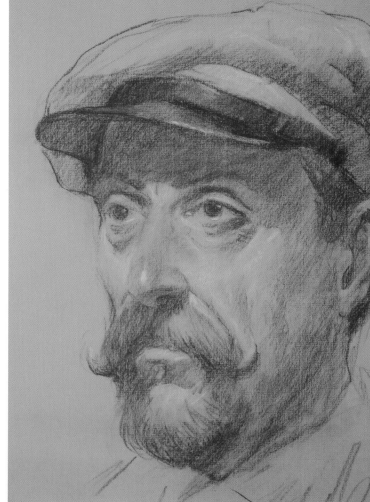

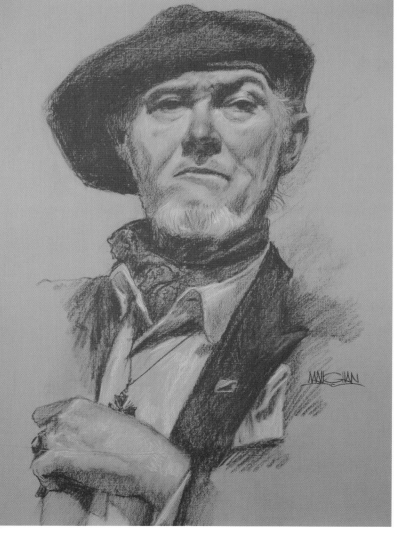

Render the beard as a three-dimensional mass of light and shadow. Follow the light and shadow on the head if the planes are not readily visible. For example, if the cheek falls into shadow, so will the beard, assuming they are at the same angle. If the front plane of the head is in light and the side plane in shadow, the beard will follow. If the bottom plane of the nose is in shadow, so will be the bottom plane of the beard.

TROUBLESHOOTING EXAMPLE

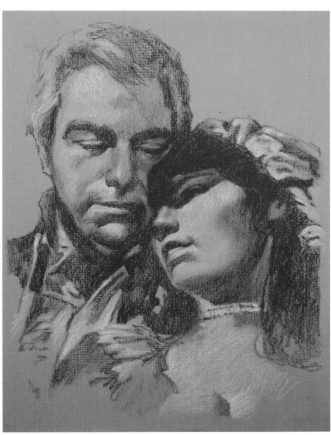

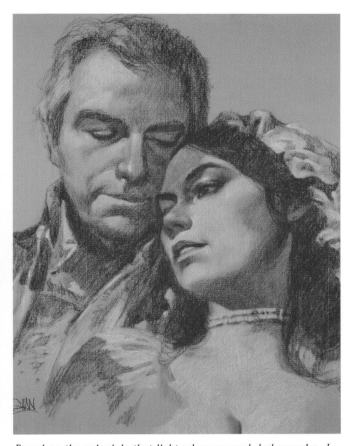

There are several problems with this drawing of a couple. The man's forehead does not appear to tilt forward. The woman's left eye appears flat, and her forehead is narrow, causing her eyes to appear too close together. The foreshortening of the woman's head is too severe, causing her head to appear small.

Based on the principle that light advances and dark recedes, I solved the problem with the male model by making his forehead lighter than his chin and his neck darker than his chin. To solve the problem with the female model, I added more value below her left eye at the point where the bottom of the lower lid curves behind and above the orbit as it transitions to the orbicular muscle. I then arched the brow to create additional dimension. I extended the brow and orbicular muscle of her right eye to add width. To correct the foreshortening on the female model, I exposed more of her forehead, thus making the upper one-third increment of brow to hairline visible.

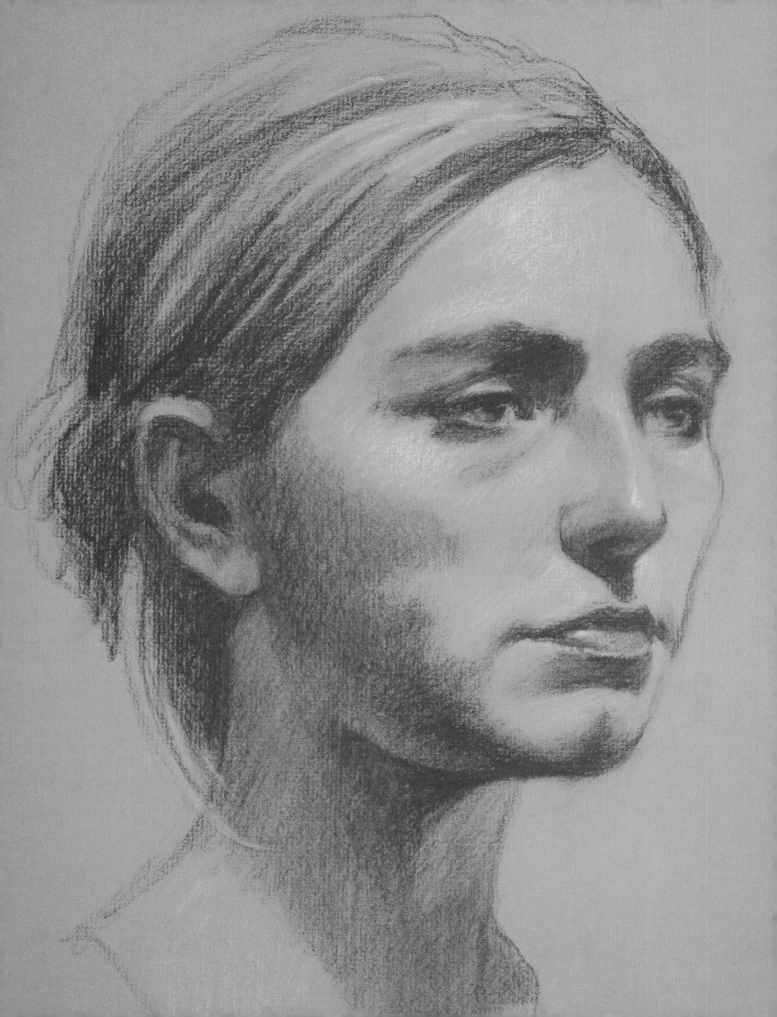

PUTTING IT ALL TOGETHER

THE FIVE ESSENTIAL DRAWING STEPS

Having been introduced to the principles of chiaroscuro and drawing the head, including the proportion and placement of the features, you are now ready to put all that you've learned into practice. This chapter focuses on *doing*. You will find four demonstration drawings, suggestions on how to constructively criticize your own work, practice ideas, and thoughts about how to take your drawing to the next level of subtlety. Before beginning the demonstrations, I will review the five essential drawing steps.

REVIEW

At first there will be nothing on your drawing surface. As you add information (shadow shapes), you will be able to determine if the size and placement of the shapes are correct. Above all, do *not* outline. Adjustments can be made easily as long as the edges of the shadow shapes remain soft. Before beginning to draw, make sure your model is placed in correct relationship to the light source, whether it is artificial or natural. Once you are satisfied with the lighting, begin to draw the gesture.

GESTURE. It is critical to visualize and indicate the gesture in the beginning. Once the features are developed, the gesture will be impossible to correct. After the gesture has been indicated, determine if its placement on your drawing surface is desirable and if the surrounding negative spaces vary in size and shape. The gesture is drawn with multiple soft strokes, not a single outline.

PROPORTIONS. Features may appear foreshortened in perspective, depending on the position of the model in relation to your point of view. Once the foreshortened proportions are correctly placed, you will indicate the features as simple shadow shapes.

SHADOW SHAPES. Record the exact size and shape of each shadow. Begin in the center of the shadow and continue to add value. Do not apply single marks with your pencil, and be sure to keep the edges soft. Once the shadow shapes of the eyes, nose, mouth, chin, ears, and hair are in place, you can more accurately determine if they are correctly positioned. For accuracy, measure the distance of negative shapes between shadow shapes on your drawing and compare them to the same areas on your model. In addition to correcting the location of the shadow shape, adjust the size of shapes as needed. For example, if the shadow shape of an eye is too low, simply add more value to the top and erase value from the bottom. If it is too high, do the reverse. Gather all the information you can at this stage to help you make judgment calls. Doing so will give you confidence in your decision making. The important thing to remember is not to commit too soon. Keep all edges soft so that you can continually correct until a likeness is achieved. Only then should you darken the values or make the edges hard.

EDGE CONTROL. In this step you will define the edges of each shadow shape, which will strengthen the structure and likeness of your model. First determine the nature of each shadow. They will be either form or cast-shadows. Soft edges are unique to form-shadows. If the shadow is determined to be a cast-shadow, crisp or make the shadow edge hard. Strengthen the core of the form-shadows, but keep the edges soft toward the primary light source and the reflected light. Remember, all shadows begin as form-shadows and end as cast-shadows, falling away from the light source.

DETAIL. Before adding the finishing detail to your drawing, step back about ten feet from it to better judge what is needed. If you add detail to your drawing up close, you risk overworking it. Detail is added contrast, whether it consists of highlights on the light side of a form or dark accents on its shadow side. Not all drawings require additional highlights or dark accents, and some may require one but not the other. Only you can be the judge of what is necessary to finish a drawing, or to what is to be left out—what I like to call "editing."

THE DEMONSTRATIONS

Each of the four demonstration drawings that follow includes five drawing steps that never vary: 1. gesture, 2. proportion, 3. shadow shapes, 4. edge control, and 5. detail. You can complete all five steps in one or several sittings. It does not matter, so long as all five are completed in the same order. I finished the first female and male demonstration in four sittings each, combining two of the stages in one sitting. I finished the last two demonstrations in five sittings each.

For each of the demonstrations, before beginning to capture the gesture, I first made sure the light source was above the model and, depending on the three-quarter view, slightly to the right or left of the model. (If the model is looking to your left, the light should be to the right of center, and vice versa.) This will ensure that the light is centered on the model. Before completing the fifth step—adding detail—I took about ten steps back from the drawings to better determine if further contrast was necessary. If I finished the drawings without viewing them from this distance, I would have risked overworking them.

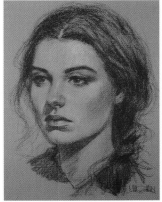

Demonstration One

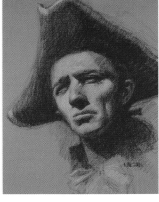

Demonstration Two

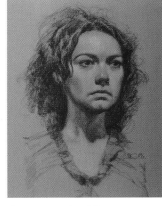

Demonstration Three

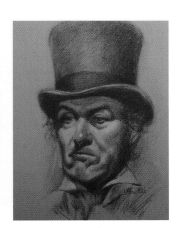

Demonstration Four

Shadow Shape Reminders

- Look at the shadow as a shape; think only shape.

- Do not outline the shape of the shadow and then fill it in later. Rather, begin by applying value with the side of your pencil at the center of the shape.

- Define the shape in one value and then add contrast within the shadow shape for detail. But be careful not to go too dark too soon.

- Strengthen the core by adding a darker value within the form-shadow, but keep the edges soft both toward the primary light source and reflected light.

- Use your initial and very light application of sanguine—applied to build the basic shadow shape—to indicate reflected light in the form-shadow. The halftone of the paper surface should not be used for reflected light.

- Include dark shapes that become part of the shadow value, for example, the brow, eyelashes, pupil, and iris.

- Once you feel satisfied that you have achieved a likeness, crisp or harden the edges of all cast-shadows.

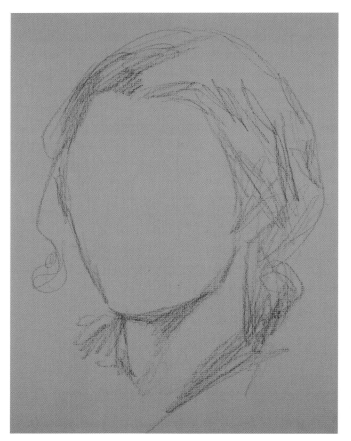

Step 1. I captured the gesture in the first sitting.

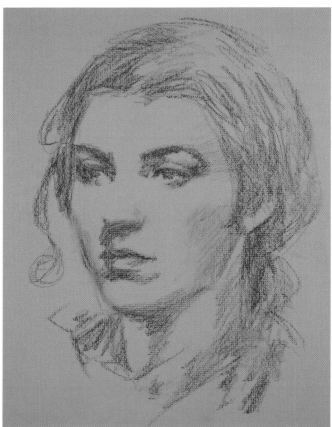

Step 2. I established the proportions, in correct perspective, in the second sitting.

STEP 1: GESTURE. I set this model at a three-quarter view, facing to my left at eye level. While visualizing the completed head on paper, I gestured in a loose contour of the hair, head, neck, and collar. I created the gesture with multiple soft strokes, not a single outline. I positioned the head higher than halfway to avoid placing it at dead center of the paper. I want a variety of negative space around the perimeter of the head. Even at this early stage I have indicated the general shape of the hair in value to begin establishing value pattern. I have also included the large cast-shadow under the chin and on the neck to give the sense of a dimensional mass.

STEP 2: PROPORTION. When the model posed for the second step—establishing the proportions—she seemed more relaxed. She held her head with a slight tilt to her left and toward me. To adjust for this slight change, I brought the distant contour of the forehead to my right and pushed the point of the chin to my left, adapting the contour to the gesture. I then placed the features on the

correct axis in proper proportion. Since the features are indicated in value as shadow shapes, it is important to note the position of the light source. As I apply the principles, I ask myself several questions, "Are the eyes on the proper axis to maintain the subtle tilt of the head? Are the eyes drawn halfway between the crown of the head and the bottom of the chin? Is the mouth placed at the proper upper-third distance between the bottom plane of the nose and the bottom of the chin? Do the eyes and mouth appear to converge at some distant vanishing point? Finally, have I achieved likeness?" If the answer is no, I must take the time now to correct while the shapes have soft edges, are light in value, and can easily be adjusted.

STEPS 3 & 4: SHADOW SHAPES AND EDGE CONTROL. Having established the contour and achieved the likeness, I now refine each feature by visually identifying each shadow, both form and cast. Remember that all shadows begin as form and end as cast, so that alone will indicate the source. But cast-shadows can merge into

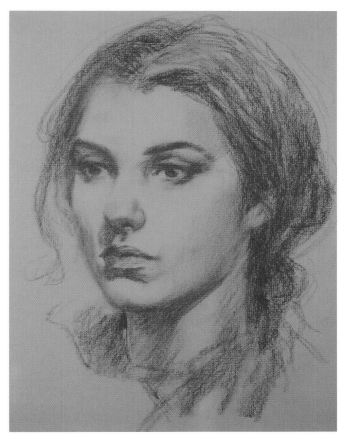

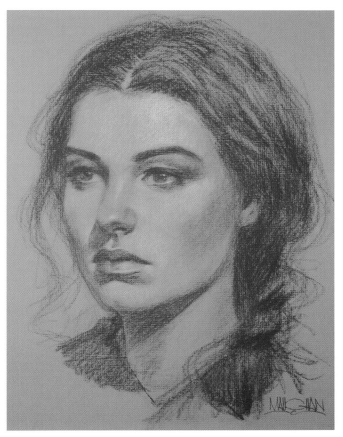

Steps 3 & 4. In the third sitting I developed the shadow shapes and defined the shadow edges.

Step 5. I added the details, both highlights on the light side and accents in the shadows, in the last sitting.

form-shadows, and their edges can quickly change from a hard cast-shadow to a soft form-shadow. For example, the shadow on the eye closest to the viewer begins as a form-shadow above the brow, ends as a cast-shadow beneath the brow, then merges into the form-shadow of the orbicular muscle, finally ending as a hard shadow cast from the upper lid on the orbit. The lower lid falls into a form-shadow on the side nearest the nose and ends as a cast-shadow on the farside of the lower lid along with the cast-shadow from the upper lid and orbicular muscle. Here, all these shadows converge into a single shadow shape. The lower lip and surrounding tissue are convex toward the corners of the mouth. This produces a form-shadow that quickly becomes a cast-shadow when the tissue becomes concave beneath the center of the lower lip, before merging into the form-shadow of the distant jaw. Once I've drawn the shadow shapes, I complete them by addressing the edges—leaving the form-shadow edges soft and crisping the cast-shadow edges. The anatomical structure of the feature

will become visible as you do this. I have also added a slight value to the side plane of the nose and cheek to force the side plane to recede in perspective.

STEP 5: DETAIL. In the last sitting I finished the light side and added dark accents to the shadow shapes. Using the white pencil, I applied highlights to the forehead, since it is closest to the light source. I know that the frontal plane of the head is rounded, not flat, and that the chin also curves away from the light. Having properly centered the light source above the model, the front plane diminishes in light intensity from the top of the head to the bottom, which causes the chin and neck to visually recede in perspective. I have therefore restrained the amount of light I've rendered on the chin and neck to visually force the neck farther below and behind the chin. The result should be a head that is dimensional not only from top to bottom but from side to side as well. I placed dark accents on all the features to add detail within the shadows.

Steps 1 & 2. In the first sitting I established both the model's gesture and proportion.

Step 3. I described the shadow shapes in the second sitting.

STEPS 1 & 2: GESTURE AND PROPORTION. With very light pressure I loosely drew in a gesture that includes a rather large tricornered hat. I paid particular attention to the variation of each corner of the hat and its distance to, or cropping at, the edge of the drawing surface. I positioned the head at a slight angle to my left to avoid similarity of negative shapes between the hat and edges of the picture plane. My point of view is well below the model, necessitating foreshortening. I have divided the proportions for the features and indicated them as simple shadow shapes. I made sure, before moving on to the next drawing stage, that I was satisfied with the model's gesture, which includes the tilt of the head. I also made certain that I was satisfied with the variation in the surrounding negative spaces, and that the features were correctly placed. I know that later, as I develop the shadow shapes, it will become much harder to make adjustments to these preliminary steps.

STEP 3: SHADOW SHAPES. I have added a darker value to the left side of the model's nose and cheek to separate the front and side planes. Value was also added to the underside of the chin and jaw to establish a bottom plane to the head mass. I tell myself constantly to keep

Steps 4 & 5. In the third sitting I defined the shadow edges and added dark accents in the shadow shapes.

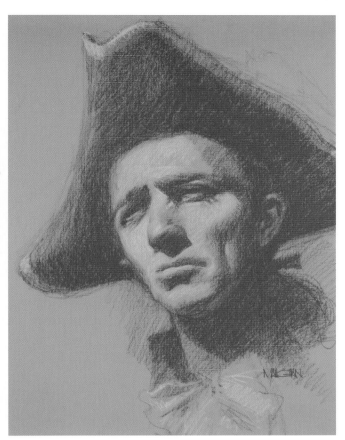

Step 5 (continued). I added highlights in the fourth sitting.

pushing the head up and back so as not to lose the gesture. Then, starting with the eyes, I began to define each feature by duplicating the unique shadow shapes I saw describing each form.

STEPS 4 & 5: EDGE CONTROL AND DETAIL. I revisited the shadows of each feature by comparing the relationship of one to another. I studied not only their shapes and positions, but also the distance between each shape. When I was satisfied that they were accurate, then, and only then, did I commit to hard edges on cast-shadows. I added dark accents within the shadow shapes, defined the hair, and darkened the hat.

STEP 5: DETAIL (CONTINUED). I added highlights to the forehead, and the bridge and tip of the nose. I faded the highlights into halftone before the feature turned into form-shadow. I then added highlights that share the hard edges of cast-shadows along the bridge; under the lower eyelids, the nose, and the lower lip; and finally on the chin where the shadow was cast from the lower lip. Highlights were indicated on the hat and tie as well.

DEMONSTRATION THREE

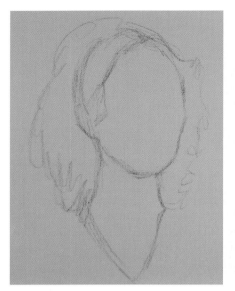

Step 1. I captured the gesture with accurate but loose drawing.

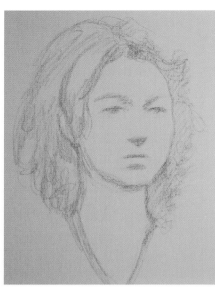

Step 2. I used simple shadow shapes to divide the proportions.

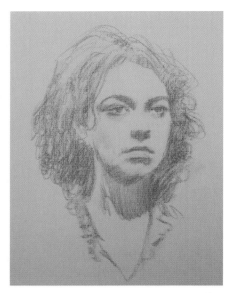

Step 3. I kept all the shadow edges soft as I developed their correct size, shape, and placement, which will give me a likeness.

Step 4. Once I had achieved a likeness, I darkened and hardened the edges.

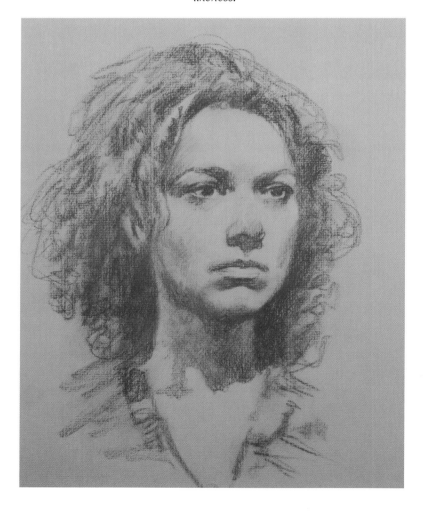

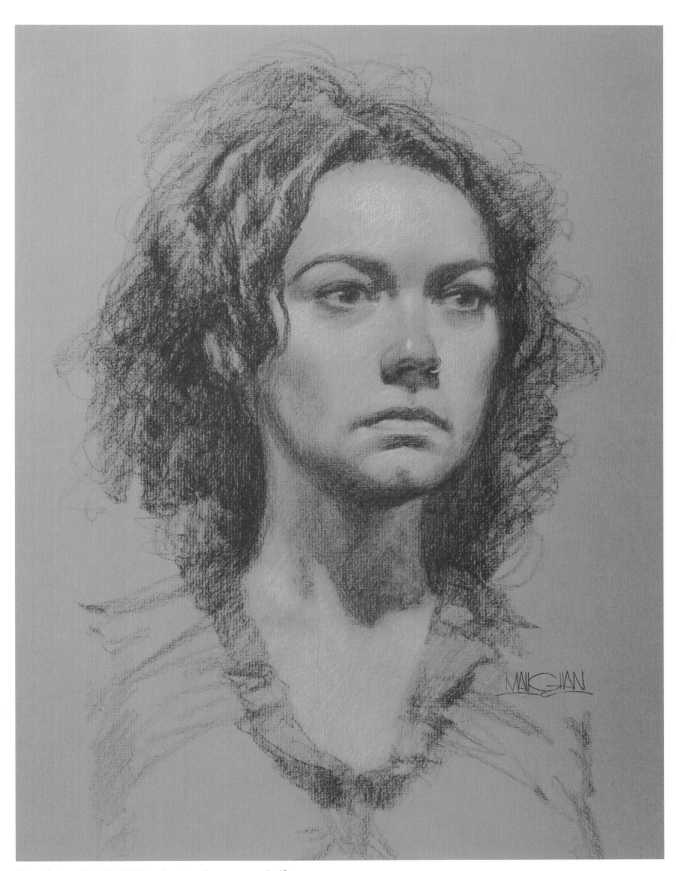

Step 5. I applied highlights, leaving the paper as halftone.

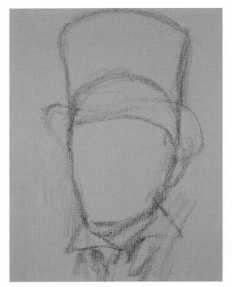 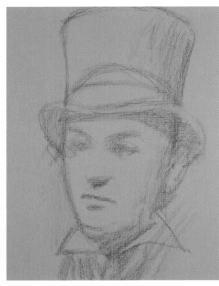 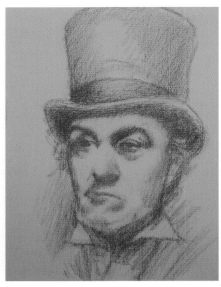

Step 1. For correct placement and size, I visualized the head under the hat. I gestured in the entire head (I did not stop at the edge of the hat). I then gestured the hat around the head. I placed the head to the right of center of the picture plane, so the sitter is looking into a larger negative space on the left.

Step 2. I indicated the proportions as simple shadows.

Step 3. By comparing the positive and negative shapes, I corrected the size, shape, and placement of shadows.

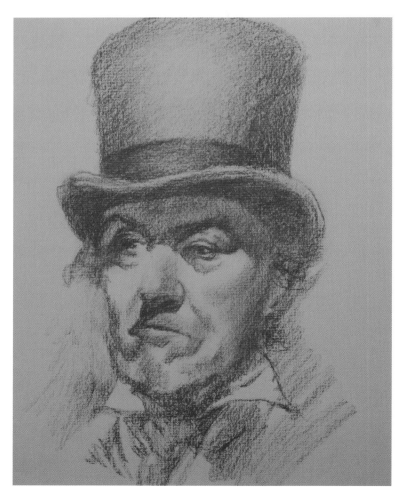

Step 4. I defined the shadows by hardening the cast-shadow edges and leaving the form-shadow edges soft.

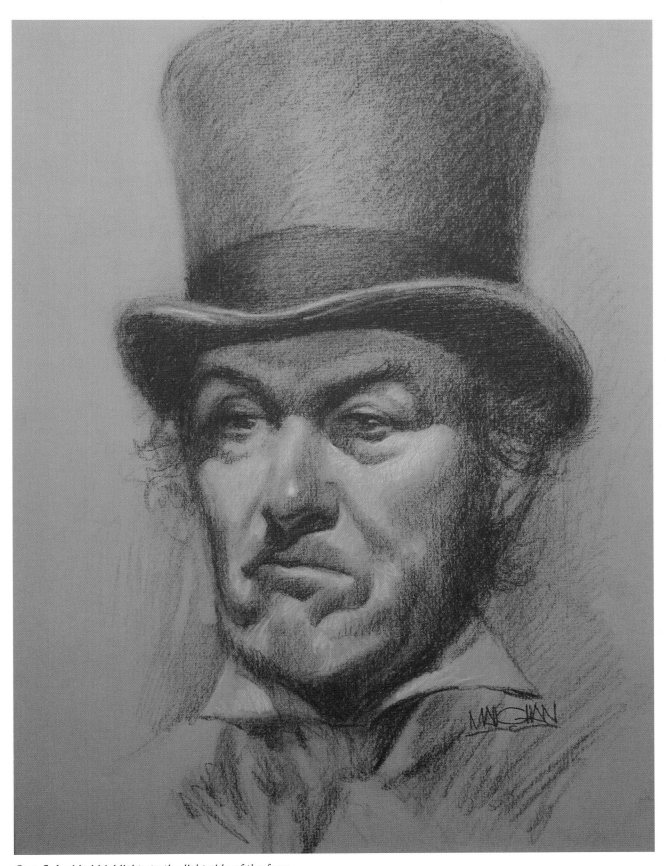

Step 5. I added highlights to the light side of the form.

GOING FORWARD

The principles I applied in the demonstrations are a repeat of everything you have learned thus far. Though the fundamentals of the principles are general—in that they apply to every head you will draw—they must not be applied blindly without regard for the uniqueness of each model, or even pose. For example, the characteristics of form- and cast-shadows are unchanging; but how they appear, and thus reveal facial structure, will differ not only from model to model, but also from pose to pose and from lighting condition to lighting condition.

PRACTICE IDEAS

Chiaroscuro is a living technique, not a hidden mystery available only to the old masters and their contemporaries. It is so simple, so obvious, yet it is often passed over for a more complicated solution. Students often ask me, "What do you see that I don't see? What do you know that I don't know?" And they will say, "There must be more to it than that; it couldn't be that simple!" Yet it is. The real struggle lies in breaking the old habit of drawing what you think you know rather than what you see. There is a tendency to become more set in our ways as we get older, and to be less susceptible to change. Instead, train yourself to be as teachable as a child, and allow the wonder of what you see to teach you.

You can practice your skills every day by drawing heads from magazines, using shadow shapes only to describe the features. Look for small photos in magazines. If you are drawing a head from a full-length photo, the head may be the size of a quarter or even a nickel. On such a small scale, the prominence of individual detail is diminished and the shadow shapes of the features are emphasized. This can be an advantage when first learning to draw shadow shapes and to see the head as masses of light and shadow. By working from small photos, you will see clearly and gain confidence in the fact that shadow shapes alone can and do describe likeness and expression. Turning a photo upside down will also help you to divorce your mind from the object and focus on the shadow shapes.

When you leave home, carry a small sketchbook so that you can draw heads wherever you are—on the bus, in a restaurant, or in a park. This can be done without being obvious. Make a rough drawing, capturing gesture in one glance. Using your knowledge of proportions, place the features in perspective. The position of the head, including the tilt, which you captured in the gesture, will guide any foreshortening that may be needed. With a second glance, note the shadow shape of each feature. If the model moves, look for another model in the same position and adjust the shadows accordingly. This is easier than you might think, since basic human gestures are universal. For example, if you have started to draw someone who is walking down a street, you will notice that, as they walk, most people look in the direction they are walking with their heads in very similar positions. You may be inspired by another individual with more interesting shadow shapes; simply correcting the shadow shapes can quickly change a woman into a bearded man. Remember that shadows alone describe the age, sex, and mood of each individual.

▶ *Through practice, and from drawing different heads, you will learn that there are no special drawing challenges since the principles of chiaroscuro apply to all models. There are just shadows unique to each feature. The trick to drawing well is to spend more time looking than drawing, and to take the time to duplicate shadow shapes accurately.*

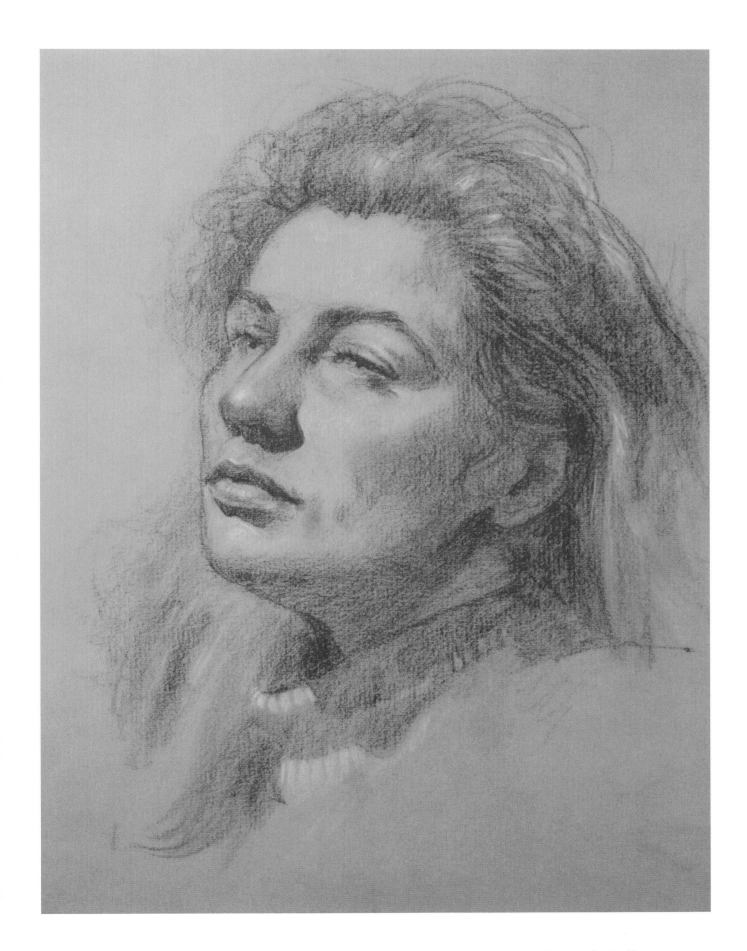

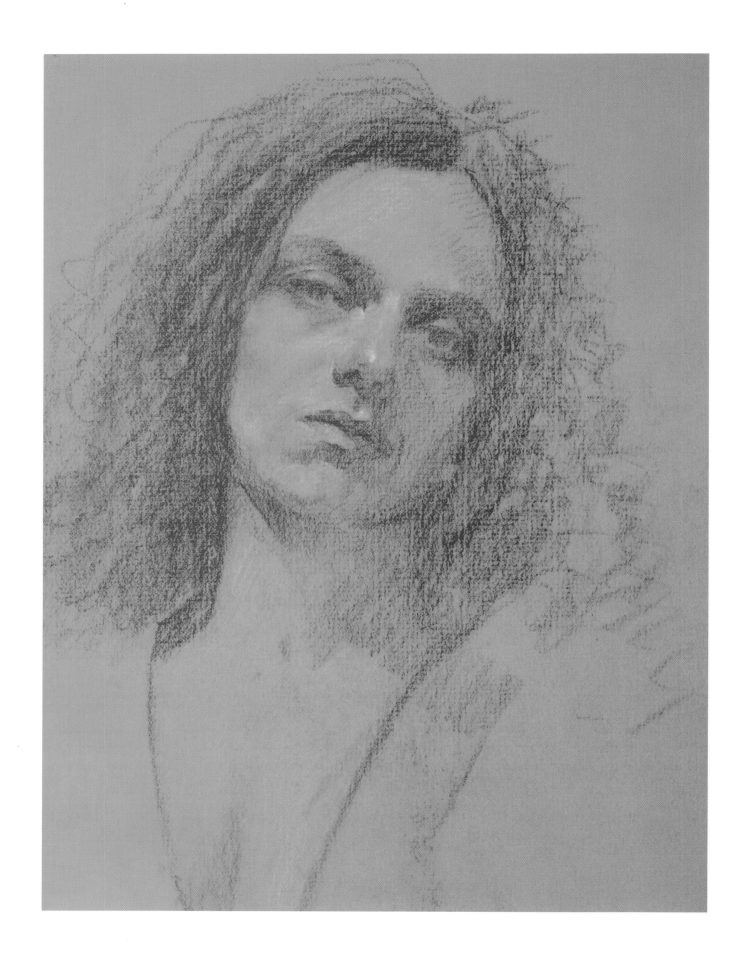

SELF-CRITIQUE

After you have completed a drawing, the best way to critique yourself is to assess, at each step, how well you understood and applied the principles in this book. How accurately you have followed them will determine your drawing's success. You must ask yourself, "Is the head well placed on the drawing support? Is the negative space around the head interesting, or is it equal on all sides? Did I capture the gesture of the pose, or did it turn out stiff? Are the light and shadow shapes on the head—that is, negative and positive shapes—correct in size, shape, and placement? Have I correctly defined the shadow edges as either soft or hard? Is the light centered? Are the proportions correct? Do the eyes and mouth converge at a distant vanishing point? Did I treat the hair like smoke? Did I achieve a likeness? Is there sensitivity to my drawing?"

For homework I sometimes ask students to work from photos they have taken of a model. I then ask them to pin the photo alongside their drawing. By comparing the photo with their drawing, they immediately see where they have gone wrong. If, for example, the eyes are too low or the shadows the wrong shape, it will be obvious. If a shadow shape is round in the photo and they have drawn it pointed, it will not look like the photo, which captured the likeness of the model. However, if they redraw the shadow shape so that it is round, it will look like the photo and achieve the same likeness. This method of criticism is an excellent self-teaching tool that you can carry out on your own. It will help you analyze your drawings and recognize where you still need work. I have found that the major difference between teachers and students is not in the ability to draw, but in the ability to see and compare shapes of value.

TAKING YOUR SKILLS TO THE NEXT LEVEL

Like anything new that must be learned, getting the proportions correct and in proper foreshortened perspective, recognizing when and why a shadow changes from a form-shadow to a cast-shadow and back again is difficult and can be frustrating. When you first learned to drive a car, it was difficult to clutch and apply the throttle or brake without stalling or racing the engine. But in time operating a vehicle smoothly could be done even while concentrating on other things, such as changing a CD.

Often it has been noted that the more a person does a particular task, the easier that task becomes. This is not because the task becomes any less difficult but because the person's ability to do more increases. After reading this book and putting its principles into repeated practice, in time you will become proficient in applying the principles of chiaroscuro, so much so that your understanding of and rendering of shadow shapes will be intuitive. Soon, if not already, you will see everything in terms of form- and cast-shadows. At that point you will have mastered the technique and will be freed to develop a refined sensitivity and personal style in your drawings.

There are multiple ways to develop nuance in your work. To begin, you might imagine that you have lost your sight, fallen in love with another, and desire to know his or her appearance. Most likely, you would very gently caress the contour of your lover's face with both hands. As your fingers gently rise and lower over the subtleties of contour variation, you are visualizing in your mind's eye what your fingers record. For the visual artist, art making parallels the above scenario but in reverse. As the eye gently caresses the subtleties of contour variation, so the hand caresses the drawing surface as gently and sensitively as if the hand were touching the actual face of the model. It is a symbiotic relationship.

◄ *When your hand and eye become effortlessly coordinated, all of your emotion, reverence, experience, sensitivity, and passion are transferred to your work.*

DRAWING FROM MULTIPLE SOURCES

COMBINING REFERENCES

Taking artistic license, the same set of skills you have cultivated to successfully create the illusion of three-dimensionality in conventional portraiture can also be used to create whimsical heads. Once you grasp that both form- and cast-shadows are the basis of realistic illusion, you can create convincing creatures by combining human and animal features from life, imagination, and photo references. You might decide to dress your model in a period costume (try using a photo reference if you don't have access to costumes), or you might create historical figures from your imagination. Exaggerating the expression or features of a model can create wonderful characterizations. Anything you can imagine is possible.

Besides just being enjoyable to do, the additional skill you will gain by combining two sources of reference (either life and photo, or two or more photos), and using your imagination to combine the references convincingly, also has professional applications. For example, as a professional illustrator, you may need to alter the features of your model to fit the character in the story or add a costume from a photo reference. You might be required to create an extraterrestrial creature for a science-fiction movie or a pirate for a children's book.

◀ This composite drawing of a female model and photo references of a monkey's mouth and elephant's ears creates an expressive, imaginary creature.

▶ This is a composite drawing of a female model and photo references of elephant ears, cat eyes, and beaver teeth. The nose was from my imagination, though the model had the piercing. As long as the model and the photo references are identically positioned to the light source, the light and shadow will be consistent and the composite convincing.

A DEMONSTRATION

The principles of chiaroscuro, and the very same five drawing steps applied in the previous chapter, are followed when combining references. The demonstration that follows is just one example of drawing from multiple sources. I suggest that you use it as a guide for combining a model with photo reference. It's a fun way to develop your ability to visualize, in your mind's eye, how light on form and the resulting shadows describe the connecting structure between two or more photo references. It will also build your confidence that anything real or imagined can appear dimensional if described in form- and cast-shadows. So get creative and have fun.

STEPS 1 & 2: GESTURE AND PROPORTION.

The first step when making a composite drawing is to find a reference that is exciting and dramatic, for example, a bear with its mouth wide open. It is important that the subject in your photo reference is lit from a single light source that clearly defines its structure through a combination of both form- and cast-shadows. If you use more than one photo reference, it is essential that the light and camera angles are identical in each one. For this demonstration I have selected two photos with the same angle of light (above and to my right) and the same camera angle (three-quarter view to my left). I then positioned the light on my live model to match the

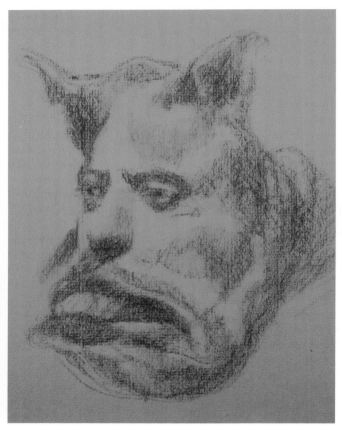

Steps 1 & 2. Three references—two photos and the live model—are combined in this single drawing. Nonetheless, the same order of drawing steps I followed in the last chapter— from gesture to detail—are practiced here. In this sitting I addressed the gesture and proportion. I made certain that the light and camera angles were identical in both photo references and then matched the lighting on the model, as well as my viewpoint, to that used in the photos.

Step 3. At this stage I developed the shadow shapes using my photo references and the model as a guide.

two photos and positioned myself to align with the three-quarter view in the references. I combined all three references in one gesture drawing and established the proportion of features as well. Since this drawing is a compilation of sources, it is necessary to determine how high the ears are to be placed above the eyes and how large the mouth will be at this stage.

STEP 3: SHADOW SHAPES. Beginning in the center of each shadow shape, and with the side of my pencil, I duplicated the structure of each feature by referring to the appropriate reference. I used my imagination to fill in the transitional structure between features.

STEP 4: EDGE CONTROL. Once I was convinced that the shadow shapes of each feature and the connective structure were correct in size, shape, and placement, I crisped the edges of all cast-shadows and blended all form-shadow edges.

STEP 5: DETAIL. Stepping away from my drawing, I analyzed the previous stage to access if and where additional contrast was needed, though I was careful not to overwork the drawing. Dark accents and highlights were added in this final stage.

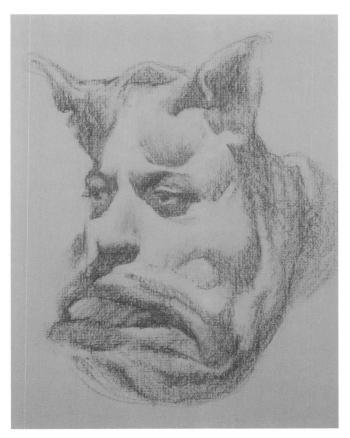

Step 4. After making any necessary adjustments to the size, shape, and placement of the shadow shapes, I addressed their edges.

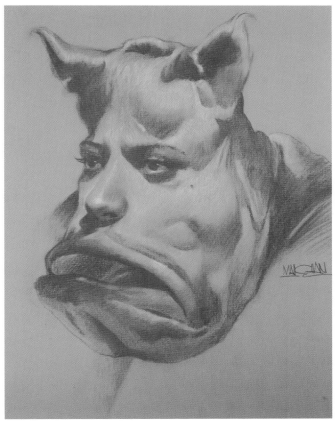

Step 5. So as not to overwork the drawing I stood back about ten feet from it. From this distance I was best able to determine how much detail was needed.

EXAMPLES OF COMPOSITE DRAWINGS

Since shadows change shape in relationship to the light source, a convincing reality can seldom be faked when using poorly matched sources. Think of a composite drawing as a record of truth. If one area of your drawing is faked, it is like a lie; when you lie, you eventually get caught. To be successful, it is necessary to arm yourself with a reference that describes structure consistently with your model or other references. Coordinating your sources before you begin drawing will make your work much easier. Otherwise you will struggle needlessly, and most likely fail to correct whatever is incongruous, whether it is the lighting or head position. If, for example, a costume reference is not lit with identical intensity of light and at the same angle of light as on the model, your marriage of the two sources will never be convincing.

For this composite drawing I began by using the model's basic gesture and head shape, and his eyes and mouth, which gave the drawing its partial-human look. The nose and ears were from different animal sources, but with identical lighting. The top horns and costume were created from my imagination.

I combined a female model with a photo reference of a pig's nose, mouth, and ears. The reference of the pig's nose, mouth, and ears would never have worked with the previous male pig head since its position was flopped.

You might also try combining a model with a photo reference of historical costumes, as in this drawing. Had I invented the costume, my drawing would not have looked authentic. By combining the model with an authentic photo reference, he appears to have actually modeled in the costume. As an illustrator, I learned early in my career that an illustration is never any better than your reference. One difference between a good illustrator and a great one is the extent to which the illustrator will go for the best reference.

Here, though I lengthened the model's hair and added a beard, a likeness is still maintained.

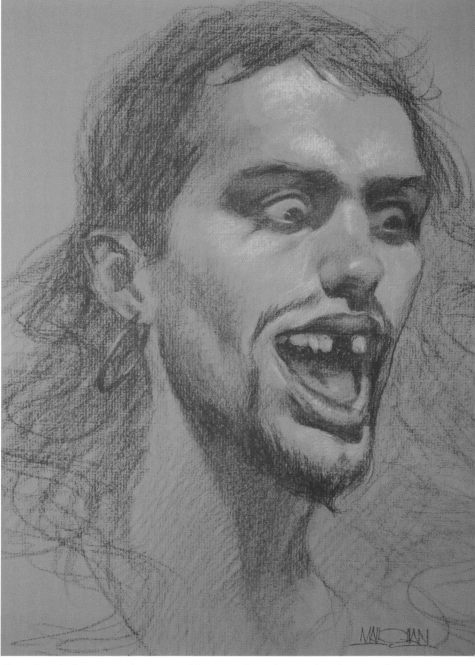

Even though the eyes and open, toothless mouth are invented and extremely exaggerated, a likeness can be seen because I used the model's shadow shapes to describe the ear, nose, eyebrows, orbicular cavities, and upper lip.

On Source Material

When searching for source material, look for photos with clear form- and cast-shadows. If there are no shadows, there is no form structure.

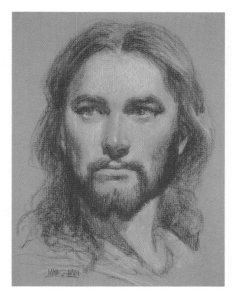

This portrait of Jesus Christ was done entirely from photo references and from my imagination. The eyes are from one source, the nose and mouth from another. The hair and beard are from my imagination. Together they create my interpretation of what Christ might have looked like. Without reference he would not have looked real.

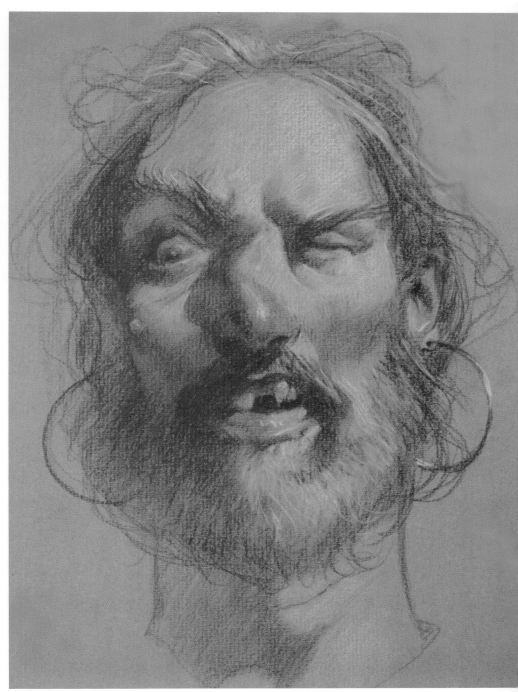

This drawing of a pirate started with a model, though I've taken many liberties. Guided only by my imagination, I've broken his nose, closed one eye, given him bad teeth, and added an earring. Despite these changes, the drawing is convincing because it is rendered in soft form-shadows and hard cast-shadows.

WORKING
WITH COLOR

From Drawing to Painting

When drawing the head, you have been holding your CarbOthello pencils as you would a brush. And you have applied broad strokes of value as you would in paint. By the end of this chapter on working with color, you will understand that drawing is identical to painting. Those who say otherwise are looking at drawings that have been drawn in line. Whether drawing or painting, you are rendering form in value, not line. Having learned to draw the head in value, painting is a logical progression.

Using the principles of chiaroscuro, the Renaissance masters began their paintings with full-value monochromatic underpaintings made with an opaque, white paint and a transparent color called bitumen (asphalt). Though like drawing in terms of their monochrome palette, old-master under*paintings* qualified as such since the entire surface of the support was covered with pigment, and because forms were rendered in full value. In contrast, old-master drawings were usually not full-value renderings but instead quick sketches done in an abbreviated form. This is why the *Mona Lisa* (see page 14), rather than one of Leonardo da Vinci's drawings, was used to introduce chiaroscuro at the beginning of this book.

This painting was developed with an underpainting of brown madder, which creates warm shadows. Brown madder is a more stable color than the fugitive bitumen that the old masters used. When I begin an oil painting, I "draw" with a brush in oil following the same method taught in this book. I began this portrait with an underpainting and completed it using the glazing and scumbling technique.

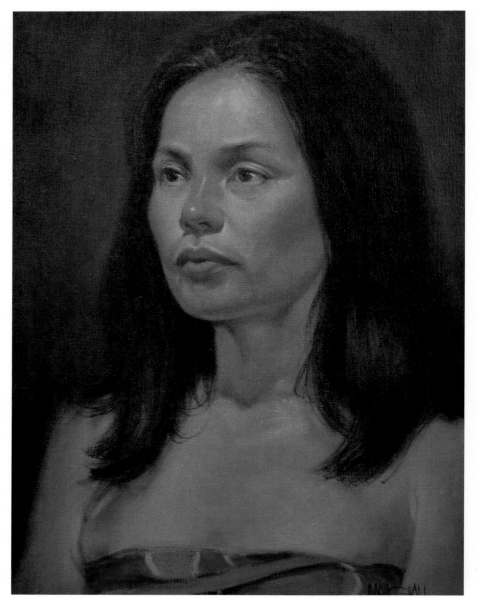

Leonardo began the *Mona Lisa* with a full-value underpainting that established form along with the value pattern, using the same principles you have learned to draw the head. Once dried, color could be added to the surface after a dark, transparent color was applied over the underpainting. This step is known as glazing. The surface was physically built up by applying a dry, stiff, lighter and opaque color over the darker, dried color. This step is known as scumbling, or dry brushing. To scumble, a brush with very little medium (nearly dry) is dragged across the glazed surface. The *Mona Lisa* is a beautiful example of this technique. In essence the only difference between the *Mona Lisa* and the CarbOthello pencil drawings in this book is the addition of color, through the steps of glazing and scumbling.

As you work with color, you will continue to use all that you have learned up to this point. As the old-master painters did, you will simply add the element of color, literally as another layer, to your rendering of the masses of light and shadow. Though the choices of color media are vast, in this chapter I will focus on pastel painting. Having grown accustomed to using the pastel pencil to draw the head, working with pastel sticks to create paintings is a natural development. Before introducing you to the technique of pastel painting, however, it is necessary to cover a few basic points about how colors behave.

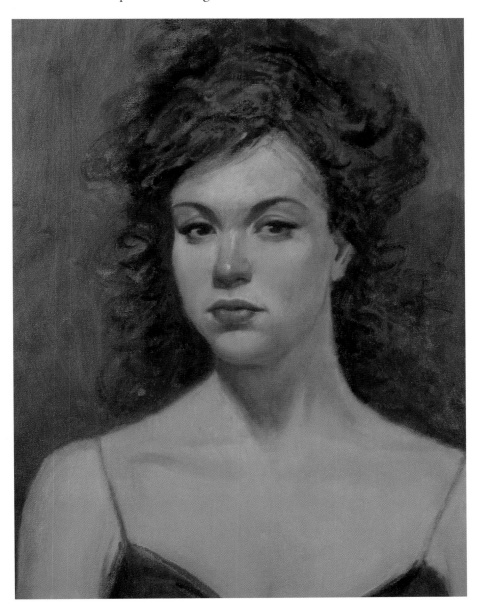

This painting was developed with an underpainting of blue, which created cool shadows. It was finished with a direct application of oil paint called "ala prima" in which thick opaque touches of color are applied over a thin underpainting.

THE COLOR "WHEEL"

The color theory discussed in this book relates to all media and genres of art. The principles are based on the harmonious relationship of one color to another, whether optically mixed with pastel pigment or physically mixed on a canvas with oil or acrylic. Along with learning to create a harmonious palette, you will learn how to control the intensity of color and to approximate as closely as possible the quality of light-filled color.

Most color theories begin with the three primary colors—red, yellow, and blue. The primaries cannot be made by mixing other colors together. They must be purchased from a manufacturer. Each primary is unrelated: There is no red in the color yellow, no yellow in the color blue, no blue in the color red. Combining two primaries will create the secondary colors—orange, violet, and green. The six tertiary colors are mixtures of a primary and a secondary color. They are yellow-orange, red-orange, red-violet, blue-violet, blue-green, and yellow-green.

All of these colors—the primaries, secondaries, and tertiaries—exist in relationship to one another on a diagram known as a color wheel, though in fact the colors form a triangle rather than a wheel. The primaries are located equidistant from one another, with the secondaries and tertiaries between them.

It was Isaac Newton who, in the early eighteenth century, first used the color "wheel" to set down the colors of the spectrum, or light. Newton had discovered that when a ray of white light is passed through a glass prism, it is refracted, or dispersed, as red, orange, yellow, green, blue, indigo, and violet. These are known as prismatic colors. When two of these colors are mixed together, the resulting color is lighter; and if all are mixed together, the result is white light.

However, since you are mixing pigments and not pure light, your results are just the opposite. If all three primaries are mixed together, the result is a middle-value gray, a color known as "mud." If you mix from the three primaries, the resulting secondary and tertiary colors will be less intense than the primary colors. However, through experience you will learn how to manipulate pigment to most effectively imitate the appearance of light-filled color.

COMPLEMENTARY COLORS

A complementary color is that color situated directly across from another color on the color wheel, or triangle. Complementary pairs always consist of a primary and a secondary color, or two tertiary colors. Directly across the wheel from primary red is secondary green, from primary blue is secondary orange, and from primary yellow is secondary violet. Directly across the wheel from each tertiary is its complementary tertiary color. Red-violet is across from yellow-green, blue-violet is across from yellow-orange, and red-orange is across from blue-green. When physically mixed together, complementary colors neutralize each other—thus a complementary can be used to mute another color, or to create beautiful grays. However, when placed side by side, they activate and intensify each other, enliven a composition, and create a center of interest.

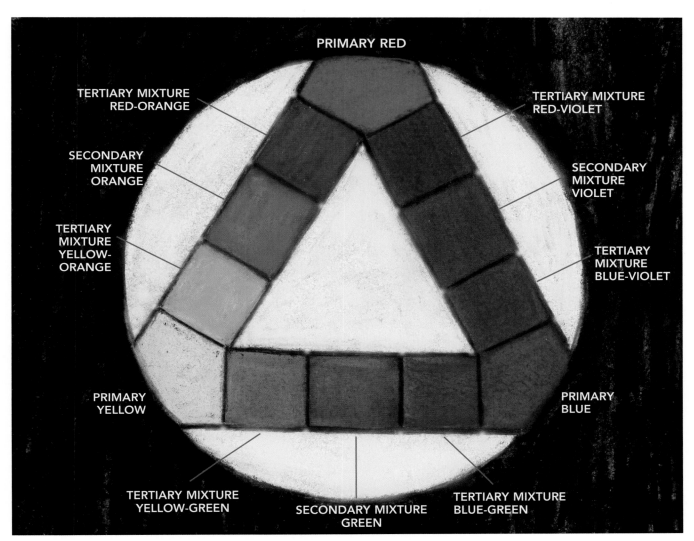

PRIMARY RED

TERTIARY MIXTURE
RED-ORANGE

TERTIARY MIXTURE
RED-VIOLET

SECONDARY
MIXTURE
ORANGE

SECONDARY
MIXTURE
VIOLET

TERTIARY
MIXTURE
YELLOW-
ORANGE

TERTIARY
MIXTURE
BLUE-VIOLET

PRIMARY
YELLOW

PRIMARY
BLUE

TERTIARY MIXTURE
YELLOW-GREEN

SECONDARY MIXTURE
GREEN

TERTIARY MIXTURE
BLUE-GREEN

*When mixing from the three primary colors, the secondary and tertiary mixtures are
less intense than the primaries, creating a triangle rather than a circle of equal
intensity.*

COLOR INTENSITY

Intensity refers to how bright or muted a color appears. It is sometimes called its saturation. A tint is a lighter version of the same color; a shade is a darker version of the same color. White is added to create a tint, and black to create a shade. Intense, fully saturated, and brilliant color is unadulterated by the addition of other pigments. Intense colors are located on the perimeter of the color wheel. Used thoughtfully, a very intense color surrounded by colors of lesser intensity can be exciting. However, the use of too many fully saturated colors in a painting can be jarring. Learning how to control the intensity of a color—both to brighten or mute it—will help you create the results you want.

Secondary colors are considered straight-line mixtures between two primaries. Straight-line mixtures give you only the color that the mixture produces. You cannot make the color more intense by adding more of the primary color. But a secondary color can be altered by adding white to create a tint and black to create a shade. Or it can be muted by mixing it with its complementary color. We know, for example, that yellow and blue make green. Adding more blue or yellow will not make the resulting color a more intense green.

MIXING FROM THE TERTIARY COLORS

With the invention of tube paints as well as soft pastel "à l'Ecu" by Gustave Sennelier in France near the end of the nineteenth century, it became possible to obtain pure tertiary colors in tube and pastel form. Previously it was only possible to obtain tertiaries from primary and secondary mixtures. For several reasons this was a great advantage. Using the six tertiary colors (two reds, two yellows, and two blues) rather than the primaries (one red, one yellow, and one blue) will give you a greater range of colors and produce the closest approximation of light-filled color. Painting with tertiaries will also insure harmony within your composition, since all colors are already mixtures of one another. Not only that, since the tertiary mixtures available in stick pastel and tube paints are produced from selected chemical compounds, they produce the most intense color possible, from which equally intense secondary colors can be mixed. For example, in the previous discussion on color intensity, you learned that adding more blue or yellow will not create a more intense green. However, if you start by mixing yellow-green and blue-green, two tertiaries, the resulting green created is much richer.

On Intensity

Be aware of the true nature of the colors you purchase and use. For example, cadmium yellow medium is not simply a yellow, but a yellow-orange and therefore a tertiary color. If it were mixed with ultramarine, a blue-violet (its complement and also a tertiary), the result would not be green but instead a color near the center of the color wheel commonly referred to as "mud."

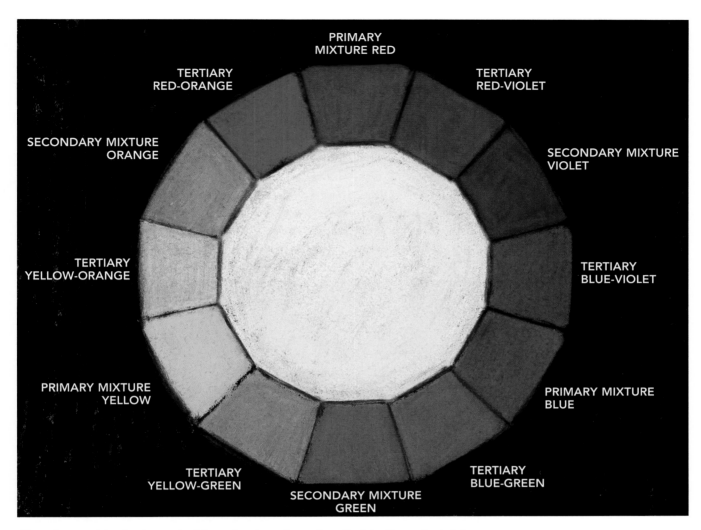

The colors on this wheel are mixed from the six tertiary colors. Each tertiary color is intense when purchased in tube form, since it is not a mixture of a primary and secondary color. Working in reverse, it is possible to mix secondary and primary colors from the six tertiary colors. For example, the tertiaries red-orange and red-violet are mixed to create primary red. The tertiaries red-orange and yellow-orange are mixed to create secondary orange.

On Light–filled Color

Monet's paintings are often described as being light filled. He, and the other Impressionists, made use of the tertiary colors then available in tubes. For example, Monet used two tertiaries to describe foliage. He used yellow-green to describe the local color on the underside of leaves. He used blue-green to describe the top, shiny side of the leaf that reflects the blue sky, creating a darker and bluer green.

COLOR TEMPERATURE

The temperature of colors is a complex phenomenon that is modified by many factors: lighting, the color itself, and the reaction with neighboring colors. All colors, with the exception of red and yellow, have an intrinsic temperature: for example, orange is warm and blue is cool. Red, however, is located between the tertiary red-orange, which is warm, and the tertiary red-violet, which is cool. Therefore red is neither warm nor cool. The same is true of yellow; it is also located between a warm and a cool tertiary color. How warm or cool a color appears, however, is greatly affected by the temperature of the light source illuminating the color and the temperature of adjacent colors. For example, an object viewed indoors under a warm tungsten light will look drastically different than when viewed out-of-doors in cool daylight. It is generally accepted that warm lights produce cool shadows and cool lights produce warm shadows. Thus once you've identified the temperature of the light source, you will know how to treat the light and dark masses.

I illuminated this model with a cool natural light that has created dark, warm shadows. Although difficult to see under layers of flesh, there is a layer of blue around the eyes, mouth, and nose. When you look closely, you will see that skin has a translucent quality and that the veins under the surface appear blue. This is most apparent on light-complexioned models in natural lighting.

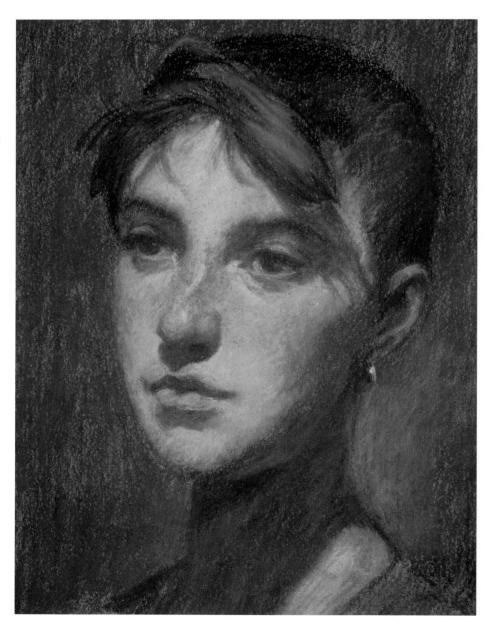

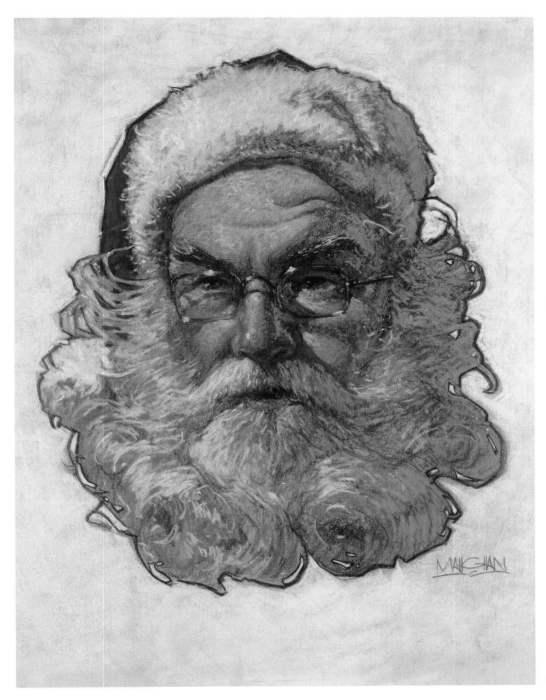

I rendered Santa in a warm artificial light that created cool shadows. A solid dark outline follows the outside contour of Santa's hat and beard. I added the line as a graphic, decorative element to give the portrait an illustrative or commercial quality. Note, however, that the features have not been outlined but have been rendered in value.

On the Temperature of Light

Daylight is cool; however, at sunset or sunrise natural light takes on an warm, orange coloration that produces cool shadows. Common indoor lighting, such as tungsten bulbs, is warm. However, fluorescent lights are cool and therefore produce warm shadows.

COLOR RELATIONSHIPS

The tertiary colors on either side of a primary around the color wheel are thought to be warm on one side and cool on the other. For example, yellow-orange is warm and yellow-green is cool; red-orange is warm and red-violet is cool. Everyone agrees on the yellow and red tertiary, but which blue tertiary is warm and which is cool? Some might guess that blue-violet is warm, yet others guess blue-green. Actually neither is warm, and can never be in a composition that contains their unmuted complements yellow-orange and red-orange. Since yellow-orange and red-orange are warm (containing orange) and blue-green and blue-violet are cool (containing blue), blue-green and blue-violet could become warmer if they are muted with vast amounts of yellow-orange and red-orange. But they would still look cool next to yellow-orange or red-orange.

If yellow-green is cool, then blue-green is cooler. If red-violet is cool, then blue-violet is cooler. Therefore, if blue-green and blue-violet are both cooler, then blue is the coldest color on your palette. If red-orange and yellow-orange are both warm, then orange is the warmest color on your palette. Thus, adding blue will cool any color, and adding orange will warm any color.

WARM ADVANCES; COOL RECEDES

Temperature also refers to an optical effect in which a color, depending on its warmth or coolness, appears to advance or recede. Warm colors advance and cool colors recede. By now you know that in order to create the illusion that an illuminated object is round, its edges must appear to turn away, or recede, from the viewer. This is accomplished by darkening the edges of the form, which you learned to do earlier in the book by manipulating the light source and applying value (see pages 37–42). With the knowledge that warm colors advance and cool colors recede, you can now also use the temperature of colors to help "turn" the edge of a form.

Color temperatures of the six tertiary colors, the primary blue, and its complement, orange. Blue will cool any color, and orange will warm any color.

Color Charm

Warm and cool temperature mixes of the same color will appear to advance and recede simultaneously if they are placed next to one another. This naturally occurring phenomenon is known as color charm, and can be used to great effect in a composition. For example, when yellow-orange, a warm yellow that advances, is placed next to yellow-green, a cool yellow that recedes, the surface becomes active and more beautiful than if only pure yellow were used.

FAMILY OF COLORS

In painting, harmony refers to visual unity. The best way to achieve harmony is to use analogous colors—that is, those that are related and are close to one another on the color wheel. All six tertiary colors exist in each analogous color scheme and thus will always be in perfect harmony. Since each primary is unrelated, each is out of harmony with the other. If used in a pure state, the three primaries will fight for attention in the same composition. Thus a fundamental rule in color theory is, Never use more than one primary in a composition. A "mother" primary color in an analogous scheme allows you to follow this fundamental rule with a variety of harmonious colors to choose from on your palette. The following story illustrates how a family of analogous colors is born.

This is the story of a mother and her offspring. Primary red plays the role of the mother, though it could be played by either of the other two primaries as well, to the same effect. The story starts when the mother meets, falls in love with, and marries pure blue.

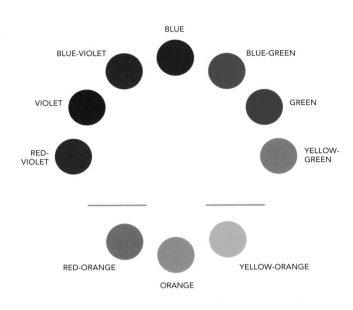

The blue-analogous palette with a split-orange complement

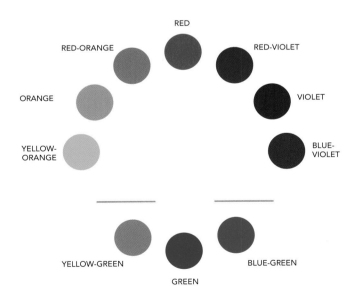

The red-analogous palette with a split-green complement

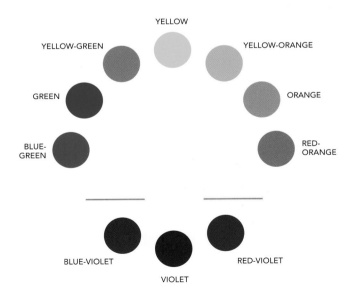

The yellow-analogous palette with a split-violet complement

The first child looks more like Mom than Dad. This child is named red-violet. The second child looks as much like Dad as Mom. Its name is violet. Their third child looks more like Dad, but you can still see some of the mother. Its name is blue-violet.

The mother color soon discovers that she and her husband always fight in the same composition. She realizes that she can't change him; he is always blue. The marriage is dissolved, and the mother color keeps the children.

She then meets pure yellow. He is a great color. They fall in love and marry. Again, the first child looks more like the mother. This child's name is red-orange. The second child is named orange, since it looks equally like Mom and Dad; and the third, who looks more like Dad, is named yellow-orange. The mother color once again decides that she can't live with her second husband. She realizes that she cannot exist in the same composition with either of the two primaries without fighting.

The three children from each of her marriages have something in common. Half-brothers and -sisters, they share the same mother, the color red. They are analogous reds in perfect harmony with one another. Yet the mother, being the only pure color, is reserved for a special place, the center of interest. However, paintings made using one family of colors can look oppressive and monotonous. To make all the red-analogous colors *look* red, a composition needs the complementary color of the mother, which is green. This is especially true of the yellow-orange and blue-violet, since they contain the least amount of their mother. In this example it will be much more visually interesting and pleasing to use the green tertiaries—yellow-green and blue-green—rather than just pure green. Known as split-complementaries, these more complex greens automatically create a sophisticated and relational palette. For example, yellow-green is closer to yellow-orange, and orange and red-orange have yellow in common. Blue-green is near to blue-violet, and violet and red-violet all have varying

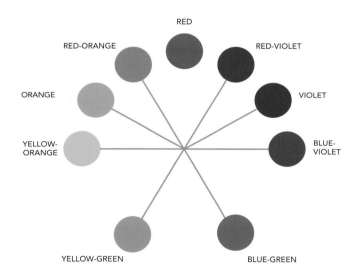

The split-complement is used to mute the analogous colors. In the red color scheme, the yellow in the yellow-green is the complement to the violet in red-violet, violet, and blue-violet. The blue in blue-green is the complement to the orange in red-orange, orange, and yellow-orange.

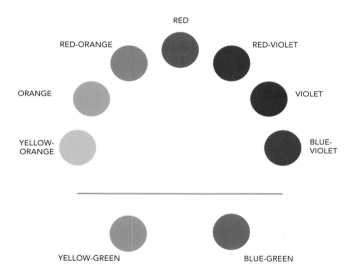

One way to divide light and shadow when working in an analogous color scheme is based on a contrast of color. In this example the red-analogous colors make up the illuminated side and the complementary greens the shadow side.

quantities of blue, which appear in harmony and are complementary. Also, yellow-green placed next to blue-green is simply more exciting and beautiful than if only pure green were used. Your choice of split-complementary colors will be based on whether you desire harmony or contrast in a given area.

If the role of the mother color were played by yellow or blue, each analogous color scheme would contain all six tertiary colors. Absent from each color scheme would be the two unwanted primaries, at least in their pure states. They are present, however, in a mixed state. For example, in a blue-analogous color scheme, there would be two choices of yellow (yellow-orange and yellow-green) as well as two choices of red (red-orange and red-violet).

An analogous color composition can be divided in two ways. A composition can be divided based on the contrast of color. It would contain blue-violet, violet, red-violet, red-orange, orange, and yellow-orange on the light side with the split-complementaries yellow-green and blue-green as shadows. The second method is to divide the composition based on the contrast of temperature. It would contain red-violet, violet, and blue-violet plus the blue-green complement, producing cold shadows. Red-orange, orange, and yellow-orange plus the yellow-green complement with added orange create a warm olive green, which produces warm lights.

EXPRESSIVE COLOR

Analogous color schemes need not only describe reality. In the next two portraits (see pages 146 and 147) I've experimented with my use of analogous colors for expressive purposes. (In Western painting this approach to color was first adopted by Vincent van Gogh in the nineteenth century.) Just remember, if the values are correct, meaning light and shadow masses, as well as value pattern, the colors need not describe local color, so long as your color choices are in harmony.

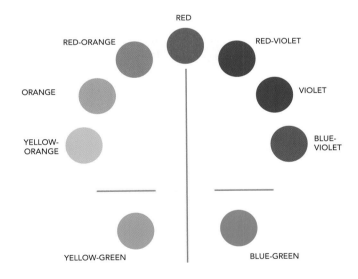

Another way to divide light and shadow when working in an analogous color scheme is based on a contrast of temperature. In this example, the red-analogous colors are used. Since they are divided down the middle, producing both cool and warm reds, the red-analogous colors allow you to divide light and shadow by temperature while adding the complement in both light and shadow.

On Harmony

In an effort to achieve rich color, students often resort to using the primaries in their pure state because they are the only intense colors on their palette. This, however, will destroy any mood or harmony within the painting.

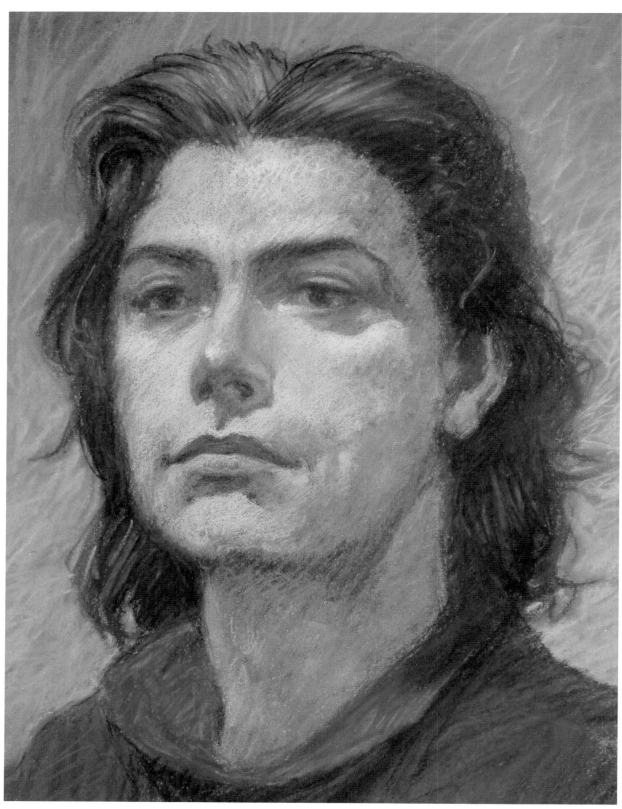

In this portrait I used a red-analogous and split-green complementary color scheme. Orange lips, red-violet shirt, with dark blue-violet coat and hair make up the reds. Yellow-green, blue-green, and olive-green (yellow-green plus orange) make up the flesh tones. The background is a blue-green.

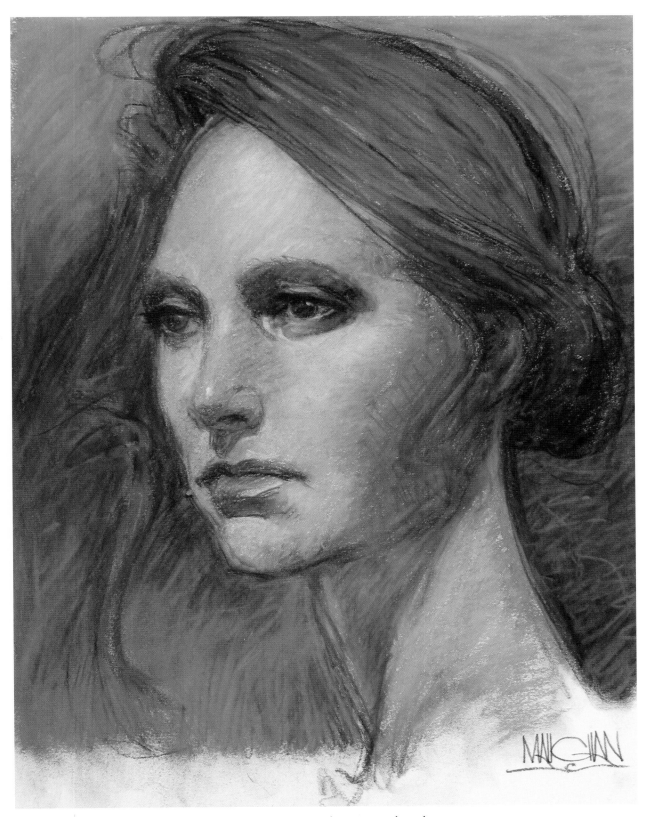

In this portrait I used a blue-analogous and split-orange complementary color scheme. Blue-violet and red-violet make up the face with touches of blue- and yellow-greens for the background. Red- and yellow-oranges make up the hair.

PASTEL PAINTING

The term *pastel* is derived from the French word *pastische*, because the pure, powered pigment is ground into a paste, with a small amount of gum binder, and then rolled into a stick. The term does not refer to "pale" colors as it does in the cosmetics and fashion industries. The colors available in the pastel palette are equal to any paint medium.

Distinct from other painting media, pastels are available in a ready-made range of tints and shades for each color. This is because the pigment cannot be mixed on a separate palette. The mixing can only occur on the surface of the support itself by layering the pigment—thus creating an *optical* color mixture—or by smearing it with a finger or paper stumps. When pastel pigment is layered but not smeared, pastel naturally has what is known as a "brittle" quality. If this look is not desired, smearing the pigment will lessen its dry or flaky appearance.

The luminosity of pastel is created by air molecules suspended in each layer of pigment. If the pastel is sprayed with fixative, the air molecules collapse and the pastel darkens. For this reason pastelists generally do not spray a final coat of fixative over finished works. Spray fixative is, however, used to build up the pastel in a process similar to glazing and scumbling in oil painting. Pastel pigment will appear darker if applied over a light surface. To achieve a scumbled look pastel must be dragged over a darkened surface. As you learned at the beginning of this chapter, glazing is the act of applying a dark, transparent color over a dried, lighter color. Spray fixative has the same effect on pastel. If applied over lighter colors, the colors will darken. If enough fixative is applied, the lighter colors will darken altogether, bringing you back to a previous step, or application of pastel pigment.

On Pastel Painting

Pastel paintings, though created with a dry medium, are considered paintings if the entire support is covered with pastel. The drawings in the book made with the CarbOthello pencils, though also made with pastel pigment, are considered drawings because the paper support is visible.

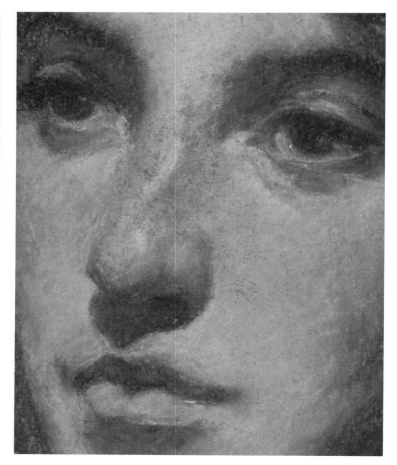

Detail of finished pastel painting

THE MATERIALS

For pastel paintings I use **soft pastels** in stick form, which allows greater coverage than pastel pencils. Any brand of pastel is fine, though I prefer Sennelier's extra-soft consistency and color selection. The tints and shades of a pastel color are indicated by a number. The highest number denotes the darkest shade and the lowest number the lightest tint. White is added to create the tints, and black is added for the shades. In general if you want a pastel in its purest form, look for a color with a middle-range number. How big of a starter set should you get? Ultimately it depends on your budget. But nothing is more frustrating than not having the right colors. Several manufacturers, including Sennelier, sell portrait sets.

What You Will Need

- ☐ Soft pastels, preferably Sennelier's extra-soft pastel "à l'Ecu"

- ☐ 6B or extrasoft charcoal pencil

- ☐ Rives BFK paper, white

- ☐ Spray fixative, preferably Grumbacher's Myston Workable Fixative

- ☐ Chamois

- ☐ Paper stumps (optional)

I have arranged the pastels I use in two drawers of a shallow file cabinet, where I keep
watercolor, pastel, gouache, oil, and prismacolor pencils. It is located to the right of my easel.
The drawers are positioned far enough apart to access both layers of pastels simultaneously.

Charcoal pencils come in wood and paper. Either is fine to use, though the paper pencils are easier to sharpen than the wood pencils. The paper pencils are sharpened by pulling the paper away in strips. This reveals the charcoal, which is then sanded to a point. The wood pencils are sharpened with an X-Acto knife, the same way the CarbOthello pencils are sharpened, and then sanded to a point.

Rives BFK is a 100 percent cotton paper that has enough tooth to hold several layers of pastel. Both sides of the paper surface are the same, so you can use the reverse side if you have a false start. The paper is heavy enough to allow minimal buckling when framed. The paper is pH balanced and acid free, so it will not yellow or become brittle with age. I only use white paper, since I prefer to work on a middle-value gray created from pastel. A colored paper would dictate my color choices. Rives BFK comes in full and half sheets. A half sheet is sufficient for a drawing of head and shoulders.

For a **spray propellant** I prefer Grumbacher's Myston Workable Fixative. The propellant disseminates before making contact with the pastel, causing only the resinous particles to adhere to the surface, which leaves the surface workable. The more fixative that is applied, the darker the pastel will become. It should be sprayed eighteen inches from the drawing surface. When applying the spray fix, try not to inhale the vapors. To be extra careful wear a mask when using spray fixative.

Chamois is traditionally used to tone the surface of drawing paper in charcoal drawings. Once the chamois is saturated with charcoal dust it will add tone rather than absorb it.

You can use your finger to smear the pastel pigment on the surface, though I recommend using **paper stumps** for this purpose. Like spray fixative, it is not healthy to inhale or ingest pastel pigment. Therefore, if you do use your finger to smear the pastel, be sure to wash your hands before eating. (On a personal note, I avoid smearing pastel since I prefer its naturally brittle quality.) Also, do not blow pastel dust from the surface of your painting since particles of pastel pigment in the air may be inhaled.

CARING FOR YOUR PASTEL

If placed on an archival support, and properly framed, pastel is the most stable of all media. To protect its surface, a finished work should be placed behind glass as soon as possible. A liner attached to the frame is needed to separate the glass from the pastel. This will prevent pastel dust from adhering to the glass caused by static electricity and moisture damage from condensation. Since pastel is pure pigment, it will not fade, crack, or discolor over time. You can return to the work years later and continue to apply pastel over previous layers to maintain original freshness. However, if the ground or support contains acid, the work will yellow when exposed to light.

APPLYING THE CHARCOAL PENCIL

Use the charcoal pencil to establish the first four of the same five drawing steps you have followed when drawing the head with the CarbOthello pencils—that is, gesture, proportions, shadow shapes, and edge control. The details of the portrait—the fifth and final step of the pencil drawings—will be rendered in color with soft pastel. When drawing, the charcoal pencil is held in the same position as the CarbOthello pencil. If you make a mistake, you can rub it down with the chamois, which produces a middle value. Then continue drawing over the middle value. Be sure to apply the charcoal darkly. If you apply the charcoal too lightly, your drawing will be covered up during the next step when the tone is applied with the black soft pastel. When you have completed the charcoal drawing, spray fix the surface. Make sure the drawing is properly fixed by rubbing your finger across an unimportant section of the drawing. If any of the charcoal comes off on your finger, apply more fixative.

APPLYING THE TONE

After the charcoal drawing is complete and fixed, you will create a middle-value tone by sliding a stick of black pastel across the surface. You will then force the pastel into the drawing surface by rubbing it with a chamois

On Spray Fixative

Pastel pigment cannot be wiped off or removed with an eraser. However, if the pastel becomes "pasty" (too light in value), it can be darkened through spray fixing. If a large quantity of the liquid propellant in fixative is allowed to saturate the surface, eventually it will dissolve pastel pigment.

in a circular motion. Then fix this layer of tone. The charcoal drawing and layer of tone form the foundation for the color that you apply next. Everything you apply following these first two steps will be lighter. If you make a mistake, you can always spray fix to darken the surface and return it to these first two steps.

APPLYING THE PASTEL

To create a pastel painting you will stroke the pastel sticks across the surface. This will cause the dry pigment to be embedded in the tooth of the paper. Apply the pastel in a loose scribble, allowing the darker middle value to remain visible between strokes. Do not fill the surface with flat areas of color. This will not only expend the pastel but will also saturate the fibers of the support and prohibit subsequent layers. Avoid making

your strokes of color at a repetitive diagonal. Right-handed artists unconsciously make marks from the upper right to the lower left. Try to consciously follow the form or describe the form with your strokes.

Begin applying color using a middle-value flesh color on the illuminated side of your model. Most likely no single color, or pigment, will exactly match the flesh color on the light side of the form. Instead, you will arrive at that exact color through an optical mixture of several layers of different colors. Colors appear to blend at a distance when they are applied side by side or layered loosely on top of one another. The key is, Don't go too light too soon. After you've worked up the light side, layer the shadow side, beginning with the darkest color in the shadow. Be careful to maintain a strong value separation between light and shadow.

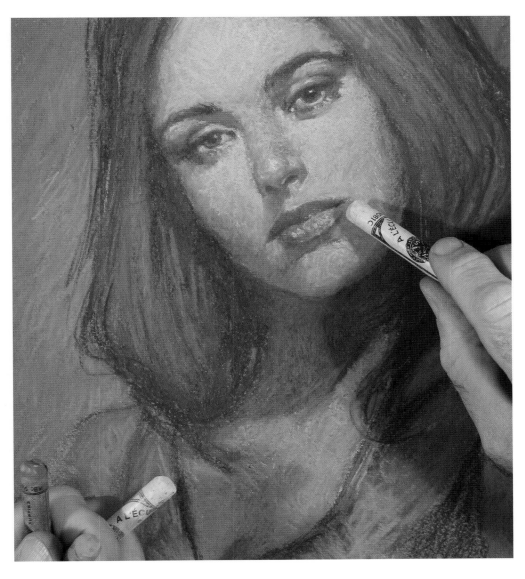

Don't fill the paper surface with flat areas of color. Not only will you use up the pastel pigment far too quickly, but the paper fibers will become saturated and will not permit subsequent layers.

PAINTING THE BACKGROUND

The background relates the sitter to the environment. A simple rule of thumb is that the background value should always be darker against the light side of the sitter's face and lighter in value against the shadow side, though the difference in value should be subtle. This creates the illusion of atmosphere so the portrait does not appear painted on the background surface. In traditional portraiture the background is often a muted green, sometimes blue, or less often brown. A green background will complement a robust complexion and make the grays in the flesh appear richer. Whichever color you choose, it should appear somewhere on the flesh. Otherwise the head will look like a cutout pasted on an unrelated environment. The background color must appear in either the halftone or reflected light on the form, though it will not always be equivalent in value to the halftone or reflected light (remember too that the halftone and reflected light are two different values). Most often the background color will be adjusted in value.

This sitter is also illuminated by a cool natural light. I have rendered this pastel much looser than the previous one, without sacrificing accuracy of proportion, shadow shapes, or edge control. To improve the composition I placed the model slightly to the right of dead center. With a slight tilt to the head and severe cropping of the hat and shoulders, I have divided the background into a variety of shape configurations. Successful use of the negative space around the model adds interest and is fundamental to a strong composition.

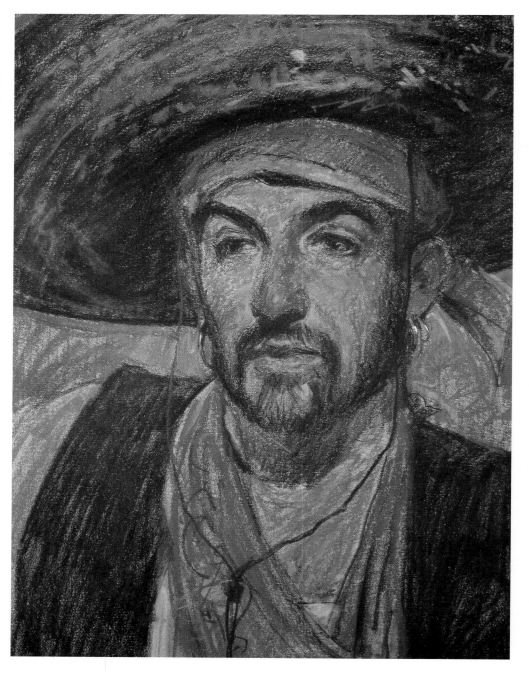

PASTEL DEMONSTRATION ONE

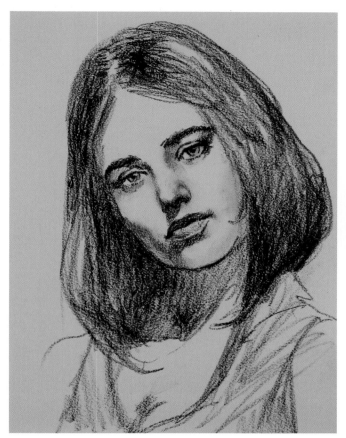

Step 1. The shadow shapes and dark, local value were rendered with a charcoal pencil.

Step 2. I slid a stick of black pastel across the paper surface to cover it completely, then rubbed the pastel into the paper with a chamois.

STEP 1. I established the shadow shapes, as well as dark, local value with my charcoal pencil, following the usual sequence of gesture, proportion, shadow shapes, and edge control. Later I will apply the details with soft pastel. Having established these steps, I then spray fixed the drawing.

STEP 2. To ensure a complete coverage of the paper surface—thus qualifying the work as a painting rather than a drawing—I applied a middle-value tone by sliding a stick of black pastel across the surface. Next I forced the pastel into the textured surface by rubbing it with a chamois in a circular motion. I then spray fixed this layer.

STEP 3. I began to apply color by layering middle-value colors on the light side of the model's head. I loosely applied each color with a light pressure, being careful not to saturate the surface with any single color. After I

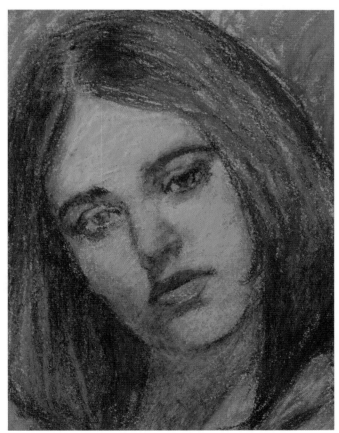

Step 3. To begin applying color I layered the middle-value colors on the model's light side. I then layered the shadow side, starting with the darkest color in the shadow.

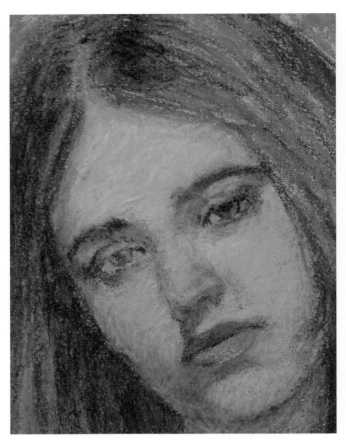

Step 4. I used red to blend between the light and dark sides of the model's head and to turn the form, creating an illusion of roundness.

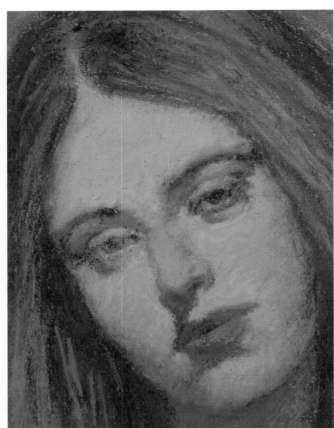

Step 5. At this stage I added color accents to the face of the model.

worked up the light side, I then layered the shadow side by beginning with the darkest color in the shadow, being careful to maintain a strong value separation between light and shadow.

STEP 4. The brittle quality of pastel pigment disappears when it is smeared. Since red is neither warm nor cool, it is an excellent middle value between light and shadow. I used it to blend the warm, light side with the cool, dark side. Had I physically blended opposite temperatures I would have created mud. I also used red to turn the edge of the illuminated side of the form, thus creating the illusion of roundness. Though red is a middle value between the light and shadow sides, it is darker than the value of the contour on the light side of the model and thus turned the form. The contour edge on the shadow side is already dark.

STEP 5. Since I have chosen to work with a warm, artificial light, I know that my shadows will be cool. I therefore used a violet flesh color to cool my shadows and orange to warm my flesh tones in the light. At this stage I also added color accents. I added red to the flesh mixtures for the nose, cheeks, ears, and lips, and yellow to the forehead and chin. Using the additional colors in the forehead, chin, cheeks, and nose, I also blended in the red transitional color.

STEP 6. I then added highlights and dark accents. Since the shadows were red-violet, I made the background a warm green, and introduced this color into the halftone of the hair and flesh. I added interest to the value pattern by making the value of the background lighter in relation to the shadow side of the head and darker in relation to the light side of the head.

Step 6. In the final
step I added highlights
and dark accents.

On Turning a Form

If red-orange is warm and red-violet is cool and red is in between them,
then red is neither warm nor cool but is a middle value between light and
shadow. Thus at the turning of an edge, red works well as a transition
color to help blend between light and shadow.

PASTEL DEMONSTRATION TWO

STEP 1. Having set the model at a three-quarter view to my right, I then positioned the light above and to the front and left of center. I did this to cause the side plane to be slightly darker than the front plane. In contrast to the previous demonstration, I have used natural light with this model, which caused warm shadows. Since my eye level is above the model, the near eye will appear lower than the far eye, and the eyes and mouth will converge upward toward the higher eye level. With the charcoal pencil I established the gesture, proportion in perspective, shadow shapes, and shadow edges. Although it was tempting to render the halftone value in black charcoal, I did not, as it would disappear in the tone of the next step. I fixed this layer with Myston.

STEP 2. I created a middle tone by sliding a black pastel stick over the drawing surface and rubbing it into the surface of the paper in a circular motion with a chamois. I fixed this layer with Myston as well.

Step 2. To create a middle tone, I slid a black pastel stick over the surface and rubbed it in using a chamois.

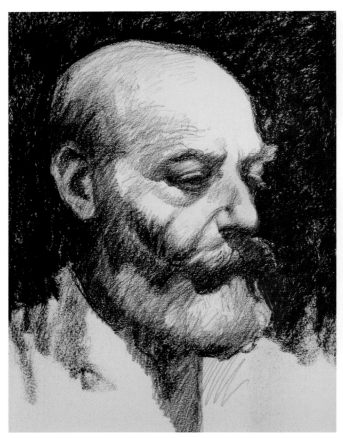

Step 1. Since I positioned the light source above and to the front and left of center, the side plane of the model's head is slightly darker than the front plane, creating a sense of three-dimensionality.

Step 3. I used a cool-gray flesh color for the base for the illuminated side of the face and a reddish brown dark value for the shadow side.

STEP 3. I used a cool-gray middle-value flesh color as a base for the illuminated side. I used a reddish brown dark value for the local color, warm temperature, and value of the shadow side. Green was applied as a background to complement the red coloration of the flesh.

STEP 4. I added blue-gray as halftone around each feature. I used red, a common color to both light and shadow, to blend all form-shadow edges. I also applied red to turn the contour of each form. I added yellow to the forehead and green to the temples (the blue halftone and yellow create green). I added red to the nose, cheeks, and ears with violet halftones (blue halftone and red create violet).

STEP 5. I used a lighter flesh color to lighten and unify all the color notes previously added, as well as to crisp all cast-shadow edges.

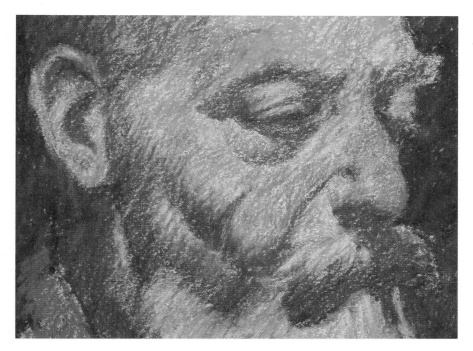

Step 4. I added color around or to each feature.

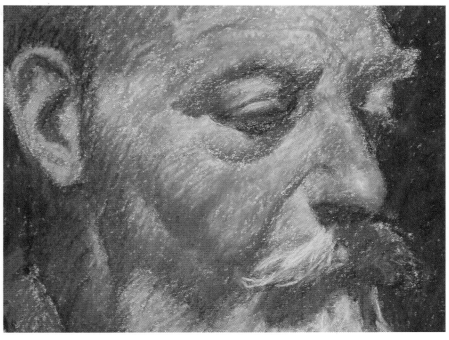

Step 5. I unified and lightened all the colors by applying a lighter flesh color.

STEP 6. I added reflected light in the orbicular cavity and bottom plane of the nose. I added green to all other shadows that received bounced light from the background color. To the shadows I added dark accents in dark green (dark green and dark red-brown create a color close to black in value but without the lifelessness). Since the light source is cool, it thus produces cool light masses. I added the highlights in a light blue-green.

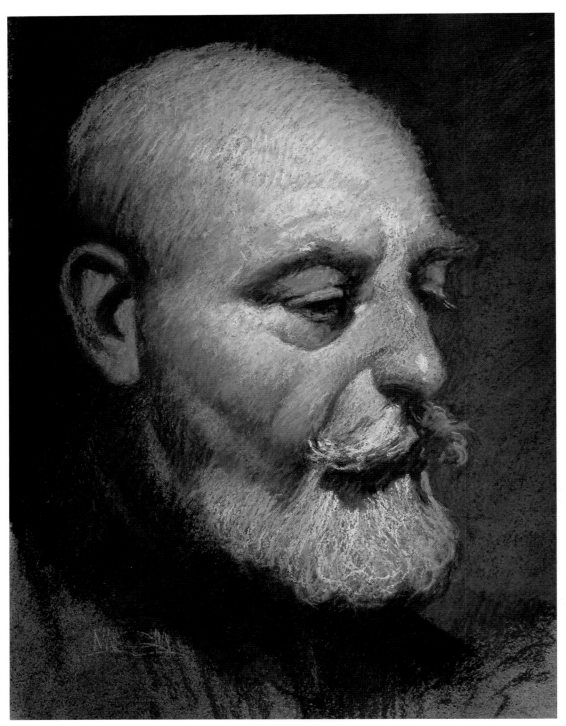

Step 6. Note the temperature of your light source when adding highlights and dark accents to your painting. A cool light will produce cool highlights on the light side of your model and warm accents on the shadow side.

From Painting to Drawing

These paintings are examples of a technique called Peinture à L'essence (meaning "painting in spirits," or "turpentine"). The Impressionist artist Edgar Degas invented the technique to create artworks that imitated the appearance of pastel drawing but that did not require glass for protection. To create a Peinture à L'essence, the artist applies oil paint to a cardboard palette, which draws the oil out of paint. The pigment is reconstituted with turpentine and applied to a cardboard support. The turpentine evaporates, leaving the pigment dry and chalklike in appearance. Since it dries so quickly, it is possible to paint light over dark and dark over light as well as warm over cool and cool over warm without the color becoming muddy. If the pigment contains too much turpentine, the finished work looks like a painting rather than a pastel drawing.

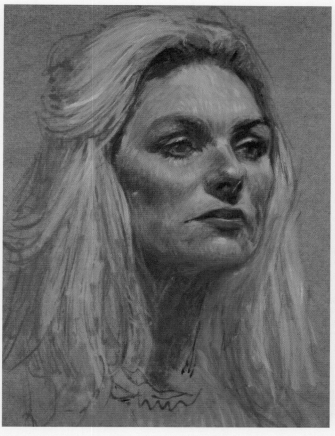

The turpentine evaporates, leaving the paint dry and chalklike in appearance.

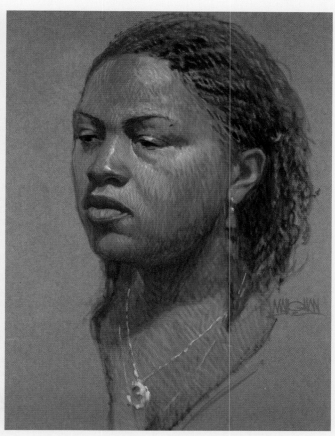

Turpentine's quick-drying property can be a disadvantage, since the paint tends to dry before it gets to the support. The only solution is to add a touch more turpentine and work faster.

INDEX

Accents. *See* Dark Accents
Advancing
 of light, 38
 of warm, 142
Ala prima, 135
Alberti, Battista, 45
Analogous colors, 143–147
Analyzing form, 30–33
Anatomy, of eyes, 65–69
Artificial light, 38, 141

Background, 53, 152
Beard, 104
Blond hair, 102
Blue-analogous palette, 143, 147
Brows, 70, 71, 78, 80
 placement of, 62, 63
Brunelleschi, Filippo, 45
Brunet hair, 103

Caravaggio, 11
CarbOthello pencils, 16
Caring for pastels, 150
Cast-shadows, 26–27, 29, 83
Chamois, 149, 150
"Charcoal" paper, 16
Charcoal pencils, 149, 150
Charm, color, 142
Cheekbones, 81
Chiaroscuro, 14–15, 21–33
Color(s), 133–159. *See also*
 Primary colors; Secondary
 colors; Tertiary colors
 analogous, 143–147
 complementary, 136, 142,
 143–147
 expressive, 145
 family of, 143–147
 light-filled, 139
Color charm, 142
Color intensity, 137, 138–139
Color relationships, 142
Color temperature, 140–142,
 145
Color wheel, 136–137
Combining references,
 124–127
Comparing, of eyes, 70
Complementary colors, 136,
 142, 143–147
Composite drawings, examples
 of, 128–131
Contour, 39, 40
Cool, receding of, 142
Cornea, 69
Costumes, 124, 127
Creative Illumination, 11
Criticism, of self, 121

Dark, receding of, 38, 39
Dark accents, 78, 86, 88, 90,
 92, 96, 98, 113, 158
Della Pittura, 45
Demonstration(s), 109–117
 of combining references,
 126–127
 pastel, 153–158
Detail, 98, 108, 109, 111,
 113, 127
Downward slant, of eye, 67

Drawing
 from multiple sources,
 123–131
 painting to, 159
 to painting, 134–135
Drawing head, principles of,
 35–53
Drawing method, 13, 14–15,
 17–19
Drawing process/steps,
 55–105, 108–117
Drawings, composite,
 examples of, 128–131

Eakins, Thomas, 14
Ears, 94–99
 placement of, 62, 95
Edge control, 108, 109,
 110–111, 113, 114, 116,
 127
Edges, shadow, 28
Eraser, 16
Expressive color, 145
Eyelids, 68, 69, 70, 71, 76, 78,
 80
Eyes
 anatomy of, 65–69
 comparing of, 70
 drawing of, 70–81
 examples of, 76–81
 placement of, 62, 64

Family of colors, 143–147
Features, placement of. *See*
 Placement
Feitelson, Lorser, 11
Five essential drawing steps,
 108–117
Fixative, spray, 149, 150
Focal point, single, 43–44
Foreshortening, 48–51
Form
 analyzing of, 30–33
 in light, 29
 turning of, 155
 value and, 24–25
Form-shadows, 26, 27, 29, 83
Full-value range, 25

Gesture, 57–59, 108, 109,
 110, 112, 114, 116,
 126–127
Glazing, 134, 135, 148
Gogh, Vincent van, 145
Going forward, 118–121

Hair, 100–104
Halftone, 24, 25, 29, 115
Hals, Frans, 11
Harmony, 143, 145
Head
 drawing of, principles of,
 35–53
 lighting of, 36–42
 planes of, 47
 sculpting of, 56
Highlights, 24, 25, 29, 113,
 115, 117, 158
 on ear, 96, 98
 on eyes, 72–74, 77, 78

on nose and mouth, 86, 88,
 90, 92
Horizon line, 45
Human Figure, The, 11

Ideas, practice, 118–119
Imagination, 124, 125, 128,
 131
Intensity, color, 137, 138–139
Inward slant, of eye, 67
Iris, 68, 69, 70, 71, 76, 78, 80

Kneaded eraser, 16
Knife, 16, 18–19
Knowledge, seeing as, 63, 98

Lashes, 71, 76, 80
Leonardo. *See* Vinci, Leonardo
 da
Light
 advancing of, 38
 artificial, 38, 140, 141
 form in, 29
 natural, 38, 140
 reflected, 29
 and shadow, masses of, 36
 temperature of, 141, 158
Light-filled color, 139
Lighting, of head, 37–42
Line(s)
 horizon, 45
 orthogonal, 45
 versus value, 22–23
Lips. *See* Mouth
Local value, 52
Loomis, Andrew, 11
"Lost-and-found" line, 23

Masses, of light and shadow, 36
Materials, 13, 16
 for pastel painting, 149–150
Measuring, sight, 45–46
Method, drawing, 13, 14–15,
 17–19
Michelangelo, 14
Mixing, from tertiary colors,
 138–139
Mona Lisa, 14, 134–135
Monet, Claude, 139
Mouth, 82
 examples of, 86–93
 placement of, 62, 63, 64, 86
 structure of, 84–85
Multiple sources, 123–131
Mustache, 88, 89, 104

Natural light, 38, 140, 141
Natural slants of eye, 67
Negative shapes, 33
Newton, Isaac, 136
Nose, 82–83
 examples of, 86–93
 placement of, 62, 63, 86
 structure of, 84

One-half increments, 60
One-third increments, 60, 61,
 63
Optical color mixture, 148
Orbicular cavity, 65–66, 67

Orthogonal lines, 45
Outward slant, of eye, 67

Painting
 drawing to, 134–135
 pastel, 148–159
 to drawing, 159
Palettes, analogous, 143–147
Paper, 16, 149, 150
 as value, 25, 75
Paper stumps, 149, 150
Pastel painting, 148–159
Pastel paintings, caring for,
 150
Pastels, soft, 149, 151
Pattern, value, 52
Pencil(s), 16
 charcoal, 149, 150
 as value, 25
 working with, 17–19
Perspective, 45–51
Photo references, 124, 125,
 126–127, 128, 129, 131
Placement
 of brows, 62, 63
 of ear, 62, 95
 of eyes, 62, 64
 of mouth, 62, 63, 64, 86
 of nose, 62, 63, 86
Planes, of head, 47
Positions, of eyes, 69
Practice ideas, 118–119
Primary colors, 136, 137, 138,
 139, 142, 143–147
Process, drawing, 55–105,
 108–117
Proportions, 60–64, 108, 109,
 110, 112, 114, 116,
 126–127
Pupil, 68, 69, 70, 71, 76, 78,
 80
Putting it all together,
 107–121

Range, full-value, 25
Raphael, 11, 14
Receding
 of cool, 142
 of dark, 38, 39
Red-analogous colors, 143,
 144, 145, 146
References, combining of,
 124–127
Reflected light, 29
Relationships, color, 142
Rembrandt, 11, 14
Rim lighting, 38, 40
Rives BFK, 149, 150

Sand pad, 16
Sargent, John Singer, 14
Sculpting head, 56
Scumbling, 134, 135, 148
Secondary colors, 136, 137,
 138, 139
Seeing, as knowledge, 63, 98
Self-criticism, 121
Sennelier, Gustave, 138
Sennelier's pastels, 149
Sfumato, 15, 18, 100

Shadow
 light and, masses of, 36
 values in, 24
Shadow shapes, 18, 26–28,
 108, 109, 110–111,
 112–113, 114, 116,
 126, 127
 edges of, 28
 structure defined with, 22, 47
Shapes
 negative, 33
 shadow. *See* Shadow shapes
Sharpening pencil, 18–19
Sight measuring, 45–46
Single focal point, 43–44
Skills, to next level, 121
Slants, of eye, 67
Soft pastels, 149, 151
Sources, multiple, 123–131
Split complementaries, 143,
 144–145, 146, 147
Spray fixative, 149, 150
Step-by-step drawing process,
 55–105, 108–117
Strathmore's "Charcoal" paper,
 16
Structure
 defined with shadow shapes,
 22, 47
 of mouth, 84–85
 of nose, 84
Substitute materials, 16

Temperature, color, 140–142,
 145
Tertiary colors, 136, 137, 138,
 142
 mixing from, 138–139
Three-quarter view, 45
Tilt, 57, 59
Titian, 14
Tone, applying of, 150–151
Trapping, 25, 75
Troubleshooting example, 105
Turning form, 155
Two-thirds increments, 60, 63

Underpainting, 134, 135

Value
 and form, 24–25
 line versus, 22–23
 local, 52
 paper as, 75
Value pattern, 52
Vanderpoel, J. H., 11
Vanishing point, 45, 48, 49,
 51
Velázquez, Diego, 11
Vermeer, Jan, 14
Vinci, Leonardo da, 11, 14,
 15, 45, 134–135

Warm, advancing of, 142

X-Acto knife, 16, 18–19

Yellow-analogous palette, 143